Black & White Photography

A Basic Manual

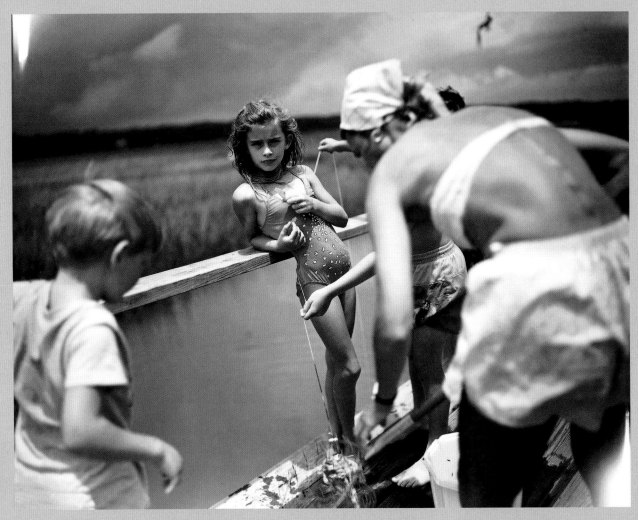

Sally Mann, *Crabbing at Pauley's,* 1989

The moody quality of Mann's family photographs is due in part to her choice to work in black-and-white rather than color. Regardless of when they were taken, black-and-white pictures often have a timeless quality, invoking an atmosphere or memory of a time past.
© *Sally Mann; courtesy of Edwynn Houk Gallery, New York, NY.*

Black & White Photography

A Basic Manual

THIRD REVISED EDITION

Henry Horenstein
Rhode Island School of Design

Little, Brown and Company
New York Boston London

This book is dedicated to Rick Steadry, my first photography teacher, who taught me a lot about taking pictures and even more about teaching.

www.bw-photography.net

Little, Brown and Company
Hachette Book Group USA
237 Park Avenue, New York, NY 10017
Visit out Web site at www.HachetteBookGroupUSA.com

Third Edition

Little, Brown and Company is a division of Hachette Book Group USA, Inc. The Little, Brown name and logo are trademarks of Hachette Book Group USA, Inc.

The Library of Congress has cataloged the previous edition as follows:
Horenstein, Henry.
 Black and white photography.

 Bibliography:
 Includes index.
 1. Photography. I. Title.
TR146.H793 1983 770'.28 82-24967

ISBN 978-0-316-37305-0

10 9 8 7 6 5 4

Production by Books By Design, Inc., Cambridge, Massachusetts:
Design and layout by Janis Owens; Illustrations and layout by Carol Keller; Copy editing by Nancy Burnett and Alison Fields

IM-SP

Printed in Singapore

Timothy Garrett, *Pain,* 1997
There are many ways to make interesting photographs, and not all require buying a sophisticated camera. Garrett makes his photographs in an old-fashioned photo booth that quickly produces four images, one after the other. Although he doesn't have to worry much about technical matters, such as focus and exposure, he does have to plan each session with care to make the four pictures work together in sequence. © Timothy Garrett; courtesy of the artist.

Contents

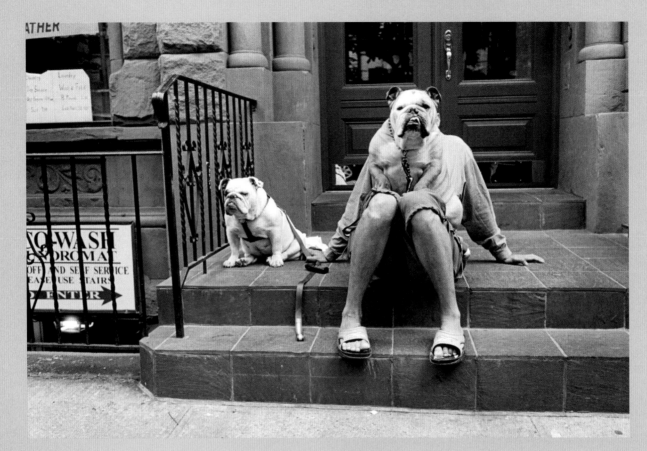

Elliott Erwitt, *New York,* 2000

Erwitt is well known for his witty takes on dog and human interaction. Successful candid photographs require a quick eye for detail and rapid composition decisions. Here, Erwitt uses what may be his most important creative tool: his own feet. By positioning himself in front of the stairs and crouching to make sure the camera was at head level—for both human and dog—he was best able to create this humorous optical illusion. © Elliott Erwitt; courtesy of Magnum Photos.

Beginnings

This manual is a basic guide to black-and-white photography, covering all the points taught in a typical introductory class. It starts at the beginning, assuming you know little or nothing about photography, and guides you through using your camera, developing film, and making and finishing prints.

Although there is much to learn, it's not all that difficult. Modern films and printing papers are easy to work with and today's cameras offer a considerable amount of automation, all of which make the job easier. Automation is not foolproof, however. A camera can't know exactly what the subject looks like and how you want to photograph it. Much can go wrong, even in the most automated cameras, for example, film that doesn't load properly, autofocus that's off the mark, or inaccurate meter readings. And, of course, there's always user error. The more you understand about how everything works, the fewer problems you will encounter along the way and the more control you'll be able to bring to the process, even when working with your camera on automatic mode.

To get the most from this book, you'll need a reasonably sophisticated camera, preferably one that works manually as well as automatically. Don't worry if you don't have a top-of-the-line model; you can make great pictures using very basic equipment. Photographic equipment varies somewhat in design and usage from one camera system to another, so keep your manufacturer's instructional manuals handy to supplement the information in this text for details specific to your equipment.

35 mm SLR camera

To make the best use of the sections on developing film and making prints, you will need access to a darkroom. Both in the darkroom and when taking pictures, refer to your equipment as you read the instructions. It will make understanding the process much easier.

Getting Started

SLR: pages 11–14

Here are some very general instructions and tips on getting started with your camera, assuming it is a 35mm **single-lens-reflex (SLR)** camera, a commonly used model. Later chapters cover these points and other types of cameras in far greater detail.

Automatic Camera: Front View

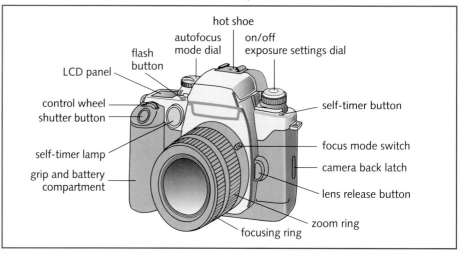

Check the battery and turn on the camera. Your camera needs one or more batteries to operate. Different models take batteries of different sizes. If your camera is new, it probably comes packaged with the needed battery or batteries. If you haven't used it for a while, you may need new batteries. At any rate, you'll need replacements after shooting about 25–50 rolls of 35mm, 36-exposure film, depending on the camera model and other factors; for instance, the more automation you use, the more battery power you'll drain. Some cameras have a battery power indicator, usually displayed on an LCD screen. It's a good idea to bring extra batteries with you when you are photographing, just in case you need them.

Automated cameras usually have a power switch or button that you must turn on to operate the camera. Keeping the power on drains battery power, so switch off the camera when you're not using it. Manually operated cameras are often ready for use all the time, without having to be turned on.

Film speed and ISO: pages 23–24

Choosing and loading film. There are many different films available for black-and-white photography. The most important difference among these films is their relative **film speed,** how sensitive they are to light. Every film has an **ISO** number that rates its sensitivity; the higher the ISO number, the more light-sensitive the film. You'll usually need a high-speed film (ISO 400 or higher) if you are photographing indoors or in a low-light situation (without a flash) to best capture what little light there is. You can generally use a medium- or slow-speed film (ISO 200 or lower) in bright light outdoors or with a flash, when there is plenty of light to expose the film adequately.

Thirty-five-millimeter film is packaged in a cylindrical cassette with the **leader,** the tapered end of the film, sticking out. To load the cassette into your camera,

35mm film cassette

first swing open the back of the camera, usually by sliding or twisting a switch on the side of the camera or by lifting a knob on the top left side.

The camera back has two chambers; usually the left chamber is empty and the right chamber contains a **take-up spool,** to wind the film as it advances out of the cassette. You insert the film cassette in the empty chamber with the extended spool end down. Then, pull the film leader to uncover enough film to reach the right chamber of the camera's interior. Don't pull out more film than you have to.

Loading Film

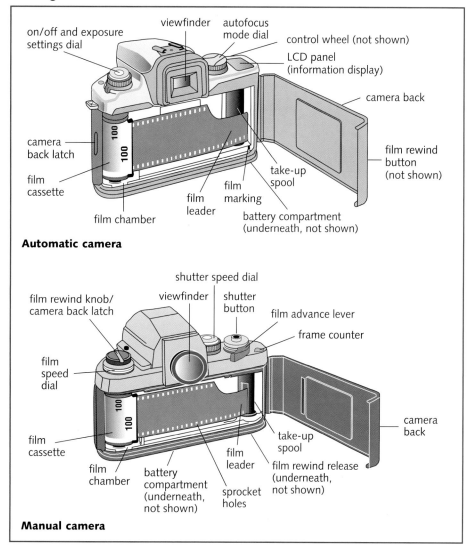

With cameras that advance film automatically, you'll need just enough film so the front of the leader reaches just beyond the middle of the take-up spool; this point is often indicated by a marking (sometimes colored red or orange). With cameras that advance film manually, you'll have to slip the end of the film leader into a groove on the take-up spool and advance the film using the film advance lever located to the right on the top of the camera. Thirty-five-millimeter film has **sprocket holes,** square perforations along the edges. Advance the film one or two times until the sprocket holes on both sides of the film fit into small teeth in the spindle of the take-up spool. These teeth grab the film and move it along after you take your pictures.

Close the camera back and advance the film. Make sure the back clicks shut. If your camera loads automatically, it may advance the film as soon as you close the cover when the camera is turned on; on some models you'll need to press the **shutter button,** the button used to take pictures, to initiate the film advance. After advancing, the camera's LCD panel should show a "1" to indicate you are on the first exposure. Some models advance the entire roll of film onto the take-up spool, then wind the film back into the cassette as you take your pictures. On these models the LCD panel may show the total number of exposures the film allows (usually 24 or 36) and count back to 1.

If your camera loads manually, you can only advance the film one frame at a time. Alternate between moving the film advance lever and pressing the shutter button until the **film counter,** usually a window on top of the camera, indicates that you're ready for the first exposure (1).

Compose your picture and set the film speed, lens aperture, and shutter speed. Looking through the **viewfinder** on the top and back of the camera, you can compose your subject the way you like it. But you also must make sure that the film is receiving the right amount of light (**exposure**) to record the subject. The first step for correct exposure is to set your ISO number, or film speed, on the camera so the built-in **light meter** knows how much light your film needs. Most modern cameras set the film speed automatically by reading a bar code on the film cassette. On older or fully manual models, you must set the film speed yourself, often using a dial located on the top of the camera body.

Once the film speed is fixed, the light meter can measure light in the scene to determine how to set the camera for correct exposure. There are two settings to control light. One is the **lens aperture,** an adjustable opening inside the lens, measured in **f-stops.** A low f-stop number, such as f/2, indicates a wide lens opening that lets in a lot of light, whereas a high number, such as f/16, indicates a small opening that lets in much less light.

The other light-controlling setting is **shutter speed,** a measurement of how long the **shutter** (a curtain or set of blades located between the lens and the

Camera parts: pages 4–5

Setting the ISO: page 74

f/2

Film exposure: chapter 6

Lens aperture, f-stop: pages 35, 38–41

Shutter, shutter speed: pages 57–60

Exposure modes: pages 81–85

film) opens up to allow film to be exposed. The most commonly used shutter speeds are indicated as fractions of a second; a "slow" shutter speed (1/30) lets in light for a much longer period of time than a "fast" speed (1/1000).

The job of the light meter is to provide the right combination of f-stop and shutter speed to achieve correct exposure. In fully automatic cameras, or cameras in a **program autoexposure mode (P)**, the camera sets the f-stop and shutter speed for you, often displaying the chosen settings in its viewfinder or LCD panel. In nonautomatic cameras, or cameras set in **manual mode (M)**, you'll have to set f-stop and shutter speed yourself with guidance from the meter. Many cameras offer various other semiautomatic exposure modes, described later.

There's a lot to know about getting the right film exposure. But to begin with you may want to shoot a few rolls in automatic or program mode to become familiar with the mechanics of picture taking. Good exposure technique is covered in great detail in later chapters.

Focus and take your pictures. Once you've composed your picture and established the correct exposure, make your subject sharp by setting the **focus,** either automatically (**autofocus**) or manually; most cameras offering autofocus have a switch that allows you to choose either manual or autofocus. In most cameras, to use autofocus you push the shutter button halfway down; there is often an

Autofocus: pages 35–37

Film Exposure

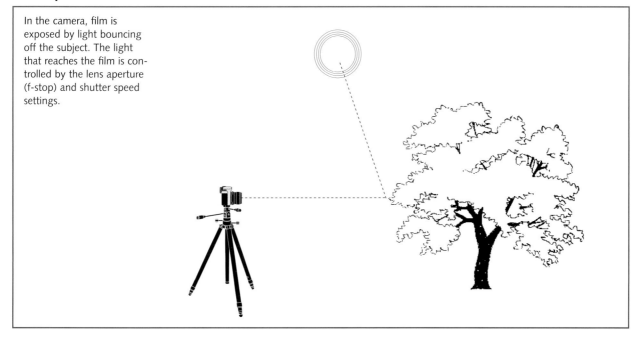

In the camera, film is exposed by light bouncing off the subject. The light that reaches the film is controlled by the lens aperture (f-stop) and shutter speed settings.

Negative and Positive

After it is processed, exposed film becomes a negative, a reversed image of the original scene; light areas render dark (dense) and dark areas render light. Making a print from the negative corrects this reversal and produces a positive—a faithful representation of the scene.

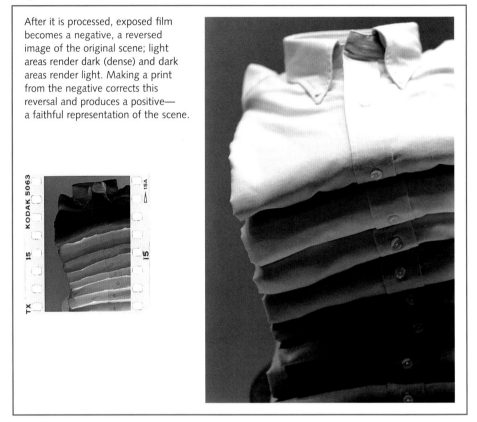

indicator such as a green dot in the camera's viewfinder that lights up when the subject is in focus. For manual focus, you turn a **focusing ring** on the barrel of your lens until you see the subject become sharp as you look through the camera's viewfinder.

Camera shake: page 66

Once your picture is composed, the exposure set, and the subject focused, press down on the shutter button to take your picture. Be very careful to hold the camera steady while you press the button; if your camera moves during the exposure, you may get a blurry image.

Rewind the film and remove it from the camera. At the end of a roll of film, many cameras wind the film back automatically into its cassette. If your camera doesn't have automatic rewind, you'll have to rewind it manually by first pressing a button (or sliding a switch) on the camera body and then flipping a crank on the rewind knob and slowly rotating it in the indicated direction. Once the film is safely back in its cassette, you can open the camera back and remove the film cassette.

Taking pictures is one part of the equation, but just as important are the steps of film developing and printing. Developing turns your film into a reversed image, or a **negative**—dark areas appear light or clear on the film and light areas appear dark. This all happens in a succession of chemical baths.

You can send film to a processing lab for development, but you can also process it yourself. You don't even need a dedicated **darkroom,** which is a room generally used for film and print processing. Developing your own film helps guarantee that your film will be carefully handled, which isn't always the case at processing labs. It also gives you more control over the final results. For example, you can increase or decrease the overall image contrast by extending or reducing the developing time.

Film developing: chapter 9

Once you have negatives, you can make positive **prints.** This process is more complicated than developing film and requires a darkroom, but it is relatively easy to learn. You put the negative in an apparatus called an **enlarger,** which projects the image onto a sheet of photographic paper. Then you put the paper through a series of chemical baths similar to those used for developing film.

Making a print: chapter 10

You can send your negatives to a processing lab for printing, and many labs produce excellent results. But a lab technician can't predict exactly how you want a picture printed. Even if you have labs make your prints in the future, knowing how to make prints gives you an idea of what kinds of results are possible and how to communicate what you want to achieve.

The best reason for learning how to make prints, as well as develop film, is to take control of the process. You'll soon see how much of a difference you can make with simple techniques to frame the image exactly the way you want it, make a print darker or lighter, alter the contrast of a negative or a print, or selectively darken or lighten specific print areas. Aside from the control it offers, successfully developing film and making prints can be very satisfying—even exhilarating. Some photographers actually like darkroom work more than they like taking pictures.

Alternative approaches: chapter 11, and finishing the print: chapter 12

The rest of the text discusses other approaches to taking pictures and making prints which may give you ideas on how to produce your own visual style. It also covers various ways to finish a print—by changing its overall color, re-touching it, and matting or mounting it.

When you have completed reading, you will have learned all the techniques necessary to make excellent black-and-white prints. You also will have learned much of what you need to know when photographing in color or by digital means. However, a book can only carry you so far. Like most skills, good photography comes from practice and hard work. The good news is that you'll have a lot of fun along the way.

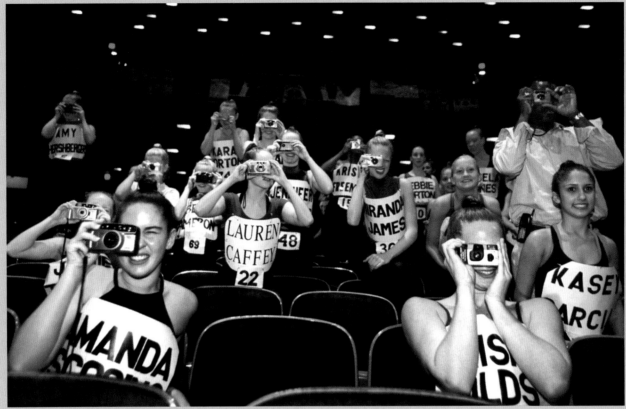

Barbara Davidson, *Rangerette Hopefuls,* 2001

To get this amusing view of an audition for the Kilgore Rangerettes, America's oldest drill team, Davidson may have looked a little funny herself as she turned her back to the try-outs and concentrated instead on the audience. Good photojournalists like Davidson must focus on the action, but still keep an eye out for less obvious details that help tell the story. © Barbara Davidson; courtesy of the artist.

There are many different types of cameras for you to choose from, ranging from cheap generic models used by millions of snapshooters to costly specialized models used by very few advanced amateurs and professionals. Most modern cameras are quite sophisticated; they are controlled by small computerized circuitry, and they offer more features than you will ever need or even learn how to use. Such models are often linked to a **camera system,** an array of lenses, flash units, and other accessories made by one manufacturer, designed to work together with the camera for maximum effect and automation.

Good pictures are made by photographers, not cameras, so don't worry if a complicated camera doesn't suit your budget or your creative goals. You don't need the most expensive model or fancy features; many wonderful pictures are made with simple, even primitive equipment. Still, it helps to understand the various types of available cameras, so you can evaluate your options and make informed choices.

One way to categorize cameras is according to the size film they use: 35mm cameras use 35mm film, for example, and medium-format cameras use size 120 (or 220) film. Another way is according to the viewing and focusing systems they use, such as single-lens-reflex (SLR) or rangefinder. This chapter describes the different categories of cameras and how to use them.

You can make good pictures with inexpensive and even primitive equipment; you don't need a costly camera or camera system.

Film sizes: pages 26–29

Single-lens-reflex (SLR)

Black-and-white film: chapter 3

The shutter: chapter 4

A **single-lens-reflex (SLR) camera** is so named because you view, compose, focus, and take a picture through a single lens with the help of a reflex mirror. You can't see directly through the lens, because the film and shutter are in the way; they have to be positioned right behind the lens to do their job. So the SLR redirects the light from the lens to your eye with a reflex mirror, focusing screen, pentaprism, and viewfinder (see the illustration on the following page).

Reflex mirror. The **reflex mirror** is located in the camera body right behind the lens and in front of the film. It's positioned at a 45-degree angle; when light comes through the lens, the mirror reflects it upward. The mirror also is hinged; when you press the shutter button, it flips up and out of the way as the

Single-Lens-Reflex Camera

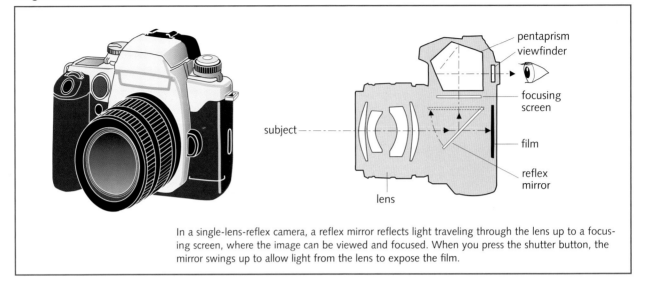

pentaprism
viewfinder
focusing screen
film
reflex mirror
subject
lens

In a single-lens-reflex camera, a reflex mirror reflects light traveling through the lens up to a focusing screen, where the image can be viewed and focused. When you press the shutter button, the mirror swings up to allow light from the lens to expose the film.

shutter opens, permitting light to expose the film. The mirror then quickly flips back into position, so you can view the subject and take another picture. It's this flipping action that creates most of the noise you hear when you take a picture with an SLR—and it also may cause the camera to vibrate somewhat.

The reflex mirror has another important function. All lenses naturally project an image that is upside down and laterally reversed, so that the left side of the picture is on the right and the right side is on the left; for example, words read backwards and upside down (see the illustration on the following page). The reflex mirror turns the image right side up to allow you to view your subject more easily, but it doesn't correct the lateral reversal. That comes later.

Focusing screen. Light reflected upward strikes a **focusing screen,** a textured sheet of thin plastic or glass. This is where the right-side-up (but still laterally reversed) image forms for you to view and focus. The screen is positioned at exactly the same total distance from the lens as it is from the film. Thus, when you've focused the image on the focusing screen, it also will be in focus on the film.

With most SLRs, the focusing screen is nonremovable, but in some advanced cameras you can choose from a variety of screen types. There are screens that are brighter than others for easier viewing and focusing; screens with a split-image circle or other features to help focus; screens with grid lines, used by architectural photographers and others who want a guide for precise composition; and various other types.

Image Orientation

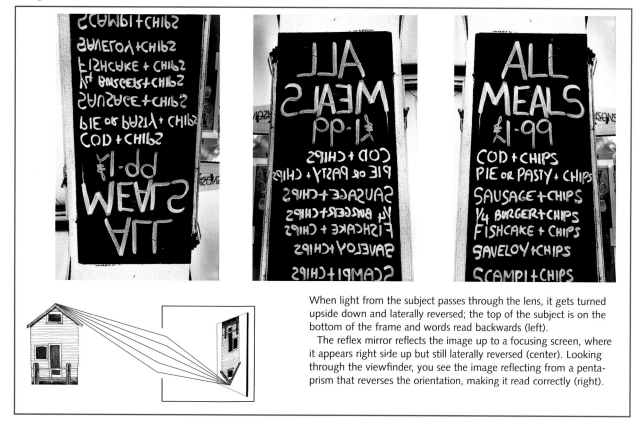

When light from the subject passes through the lens, it gets turned upside down and laterally reversed; the top of the subject is on the bottom of the frame and words read backwards (left).

The reflex mirror reflects the image up to a focusing screen, where it appears right side up but still laterally reversed (center). Looking through the viewfinder, you see the image reflecting from a penta-prism that reverses the orientation, making it read correctly (right).

Pentaprism. The hump on the top of the camera body incorporates a **penta-prism,** which is a prism or mirror system that reflects and directs the image from the focusing screen to a viewfinder. It also allows you to hold your camera at eye level for viewing. Without a pentaprism you would have to look down at the focusing screen to view and focus. By reflecting and directing the image, the pentaprism also corrects the image's lateral reversal, so it matches the orig-inal subject—the left side of the subject is now on the left and the right side is on the right.

The pentaprism also is usually integrated with the camera's through-the-lens meter and exposure controls, and reflects the displays of f-stop, shutter speed, and other meter settings and markers you see when looking through the viewfinder.

SLRs are available for different film formats. Most models are 35mm, but there also are many medium-format SLRs, as well as digital SLRs. One reason SLRs

are so popular is that they accept a wide variety of accessories, such as interchangeable lenses and close-up equipment. With many other camera types your choice of accessories is far more limited or nonexistent.

Rangefinder

A **rangefinder camera** has a single lens like an SLR, but you don't view and focus through it. Instead, you compose your picture by looking through a viewfinder usually located above the lens and to the right (as you look at the front of the camera), and then focus using a rangefinder, a measuring device that links the viewfinder and lens.

The rangefinder works with a prism behind a window located on the opposite side of the lens from the viewfinder (on the top left as you look at the front of the camera). As you turn your lens to focus the subject, the prism rotates and bounces light sideways to a mirror in the viewfinder. This produces a double image of the subject—one from the viewfinder and one from the prism. The double image appears as a translucent rectangular or square patch floating in the middle of the viewfinder. The image from the prism moves as you focus the lens; when the two images superimpose, the subject is in exact focus.

One advantage of rangefinder focusing is that the viewfinder is bright and always visible. With SLRs, when the reflex mirror flips up to expose the film, the viewfinder blacks out briefly. Rangefinder cameras have no reflex mirrors, which allows you to maintain sight of your subject at all times.

Steadying the camera: page 66

The lack of a mirror also makes a rangefinder quiet and easy to hold steady when using slow shutter speeds. You may even be able to handhold your camera at shutter speeds as slow as 1/8 of a second, or even 1/4 under some circumstances, and still get sharp results, unlike SLRs which cannot usually be safely

Rangefinder Camera

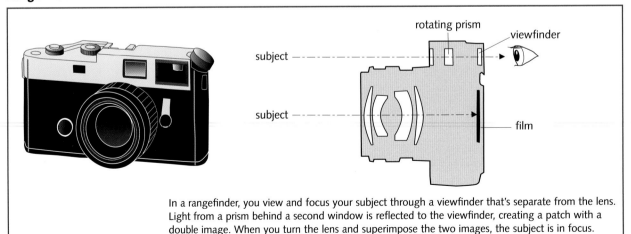

In a rangefinder, you view and focus your subject through a viewfinder that's separate from the lens. Light from a prism behind a second window is reflected to the viewfinder, creating a patch with a double image. When you turn the lens and superimpose the two images, the subject is in focus.

handheld at shutter speeds slower than 1/60 or 1/30. The lack of mirror and pentaprism also makes a rangefinder camera compact. This is good for 35mm models, but especially advantageous with medium format; medium-format rangefinder cameras can be handheld more easily and at slower shutter speeds than most medium-format SLRs.

Medium format:
pages 28–29

The biggest disadvantage of rangefinder cameras is that they don't permit through-the-lens viewing. Viewing the subject through a separate viewfinder, rather than through a lens, means that you may need a different viewfinder for every lens you use. Good rangefinder cameras do offer adjustable or accessory viewfinders or markings in the viewfinder that show what different lenses see. But none of these solutions is as precise as seeing directly through the lens. Thus rangefinder cameras do not offer as many different types of lenses and other accessories as SLRs.

See bw-photography.net
for more on parallax error.

The lack of through-the-lens viewing also may lead to **parallax error,** the difference between what you see through the viewfinder and what the lens sees (and the film records). This is because the viewfinder is usually a little higher and to the left of where the lens points. When your subject is far away, parallax error is usually not a factor; what you see through the viewfinder is pretty much what you will get on film. But parallax error becomes increasingly evident the closer you get to your subject. Some viewfinders adjust for parallax error automatically or include parallax-compensation lines that guide you as you adjust your composition manually. In general, to compensate for parallax error, you have to aim the rangefinder up a little and to the left.

View Camera

4" x 5" film holder

When focusing with a view camera, you must use a dark focusing cloth.

A **view camera** is like a camera from the early days of photography. Using one takes practice, but its design is simple enough. It has a lens mounted on a **front standard** to capture the scene and a slot on a **rear standard** to hold the film. Between the front and rear standards is a collapsible **bellows,** a light-tight accordion-like tube made of cloth, leather, or some other material. A view camera takes large-format sheets of film or a high-quality digital back, making it capable of producing finely detailed, sharp photographs.

The view camera lens is mounted on a **lens board,** and in the rear there is a focusing screen called a **ground glass.** A **film holder,** a removable accessory that contains the film or digital back, is inserted between the bellows and the ground glass. The bellows sits on a rail (or a platform); you turn a knob on the front or back of the camera and the bellows collapses or expands to achieve focus.

You view and focus the subject on the ground glass, which is positioned behind the lens and bellows; the image forms upside down and laterally reversed. Ambient light makes the image hard to see, so you must cover your head and the ground glass with a dark **focusing cloth** to keep extraneous light

View Camera

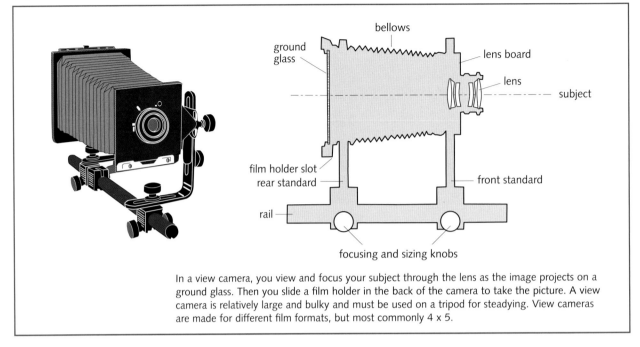

In a view camera, you view and focus your subject through the lens as the image projects on a ground glass. Then you slide a film holder in the back of the camera to take the picture. A view camera is relatively large and bulky and must be used on a tripod for steadying. View cameras are made for different film formats, but most commonly 4 x 5.

See bw-photography.net for more on view camera movements.

Field cameras and press cameras are more portable versions of the view camera.

Field camera

out. When your subject is in focus, you slip a film holder or digital back between the ground glass and the bellows, or replace the ground glass with a digital back, remove the **dark slide** that covers the film on one side of the holder, and take your picture.

A view camera offers more control over the image than any other camera type. The front and rear standards move independently and tilt and swing in a variety of directions, which gives you very precise control over focus, as well as the ability to correct or distort perspective, such as straightening converging lines when you're pointing the camera up at a tall building. The view camera also accepts a wide array of accessories, lenses, and film formats.

On the other hand, a view camera is large and cumbersome, and must be used on a tripod. It is not practical for making candid and spontaneous pictures. It also may be expensive, though view cameras are available for a wide range of prices.

A popular variation of the view camera is the **field camera,** which is a good choice for landscape photography because it is light and folds into a neat package for easy portability. It delivers many of the benefits of the view camera, including high image quality. A field camera is not as versatile as a view camera, however; it doesn't take as many accessories and has fewer front and rear controls for adjusting focus or perspective.

Other Camera Types

Point-and-shoot cameras are a good choice for working simply and quickly for spontaneous results.

Point-and-shoot camera

Instant camera

There are other types of cameras available for a wide variety of basic to specialized uses. Some are designed to take snapshots, but also can be used for advanced and even professional photography. Others are made for a specific way of working. The viewing and focusing systems used on these models also vary, from simple to complex—and it follows that some are cheap and others are quite expensive. The camera types described below include point-and-shoot, twin-lens-reflex, and digital.

Point-and-shoot. The point-and-shoot category covers a lot of territory, from cheap disposable cameras to costly high-end models. What all types share, however, is ease of use and either automatic or fixed focus, making them very convenient for times when you cannot or do not want to think about adjusting focus or other camera controls manually. Most point-and-shoots take 35mm film or are digital.

With the most inexpensive point-and-shoot cameras, you compose your subject through an open window located on the top left or center of the camera back. The viewfinder shows approximately what the final photograph will look like. With such cameras no focus is necessary, because the lens is designed and preset by the manufacturer to produce a sharp image from a distance that ranges from about 4 or 5 feet away from your subject to infinity.

While some point-and-shoot cameras are simple and allow limited or no focusing, many models come with a zoom lens, built-in flash, and sophisticated automatic focus and exposure. On a typical point-and-shoot, you have to hold the shutter button halfway down to activate and achieve focus, and the camera sets the exposure settings (f-stop and shutter speed) for you.

Some point-and-shoot cameras are quite sophisticated—and expensive—offering excellent quality lenses and some measure of focus or exposure control. Many advanced and professional photographers use such point-and-shoot models for subjects that call for a casual and spontaneous approach.

The **instant camera** is a special type of point-and-shoot camera. Most instant cameras take Polaroid brand films that self-develop in a matter of minutes. Over the years, there have been sophisticated SLR and rangefinder instant cameras—and there are film backs that take instant film for professional cameras—but the most familiar models use a simple viewfinder for composing the picture and either focus automatically or require no focusing at all.

Twin-lens-reflex (TLR). A **twin-lens-reflex (TLR) camera** has two lenses stacked one over the other. On top is the **viewing lens,** through which you compose and focus your subject; on the bottom is the **taking lens,** through which you expose the film to light.

The Holga

In recent years, a number of simple, plastic "toy" cameras have become surprisingly popular among fine-art and professional photographers, who embrace them for their flaws rather than their technical quality. There have been several models of such cameras, such as the Lomo and the Diana, but the most popular is the Holga.

The crudely-made Holga will cost you no more than a few rolls of film. It has a cheap plastic lens that doesn't distribute light evenly to the film and a body prone to light leaks. It does take relatively large-size 120 medium-format film (pages 28–29), which means that you can enlarge Holga negatives with less quality loss than with 35mm negatives. However, because the lens is so poorly made, image sharpness falls off drastically at the edges and corners, which are likely to be quite soft, distorted, and even vignetted (darkened around the edges)—all part of the characteristically quirky Holga look. Some photographers even like the random streaks of light caused by unwanted exposure from light leaks in the camera.

Another part of the Holga look is that it produces 2¼" x 2¼" square images (though it comes with an insert for rectangular results); while many good medium-format cameras produce square pictures, most cameras produce rectangular pictures. But for Holga users this is another positive feature; they are drawn to the camera in great part because it is not like every other camera.

To some degree photographing with a Holga is a hit-or-miss affair. Results are hard to control or predict, so it's best to just go with your instincts and take more pictures than you normally would, with the understanding that even your best efforts might be ruined because of inadequate light, poor lens quality, or excessive light leaks. Still there are a few things you can do to increase your chances of success. Here are a few tips:

- Holgas need fairly bright light to produce well-exposed negatives. You also should use fast film (ISO 400), because the lens has a small lens aperture (which you can adjust for sunny and cloudy days). Some Holga models have a primitive flash unit built in that provides decent illumination when you're photographing in low light, close to the subject.
- Because Holgas leak light, load your film in low light or even in the dark, if possible. After loading, immediately seal potential sources of light leaks, such as the camera's seams, joints, and the red-filtered window used for counting exposures, with black electrician's tape.
- Although 120 films use a tightly wound paper backing with the film to keep light out, Holgas often don't wind the paper (or the film) tightly enough. When you remove film from the camera, it's a good idea to immediately wrap it in aluminum foil or some other opaque material for protection.
- The Holga records a lot more of the subject than its viewfinder shows, so get closer to the subject than you normally would when composing your picture.

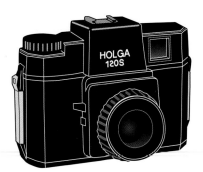

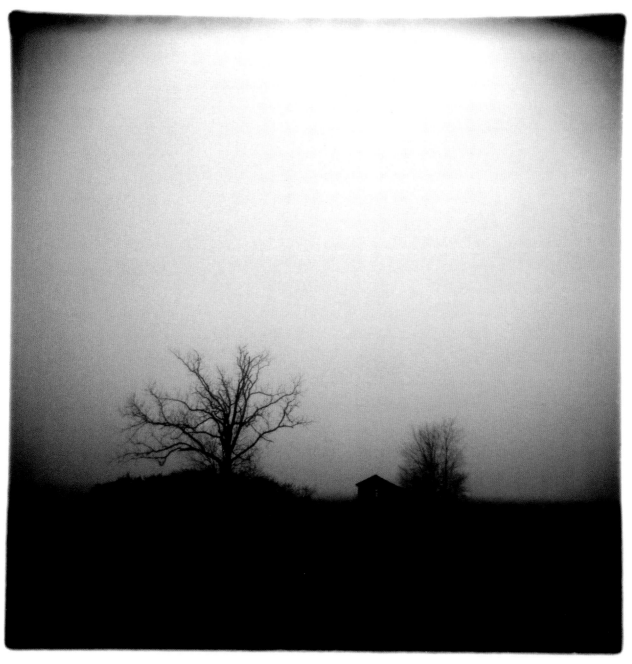

Thomas Gearty, *Near Columbia, South Carolina, 1995*

Most modern cameras are highly sophisticated tools, but some photographers deliberately take a low-tech path. To make this moody landscape, Gearty used a Holga, a cheap plastic camera known for its soft focus and unpredictability. Because the Holga has limited focus and exposure control, it allows photographers to work more spontaneously with less concern for technique. © Thomas Gearty; courtesy of the artist.

A twin-lens-reflex camera has two lenses, one stacked on top of the other; you view and focus your subject with the top lens and expose film through the bottom lens.

A fixed mirror, positioned behind the viewing lens at a 45-degree angle to the film, reflects light up to a focusing screen, so you can see the subject. The film is positioned behind the taking lens. The two lenses are mechanically linked, and as you focus the viewing lens (generally using a knob on the camera body), both lenses move simultaneously. Thus, when the image on the focusing screen is sharp, the image on the film also will be sharp.

Although not as popular as they once were, TLRs are still available, mostly used. Almost all TLRs take medium-format film and with a few exceptions have a nonremovable lens.

Unlike most camera types, TLRs don't offer eye-level viewing. Instead, you view your subject at waist or chest level, looking down at the focusing screen to view, compose, and focus your subject. Ambient light can make the focusing screen difficult to see, so a small pop-up viewing hood fits around the screen to shade it from extraneous light and help make the image on the screen more visible. There is usually a spring-mounted magnifier built into the hood for critical focusing.

Twin-Lens-Reflex Camera

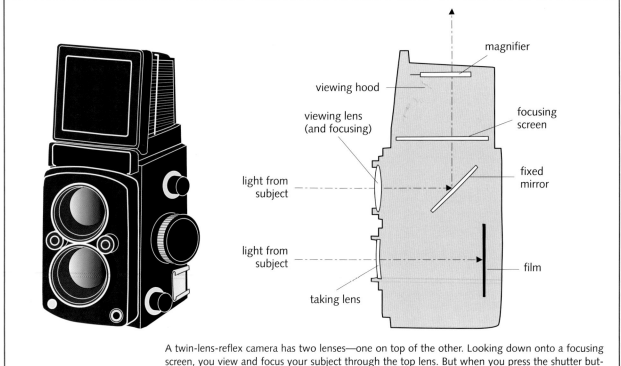

A twin-lens-reflex camera has two lenses—one on top of the other. Looking down onto a focusing screen, you view and focus your subject through the top lens. But when you press the shutter button, the bottom lens takes the picture. Twin-lens-reflex cameras take medium-format 120 roll film.

TLRs can be awkward when composing and focusing your subject, because you see a laterally reversed image when you look down at the focusing screen. This takes some getting used to when making adjustments to your composition. A very few TLRs take an accessory prism viewfinder that fits on top of the ground glass. It corrects the lateral reversal and offers eye-level viewing.

Since you don't see through the taking lens as you do with an SLR, TLRs must be parallax-corrected to allow the viewing lens to show what the taking lens records. Some cameras have parallax compensation built in, but with others you must correct parallax error manually.

Memory cards

Digital. A digital camera works a lot like a film camera, except it uses an electronic sensor rather than film to capture light. Light from the subject passes through the lens and falls on the sensor; the pattern of light recorded by the sensor is stored as a digital file of the image either in the camera or on a removable memory card. The digital image files can then be downloaded to a computer or to a portable hard drive.

Most simple digital cameras function like sophisticated point-and-shoot models. You view and compose the image either by looking through a viewfinder window or, more commonly, seeing what the lens sees displayed on a small LCD screen on the camera back. Most digital cameras offer a variety of programmed exposure modes and a built-in flash, but otherwise the camera determines focus and exposure automatically. There are digital SLRs that allow through-the-lens viewing and focusing, and **digital backs** that attach to medium-format and large-format cameras. These are mostly for advanced and professional photographers.

Digital point-and-shoot camera

Digital cameras offer a lot of advantages. There are no film and processing expenses, because memory cards can be used over and over again. Moreover you can see the results immediately and delete any pictures you don't like. You can make prints either by downloading files to a computer and printing with a desktop printer, or taking a memory card to a camera store or consumer lab for high-quality hard copies from a special digital printer. You don't even have to make a print; the image files are easy to view on a computer monitor, burn to a CD or other media, e-mail to a friend, or post on a Web site.

Keep in mind that there are still considerations after you take the shot with a digital camera. The image files may need to be adjusted and manipulated in an image editing application, such as Adobe Photoshop, and this can be time-consuming. Also, for best results, you must fine-tune the color consistency between your camera, computer monitor, and printer, a process called **color management**; managing black-and-white results is a little easier, but still must be done.

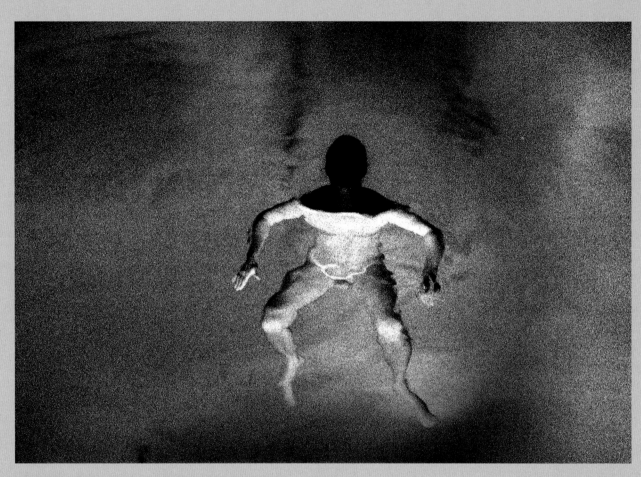

Allen Frame, *Man in Pool, Mississippi, 1997*

Photographers select one film over another for both practical and aesthetic reasons. Working in low-light conditions, Frame needed a high-speed film so he could use a fast enough shutter speed to handhold his camera. But the resulting coarse grain also adds a gritty look that helps give the picture an unsettling and mysterious mood. © *Allen Frame; courtesy of Gitterman Gallery, New York, NY.*

Black-and-White Film

There are many different types of film available and different reasons to use each type. Sometimes your choice of film is a practical matter; for instance, you may need a film sensitive enough to make a picture in low light. Other times your choice will be aesthetically driven; perhaps you need a film that reproduces all the subject's textures and tones as smoothly as possible. Whatever your choice, it's highly likely that the film you use will have a noticeable effect on the way the picture ultimately looks.

Black-and-white films consist of a clear, flexible, plastic support, called the **base,** coated with a microscopically thin **emulsion.** The emulsion is a chemical compound of light-sensitive **silver halide** crystals suspended in gelatin. It is coated with a protective layer to minimize scratching (and other physical damage caused by handling) and backed by an **antihalation layer** that helps promote image sharpness.

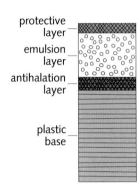

protective layer
emulsion layer
antihalation layer

plastic base

Cross section of black-and-white film

Film Characteristics

Different films often have strikingly distinctive characteristics, but sometimes the variations are quite subtle. These are the most important characteristics of black-and-white films:

film speed
grain
tones
contrast

Film speed. Film speed is a measurement of how sensitive a film is to light. A film that is highly sensitive to light is called a **fast film,** or just "fast"; a film with low sensitivity is a **slow film,** or just "slow."

The most common way to quantify film speed is according to its **ISO** (International Standards Organization) rating. A film with a higher ISO number needs less light to properly capture an image than a film with a lower ISO number. For example, ISO 400 film is more sensitive to light than ISO 100; it will take four times more light to properly expose ISO 100 film as it will take to properly expose ISO 400 film (400 ÷ 100).

Film speed choices vary with manufacturers, but these are the most common for black-and-white films:

ISO 50 slow
ISO 100, 125, 200 medium
ISO 400 fast
ISO 1600–3200 ultrafast

Medium- and slower-speed films are mostly meant for brightly lit subjects. You will usually need fast film in dimly-lit outdoor conditions, for sports and other action subjects (even in bright light) and almost always indoors, unless you're using a flash. But you also can use most fast films outdoors, even in bright light. Ultrafast films (ISO 1600 or faster) are useful in very dim conditions, such as at night or in clubs.

Grain. When film is developed, the silver halide crystals that were exposed to light form small black clumps of metallic silver, called **grain,** that make up the photographic image. Grain looks a little like particles of sand. You will recognize it when you see it, for example, when you're viewing your film through a magnifier or looking at an enlarged print. The size of the individual clumps can vary according to the type of film you use.

Slow- and medium-speed films (ISO 200 or lower) produce smaller particles of silver, and are therefore called **fine-grain films.** Such films reproduce subject tones smoothly and render subject detail finely and accurately. Fast-speed films (ISO 400 and higher) use larger particles of silver to create the image. Ultrafast

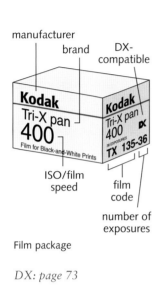

manufacturer

brand DX-compatible

ISO/film speed

film code

number of exposures

Film package

DX: page 73

Film Speed

Slow film (low speed), such as ISO 100 (left) produces fine grain and smooth tones. Fast film (high speed), such as ISO 3200 (right) produces noticeable grain and a coarse look.

Low-Speed Film (Slow) High-Speed Film (Fast)

How Film Records an Image

The film's emulsion layer holds the key to understanding how a photographic image is formed. The emulsion contains silver halide crystals, which capture the light projected by the lens onto the film's surface. Certain areas of the film receive more exposure than other areas, since light areas of the subject reflect more light than dark areas. For instance, a white sweater reflects more light than blue jeans, so more light will expose the area of the film representing the sweater than will expose the area representing the jeans.

When you take a picture, an image of your subject forms as an invisible pattern of altered silver halide particles in the emulsion. This is called a **latent image.** Chemical development converts the film's exposed silver halides to black particles of metallic silver, making the image visible.

Film development takes place in proportion to exposure. In other words, when film is exposed, a lot of silver forms in the brighter areas of the subject and renders those areas dark on the film; relatively little silver forms in darker areas, which renders these areas as light on the film. Thus your developed film contains a tonally reversed image—a negative. The light areas of the original scene are dark and the dark areas of the scene are light. Making a print from the negative reverses the image to produce a positive, correctly representing the tones of the subject.

films (ISO 1600 and higher) are sometimes called **coarse-grain films,** or simply grainy, and reproduce image tones and details more roughly and with less subtlety. ISO 400 films are generally considered medium-to-fairly-fine-grain.

The choice of film, with its inherent grain characteristics, is one of the most important controls you have over the final look of your work. Some subjects, perhaps a lush landscape or an elegant flower, may look best when photographed with a fine-grain film that reproduces the scene with smooth, rich detail. Other subjects, such as a gritty urban scene, may feel more real when photographed with grainier (coarse-grain) film. It's very much a matter of individual preference.

Film exposure: chapter 6

Developing film: chapter 9

Note that film type is only one factor that determines grain. Other factors include film exposure, film development, and print size. Even film speed isn't a totally reliable gauge of graininess. An ISO 400 film from one manufacturer may produce finer or coarser grain than an ISO 400 film from another. Some manufacturers even offer more than one film choice with the same ISO, but different grain characteristics.

Tones. A black-and-white photograph is rarely just black and white. Instead, it is made up of a range of shades—blacks, grays, and whites. These shades are called **tones,** and the variety of tones from dark to light contained in an image is called the **tonal range.** For instance, a photograph of a chess board might have a limited tonal range, since it consists mostly of blacks and whites; a photograph of the surface of a lake would have a much longer tonal range, since it is made up of dozens of subtly different values ranging from black to gray to white.

Some films are capable of reproducing more of a subject's tones than others. As a general rule, slower films, such as ISO 50 and 100, reproduce more tones than faster films, such as ISO 1600 or 3200; the fine grain of slow-speed films captures more information to better render subtle differences. Note that several other factors can play a large role in tonal range, including the inherent tonal characteristics of the subject, film format, and film exposure and development.

Contrast: pages 113–14, 152–57, 171–73

Contrast. Contrast refers to the relative difference between dark and light tones in the original subject or in the negative and print that represent the subject. All other things being equal, some films inherently produce more contrast than others. Higher contrast films produce dense blacks and bright whites, with few shades of gray, while lower contrast films produce more grays and a subtler transition from the darkest tones to the lightest.

As with other film characteristics, contrast is a function of several factors other than the film you use. The original subject lighting is critical, as is film exposure and development; when printing, you can use different papers and/or colored filters to vary the image contrast.

Film Formats

35mm film cassette

See bw-photography.net for more on bulk film.

Film format refers to the size of the film used by a particular camera. Over the years, there have been many different film formats, but today they can be generally classified as follows:

> 35mm
> medium format
> large format

35mm. By far, the most common film format is 35mm, which measures 35 millimeters wide. It is packaged in rolls that produce 12, 24, or 36 exposures; the narrow strip of film is coiled around a plastic spool and encased in a metal cassette for protection and to keep light out. You also can buy some types of 35mm films in longer rolls, known as **bulk film,** for reloading into reusable cassettes.

Because 35mm is a relatively small format, most of the cameras that use it also are small. This makes it an ideal choice for spontaneous and action work, such as candid portraits, photojournalism, and sports photography.

Thirty-five millimeter cameras almost always produce images measuring 24 x 36 mm (a little less than 1" x 1½"), but sometimes they produce different sizes and shapes depending on the rectangular opening in the back of the camera body. The most common alternative size is called **panoramic,** because it provides a wide panorama of a scene. In most models, the camera's manufacturer achieves this wider view by masking out the top and bottom of the 35mm

Film Formats

Film comes in several formats (sizes), producing negatives of varying sizes and shapes.

35mm (1" x 1½")

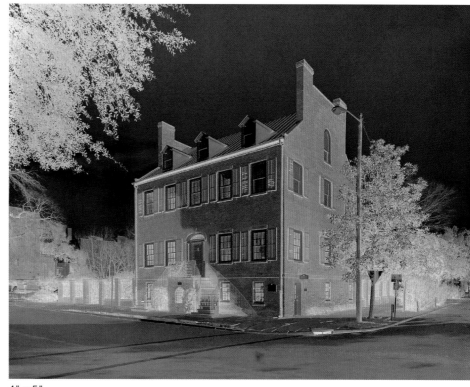

4" x 5"

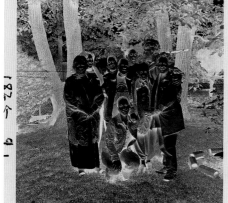

120 (2¼" x 2¼")

35mm panoramic (1" x 3")

opening. A few cameras have a bigger opening in their back to produce a larger image on 35mm film.

Medium format. Medium-format film is larger than 35mm film, so it produces larger negatives that, with rare exceptions, produce prints that are sharper, less grainy, and render more gray tones. This film format is generally used by advanced and professional photographers for such subjects as fashion, portraiture, still life, and landscape.

Rather than packed inside a protective cassette, medium-format film comes as a roll wrapped tightly onto a spool, with an opaque paper backing to prevent unwanted exposure to light. Medium-format film is sometimes called roll film for this reason. The most common medium-format size is 120; the far less common size 220 film allows double the exposures per roll. Both 120 and 220 films measures 2⅜" wide.

Some medium-format cameras produce one size image only, while others are capable of producing more than one size with the use of masking attachments or different film backs. Many medium-format cameras have interchangeable film backs that attach to the back of the camera, much as interchangeable lenses attach to the front, and take different-size pictures; these include film backs as well as digital backs that do not require film at all. Other cameras accept masking attachments that fit into the back of the camera.

120 roll film

Digital cameras: page 21

Medium Formats

The image shape and size, as well as the number of exposures per roll, varies with the particular medium-format camera. Some models produce square pictures, while others produce rectangles of various proportions, including panoramic. The most common medium-format sizes are 6 x 4.5 cm, 6 x 6 cm (sometimes called "2¼," since its square image area measures 2¼" x 2¼"), and 6 x 7 cm. Cameras producing these image sizes are widely available, but more specialized sizes also can be found. Following are almost all of the available medium-format options. Note that the number of exposures can vary slightly depending on the camera and how you load the film.

IMAGE SIZE		NUMBER OF EXPOSURES	
Centimeters (cm)	Inches	120 Film	220 Film
6 x 4.5 cm	2¼" x 1¾"	15–16	30–32
6 x 6 cm	2¼" x 2¼"	12	24
6 x 7 cm	2¼" x 2½"	10	20
6 x 8 cm	2¼" x 2¾"	9	18
6 x 9 cm	2¼" x 3¾"	8	16
6 x 12 cm	2¼" x 5½"	6	12

4" x 5" sheet film

Large format. Large-format film is much larger than 35mm or medium-format. It comes in single sheets rather than rolls—and is thus called **sheet film**—and produces only one picture per sheet. Sheet films come in a variety of sizes, including the most common size, 4" x 5", and the less common, 8" x 10".

Large-format cameras are used by advanced and professional photographers who want extremely sharp and grainless results with the widest range of tonality. Photographers working with architectural and still-life subjects, as well as many landscape and formal portrait photographers, often favor large-format film.

Special Black-and-White Films

See **bw-photography.net** for more on film suppliers.

See **bw-photography.net** for more on copy negatives.

There are several specialized black-and-white films available, originally made for a particular purpose, such as for medical or graphic-arts images. You can use some of these films for creative effect. Here are a few of the most interesting special black-and-white films, but keep in mind that some of them may be hard to find.

High-contrast. Sometimes called **litho** films, these films can be used in the camera to make high-contrast original negatives, or they can be used in the darkroom to make copy negatives and positives for a variety of darkroom manipulations.

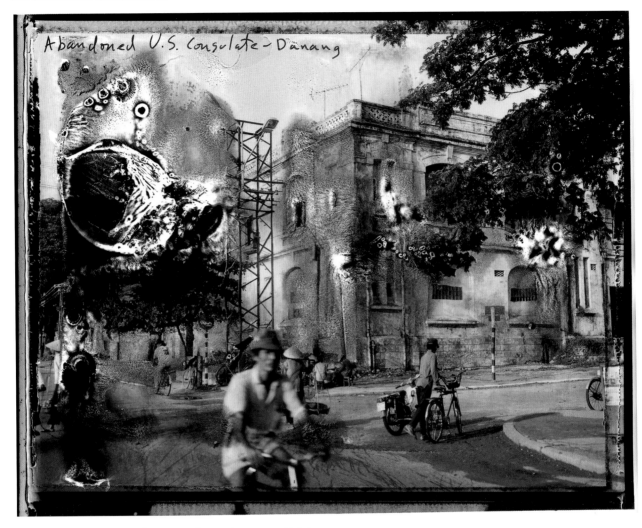

Written on image: *Abandoned U.S. Consulate - Danang*

Bill Burke, *Abandoned U.S. Embassy, Danang, 1994*

Burke's gritty pictures, taken with a special Polaroid film that produces both a negative and a print, break a lot of photographic conventions. He allows the film emulsion to deteriorate, writes on the image, and makes prints from the negative that show its jagged edges—all of which are effective in emphasizing the chaos and fragmentation of Southeast Asia after the Vietnam War. © Bill Burke; courtesy of Howard Greenberg Gallery, New York, NY.

See **bw-photography.net** for more on black-and-white transparencies.

Transparency. Almost all black-and-white films produce negatives that are then printed to make a positive image. But it also is possible to make black-and-white transparencies (film positives). One way is to buy film specifically made for this purpose, although there are few such films available. Another way is to develop standard black-and-white film in special reversal chemicals, which produce positives rather than negatives.

Chromogenic. Chromogenic black-and-white films use dyes rather than silver as the main component of the negative, which also is how color films work. While these films produce very good quality negatives, the main reason to use chromogenic black-and-white films is convenience. They can be processed in any lab that processes color film and you also can get snapshot-size black-and-white prints from such labs at an affordable price, if you choose, though often the prints have an overall cast of blue, brown, or some other color.

Infrared film: pages 209–11

Infrared. Infrared films were originally developed for industrial and scientific applications, but they are now widely used by creative photographers for their unusual visual qualities, which have been variously described as surreal, dream-like, ethereal, and unworldly.

Black-and-white instant. Most instant films are made by Polaroid; many types are available, including many made for professional use, sometimes called **peel-apart** films. These films are mostly used in medium- and large-format cameras. Many professional Polaroid films were made to use for a quick proof—to see how a picture would turn out before using standard film to capture the final image.

Nicholas Laham, *Rugby Action*

Sometimes photographers can't get physically close to their subject, such as at a sporting event when the action is on the field and the camera is relegated to the sidelines. Here, Laham uses a telephoto lens to make a tightly framed picture from a distance, while keeping himself out of harm's way. © Nicholas Laham; courtesy of Getty Images.

The Camera Lens

Enlarging lenses: pages 164–65

The lens is one of the fundamental tools of photography. There are two main types: camera lenses and enlarging lenses. The camera lens is located on the front of the camera body and has several functions: It gathers light from the subject you are photographing, allows you to focus that light on the film, and controls the amount of light that reaches the film. It also determines how much of the subject will be included in the picture and which parts of the subject will be in or out of focus. You will learn about these controls in this chapter.

Some cameras have a **fixed lens,** one that is permanently attached to the camera body. Fixed lenses are a common feature of point-and-shoot and other snapshot-style camera models. They also are found on a few more expensive, sophisticated cameras. Most fixed-lens cameras are relatively compact, but have limited versatility.

Camera Lens

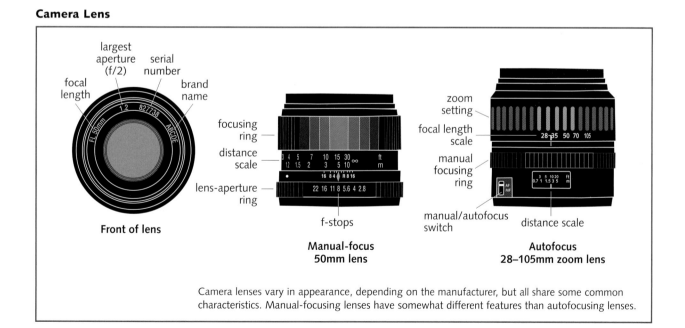

Camera lenses vary in appearance, depending on the manufacturer, but all share some common characteristics. Manual-focusing lenses have somewhat different features than autofocusing lenses.

The lens is fixed on some cameras and interchangeable on others.

SLR, rangefinder, and view cameras: chapter 2

Other cameras have **interchangeable lenses**, which offer a lot of creative control. Interchangeable means you can remove the lens from the camera body and replace it with a variety of other lenses for a wide range of uses. For example, you might choose to replace your lens with one that's better for low-light situations, close-ups, or shooting distant subjects. Cameras that accept interchangeable lenses include the very popular 35mm single-lens-reflex (SLR) models and medium-format SLRs, some rangefinder models, and view cameras. There also are digital SLRs that accept interchangeable lenses.

When buying an interchangeable lens, note that compatibility is crucial. A lens from one camera manufacturer usually doesn't fit on a camera from another manufacturer. Your best bet is to buy lenses made specifically for your camera, either from the camera's manufacturer or from an independent lens maker. Many independent brand lenses are of good quality and relatively affordable, but make sure you specify your camera model when buying any lens to make sure it is compatible.

Whether fixed or interchangeable, all lenses control or affect these basic functions: focus, film exposure, angle of view, and depth of field.

Interchangeable Lenses

SLR cameras allow you to use interchangeable lenses that come in a variety of sizes and shapes. Each lens captures a different view of the subject, depending on its focal length. Fixed-focal-length lenses offer only one view of the subject, while zoom lenses provide a range of views. Focal lengths are discussed in detail on pages 41–48.

500mm

100mm 70–200mm 35–350mm

14mm 24mm 17–35mm 50mm 28–70mm

Focus

Probably the most obvious thing a camera lens does is **focus**—make the image sharp. It does this by gathering the scattered light rays that are reflected by a subject, causing them to converge on film to form the picture. Focus is controlled by moving the lens elements (an array of small, specially shaped pieces of glass or plastic inside the lens) to control where the light converges. But you don't have to understand optics to use your camera lens. On nearly all cameras, the process is quite simple and intuitive. And most cameras provide visual aids to help you focus easily and sharply.

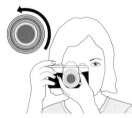

To focus manually, turn the focusing ring on the lens.

Some camera systems offer **manual focus** only. Others offer **autofocus (AF)**, or automatic focusing, in which the camera and lens work together to do the focusing for you. However, most autofocus cameras have a switch—sometimes on the side of the lens, sometimes on the camera body—that allows you to choose either manual or automatic focusing.

Manual focus is the simplest to understand, but not always the simplest to use. When you turn a ring on the barrel of the lens, it moves the lens in and out to achieve focus. With some lenses you can see the physical in-and-out movement; others have **internal focusing (IF)**, which means you can't see the movement because the focusing action happens inside the lens.

To focus automatically, press the shutter button halfway down.

As you look through the viewfinder of most manual-focus SLR cameras, you can actually see the subject become sharper when you turn the lens. Some models have a focusing aid called a split-image circle in the viewfinder. As you view the subject, you see a horizontally bisected circle in the middle of the viewfinder. When the subject is out of focus, the image details depicted in the top and bottom halves of the circle don't align; when the subject is in focus, they do align.

In most cases, autofocus is quicker, simpler, and more accurate than manual focus. To autofocus, you point your camera at your subject so that the **focus point**, usually indicated as brackets, boxes, or other marks in the center of the viewfinder, covers the part of the subject you want in focus. Press the shutter button halfway down to activate the focus, and then press the button all the way down to take the picture. Sounds easy enough, but in practice autofocus doesn't always work as well or as quickly as you might like.

Film Exposure

All lenses have an **aperture**, an opening created by a series of overlapping blades that allows light into the camera. The lens aperture is adjustable on almost all camera lenses. You can open it up to allow more light in, or close it down to reduce the amount of light that passes through.

Film of a given speed (sensitivity to light) needs a certain amount of light, not too much and not too little, to record an image. The size of the lens aperture is one of two factors in determining how much light is allowed to reach the film,

Autofocus Problems

Autofocus can be a powerful aid when it works, but frustrating when it doesn't. And there are some situations in which it simply falters. Certain techniques can help you work around these situations, but occasionally you will find it easier to switch from autofocus to manual focus.

When the subject is off-center, many autofocus systems focus on the foreground or background instead of on the main subject. This is because many cameras focus on the subject using a single focus point in the center of the viewfinder, so if your main subject is off to the side (or on the top or bottom) of the frame, your lens may focus closer or further away than you would like, putting your main subject out of focus.

One solution is to lock in focus on your subject, then reframe the subject to the desired composition and take the picture. You secure focus by using **focus lock**, a fundamental feature of autofocusing systems. Press the shutter button halfway

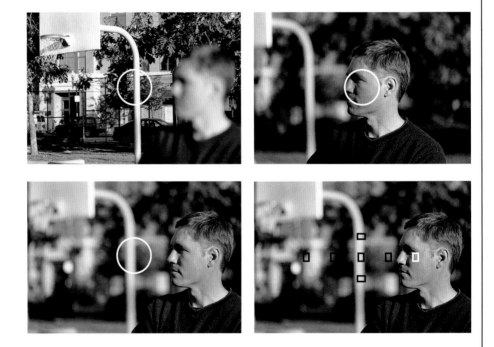

Autofocusing Off-center

Many autofocusing systems focus on the area of the subject that's in the center of the frame. If your subject is off-center, the camera may focus on the background (top, left). For an off-center subject, compose with your subject in the middle of the frame and press the shutter button halfway down to focus (top, right). Recompose, while holding the shutter button halfway to lock the focus (bottom, left). Then press the shutter button all the way down when you are ready to take the picture. Cameras with multipoint focusing let you select one of several focus points across the frame for off-center subjects (bottom, right).

down and focus on your subject; this causes the focus to lock in at that distance, even if you point the camera somewhere else. While focusing on your main subject, keep the button halfway down and move the camera until you have framed the picture the way you want it. Then press the shutter button all the way down to take the picture.

Many autofocus systems offer **multipoint** (also called **wide-area**) focusing, which uses an array of three or more focus points spaced along various parts of the viewfinder. This allows an off-center focus point to catch and focus subjects that aren't in the center of the viewfinder. Some cameras do this for you automatically, reading the subject and calculating where to focus, while many allow you to choose the focus points yourself. For example, if you want to place your subject on the right side of the frame, choose a focus point on the right side of the viewfinder, usually by pushing a button and turning the camera's **control wheel,** to achieve accurate autofocus without having to lock the focus and recompose.

Autofocus systems sometimes falter with other types of subjects besides those that are off-center. They may not find focus easily or at all in low-light or low-contrast situations. Shiny surfaces also are problematic, as are some close-ups. In these cases, the lens may drift in and out, searching close-to-far distances, trying unsuccessfully to catch the focus. When having trouble in autofocus mode, look for a clearly defined edge or an area of detail or contrasting tone in your subject and try focusing on that—or simply switch to manual focus.

Most autofocus systems work quickly and invisibly. They have tiny computers that analyze the light reflected by the subject and move the lens in and out accordingly. Such systems are called **passive autofocus.** To improve autofocus performance in low-light or low-contrast conditions, some cameras have backup **active autofocus,** which projects a beam of red light onto the subject so the camera's computer can read the beam as it reflects off the subject to determine focus.

Moving subjects also can challenge an autofocus system. The system's basic autofocus mode is called **one-shot,** because the camera won't take a picture until focus locks on a target. If your subject is in motion and moves after focus is locked, it may not be as sharp as you'd like. In these situations, set your camera to its **continuous autofocus** mode, a common option on SLRs. In continuous autofocus, the lens keeps focusing, adjusting for changes as your subject moves, and allowing you to take pictures even when the lens has not secured sharp focus. Some models can even be set to switch back and forth between one-shot and continuous autofocus.

Unfortunately, sometimes the subject is moving faster than continuous autofocus can adjust, such as when you're photographing sports and other action subjects. That's where **predictive autofocus** (also called **focus tracking**) comes in handy, if your camera offers it. With this feature, the camera and lens actually anticipate the change in position of a moving subject and adjust the focus to compensate for the very brief interval between the time you press the shutter button and the shutter opens to expose the film.

and thus is critical in controlling correct film exposure. In simple terms, you need a relatively large (wide) opening in low-light conditions to allow enough light to expose the film, and a smaller opening in brightly lit conditions so you let in no more light than is needed. Note that your other primary control, shutter speed, is equally important in determining film exposure.

Shutter speed: pages 57–60

The term **f-stop** refers to the size of the lens aperture. Most lenses offer a wide variety of f-stops, sometimes set manually by the photographer and sometimes set automatically by the camera. The terms **lens aperture** and **f-stop** are often misunderstood and confused; lens aperture refers to the physical lens opening and f-stop represents a measurement of that opening.

The following f-stops are among those available, although the range will vary depending on the model of lens:

The higher the f-stop number, the smaller the lens opening; the lower the number, the larger the opening.

f/1.4, f/2, f/2.8, f/4, f/5.6, f/8, f/11, f/16, f/22, f/32

The f-stop numbers are counterintuitive. A higher f-stop number indicates a smaller lens opening, which means that less light passes through; a lower f-stop number indicates a larger lens opening and more light passing through. A lens set at f/16, for example, allows much less light to pass through than a lens set at f/2.

Setting the f-stop. Some lenses permit you to set the f-stop using numbers printed on an **aperture ring,** a movable control on the lens. To set an f-stop, you simply turn the aperture ring on the lens until it matches up with a marker, such

Lens Aperture and F-stop

The lens aperture is controlled by a series of overlapping blades that can be opened and closed to let in more or less light. The relative size of the opening is indicated by its f-stop number; the larger the number, the smaller the opening. The f-stops shown here are sometimes known as whole, or full, f-stops. When you change from one whole f-stop to another, you let in half or twice as much light, depending on whether you make the opening smaller or larger. Note that your lens may not offer a full range of whole f-stops.

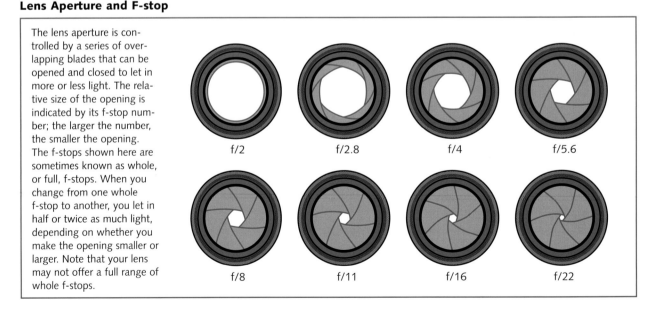

f/2 f/2.8 f/4 f/5.6

f/8 f/11 f/16 f/22

as a line or a diamond-shape indicator. Most automatic cameras don't have f-stops indicated on the lens at all. You set the f-stop on these lenses by rotating the **control wheel,** a dial on the camera body, until the desired f-stop is displayed on the LCD panel and/or in the camera's viewfinder.

The f-stops on the opposite page have a special relationship to each other, one that is critical for understanding film exposure and how to control it. Changing the lens aperture setting from one of the f-stops in this list to one that comes just before or after it halves or doubles the amount of light the lens allows through, depending on whether you make the opening smaller or larger. For example, changing from f/8 to f/11 makes the lens aperture half the size, so it lets in half the light. Changing the lens aperture by two f-stops from f/8 to f/16 reduces the light to one-fourth. Conversely, opening the lens from f/8 to f/5.6 doubles the amount of light let in and opening it to f/4 allows in four times the amount of light.

Note that these f-stops are sometimes known as **whole,** or **full, f-stops.** But not all lenses offer the full range of these stops. Some don't open as wide or close as much, while others open wider and close more. For example, one lens may have a maximum aperture of f/2, while another only opens to f/4. Still another lens may have f/22 as its smallest aperture, while another only f/16.

Still others don't offer whole f-stops as their maximum lens aperture, possibly opening up to f/3.5 instead of f/2.8. In this case, f/3.5 is a **partial stop,** meaning it is a setting in between two whole f-stops (smaller than f/2.8, but larger than f/4). For more precise exposure control, you can deliberately set lenses in between whole f-stops. On lenses that permit you to set the lens aperture by turning a ring on the lens barrel, you simply turn the ring until the

> Whole, or full, f-stops have a half and double relationship to each other; for instance, f/8 lets in twice as much light as f/11 and f/4 lets in half as much light as f/2.8.

Setting the F-stop

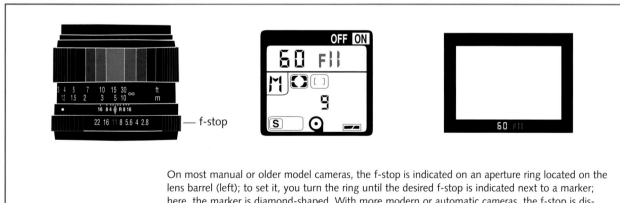

On most manual or older model cameras, the f-stop is indicated on an aperture ring located on the lens barrel (left); to set it, you turn the ring until the desired f-stop is indicated next to a marker; here, the marker is diamond-shaped. With more modern or automatic cameras, the f-stop is displayed on an LCD screen (center); you change it by turning a control wheel on the camera body. Many camera models show the selected f-stop in the viewfinder (right).

Determining F-stop Numbers

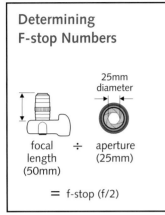

25mm diameter

focal length (50mm) ÷ aperture (25mm)

= f-stop (f/2)

On first glance, f-stop numbers can be confusing. Not only do you have to remember that the higher numbers let in the least amount of light and the lower numbers let in the most, but the numbers themselves seem to make no mathematical sense; f/8 allows four times as much light to pass as f/16, but numerically 16 is only twice 8.

An f-stop number is derived by dividing the measured diameter of a particular lens opening into the focal length of its lens. (Focal length is a measurement of the length of a lens and is explained in detail later in this chapter.) For example, suppose you have a lens with a focal length of 50mm. If the diameter of the lens opening measures 25mm, you have an f-stop of f/2 (50 divided by 25); if the diameter measures 5mm, you have an f/stop of f/10 (50 divided by 5), which is between f/8 and f/11.

You can set your f-stop in full, half, and sometimes third stops for more precise exposure control.

Flash: pages 120–26
Tripod: pages 99–101

Shutter speeds: chapter 5

marker points in between two whole f-stop settings. On many newer camera models, the partial f-stops are shown in an LCD display. In-between settings are indicated in half stops (halves) or third stops (thirds), depending on the lens or camera system.

Some lenses are described as fast and others as slow. A **fast lens** has a large maximum aperture, such as f/1.4, f/1.8, or f/2. Such lenses are capable of allowing a lot of light in to reach the film, making them excellent choices for low-light conditions, such as outdoors at night or indoors; these lenses also allow for faster shutter speeds to capture subjects in action. A **slow lens** has a smaller maximum aperture, perhaps f/3.5, f/4, f/4.5, or f/5.6. Such lenses don't let as much light in, so they require bright light conditions or auxiliary lighting, such as a flash; otherwise, they may require slow shutter speeds and possibly a tripod to steady the camera.

Lenses made for SLRs stay wide open (at their maximum aperture), regardless of what f-stop you choose, until you actually take the picture. An f/2 lens, for example, will remain open to f/2 even if you set the lens aperture to any other f-stop in preparation for your shot. The lens and shutter are coupled, so when you press the shutter button, the lens automatically closes down to the selected f-stop for the correct exposure, and then the lens instantly opens up again to its maximum aperture until you press the shutter button for the next picture. This guarantees that the viewfinder will show the brightest possible image for easiest viewing and focusing, since the most possible light passes through the lens.

All things being equal, fast lenses are preferable to slow lenses. Not only do they work better under lower light levels, they also make the subject look brighter, which makes it easier to see and focus with any camera that has through-the-lens viewing, such as an SLR.

Whole and Partial F-stops

Whole, or **full,** f-stops are always indicated clearly on the lens or in the camera's LCD panel and/or viewfinder. But you also can choose f-stops in between—either in half stops and/or third stops, depending on the equipment you use. If you set your f-stop on the lens, you may not see these increments marked numerically; instead, you may feel or hear a click as you select a setting between whole stops. (On some lenses, you may not feel or hear anything at all, whether setting whole and/or partial f-stops.) If you set the f-stop by turning a control wheel on the camera body, the half- or third-stop choices will be indicated on an LCD panel and/or in the camera's viewfinder.

It is important to remember, however, that one click on the lens ring or camera dial doesn't necessarily represent a change of one full f-stop; it may indicate a partial stop. If you intend to adjust the aperture by one whole stop, make sure you check the specific f-stop number indicated on the lens or LCD panel, or in the viewfinder.

The following chart lists available whole-, half-, and third-stop choices. Note that not all lens models offer all the f-stops listed. A maximum f-stop of f/2.8, f/3.5, or f/4 is common with many lenses; some lenses have an even smaller maximum lens aperture, such as f/5.6 or f/8. And a few lenses offer unusually wide (large) openings, such as f/1.2. On most lenses the smallest f-stop is f/16 or f/22, but on some it is even smaller, such as f/32 or f/45.

Whole F-stops	Half F-stops*	Third F-stops*
f/1.4		
		f/1.6
	f/1.7	
		f/1.8
f/2		
		f/2.2
	f/2.4	
		f/2.5
f/2.8		
		f/3.2
	f/3.4	
		f/3.6
f/4		
		f/4.5
	f/4.8	
		f/5
f/5.6		
		f/6.3
	f/6.7	
		f/7.1
f/8		
		f/9
	f/9.5	
		f/10
f/11		
		f/13
	f/13.5	
		f/14
f/16		
		f/18
	f/19	
		f/20
f/22		
		f/25
	f/27	
		f/29
f/32	*approximate values	

Angle of View

Aside from helping to control focus and film exposure, a camera lens also controls the **angle of view,** or how much of the scene the lens sees from camera to subject. Some lenses take in a narrow view of the subject while others see a normal or wide view. A special category of lenses, called zoom lenses, can see a range of angles.

Most lens types break down into these categories reflecting different angles of view: normal, wide angle, and telephoto. What makes a lens normal, wide, or telephoto is directly related to its **focal length.** The shorter the focal length, the more of the subject the lens sees.

Fixed-focal-length lenses offer one angle of view only, while zoom lenses offer a choice of angles.

Focal length is almost always measured in millimeters (mm). **Fixed-focal-length lenses**, also called **single-focal-length lenses**, offer only one angle of view; these include 28mm, 35mm (not to be confused with a 35mm camera, which refers to the film format the camera uses), 50mm, 85mm, 135mm, and 200mm—though many other lengths are available. **Zoom lenses** offer a choice of focal lengths and angles of view; they also come in a variety of sizes, such as the popular 28–80mm and 80–200mm.

Note that focal length is not totally related to how big a lens is, since lens and camera designs vary widely. A 50mm lens from one camera manufacturer may be physically longer or shorter (or thicker or thinner, heavier or lighter) than a comparable 50mm lens from a different manufacturer.

A normal lens is good for general use and sees the subject much as you see it with your own eyes.

Normal lens. A normal lens sees and records the subject much as your eye sees it. Looking through a normal lens, you will see an angle of view of about 46 degrees. Typically a normal lens for a 35mm camera has a focal length of about 50mm, but it could range from 45 to 58mm.

A normal lens is a good general-purpose lens. Its 46-degree angle of view does not create any obvious visual distortions—that is, the subject looks normal—and it offers some important advantages over other types of lenses. It is relatively compact, light, and inexpensive. There are many uses for normal lenses, including general photography of people, places, and landscapes.

See bw-photography.net for more on film format and focal length.

What constitutes a normal lens varies from one film format to another; the larger the film format you use, the longer the lens focal length needed to create a normal angle of view. In fact, you will need different focal-length lenses for wide-angle and telephoto views, as well, with different film formats. The focal length of a normal lens is approximately equal to the diagonal measurement of the film format you use. For example, a 35mm negative measures 24 x 36 mm, so the diagonal measurement is 43mm—or approximately 50mm. For larger film formats, a normal lens is accordingly longer: approximately 80mm with 6 x 6 cm (2¼" x 2¼") film, 105mm with 6 x 7 cm (2¼" x 2¾") film, and 150mm for 4" x 5 " film.

A wide-angle lens sees a broad angle of view and reproduces the subject smaller than it looks to the naked eye.

Wide-angle lens. A **wide-angle lens** sees and records a broader angle than a normal lens does. Subjects viewed through a wide-angle lens appear smaller and further away than they really are, whereas subjects viewed through a normal lens appear as they are.

Wide-angle lenses have shorter focal lengths than normal lenses, so they are sometimes called **short lenses**. Some common wide-angle lenses for 35mm cameras include 24mm, 28mm, and 35mm, and some are even shorter—the shorter the lens, the wider the view. A 24mm lens has an angle of view of about 84 degrees, whereas a 35mm lens's view is approximately 63 degrees.

Focal Length and Angle of View

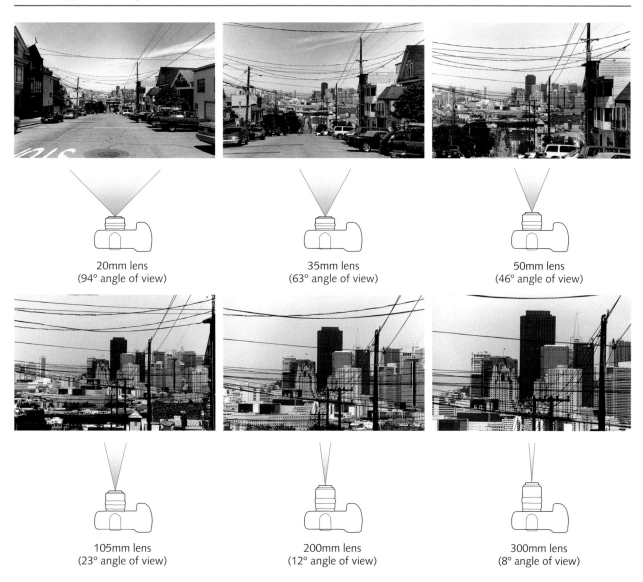

20mm lens
(94° angle of view)

35mm lens
(63° angle of view)

50mm lens
(46° angle of view)

105mm lens
(23° angle of view)

200mm lens
(12° angle of view)

300mm lens
(8° angle of view)

The focal length of a lens determines its angle of view—how much of a scene the lens sees. Short-focal-length lenses, such as 20mm, are called wide-angle lenses because they take in a broad view; long-focal-length lenses, such as 300mm, are called telephoto lenses and take in a narrow view.

A wide-angle lens is especially useful when you can't move back far enough to take in an entire subject, such as when photographing architecture (inside and outside) and broad landscape subjects. It's also useful when photographing people, if you want to show context—what's going on behind, in front of, or around your main subject. Also, with a wide-angle lens, you will get more of your subject in focus than with normal or telephoto lenses, because it provides greater depth of field, which will be discussed later.

Depth of field: pages 49–53

Be careful when photographing people, however, as wide-angle lenses can cause image distortion in the form of a curved effect, where things in the center of the image frame appear to protrude more than subjects on the edges. Some photographers like this effect, but many do not.

The degree of such distortion varies with several factors. The wider the lens, the more likely the distortion. The distortion is more exaggerated when you get very close to the subject or when you tilt the lens up or down. And you may find that more cheaply made lenses show more distortion than high-quality lenses, especially at the edges of the image frame.

Telephoto lens. A **telephoto lens** sees and records a narrower angle of view than a normal lens does. Subjects viewed through a telephoto lens appear magnified, or larger than they really are.

A telephoto lens sees a narrow angle of view with the subject looking magnified, or larger than it does in real life.

Telephoto lenses have longer focal lengths than normal lenses, so they are sometimes called **long lenses** (or **long-focal-length lenses**). Some common telephoto lenses for 35mm cameras include 85mm, 105mm, 135mm, 200mm, and 300mm; some are even longer. The longer the lens, the narrower the view. With a 35mm camera, a 105mm lens has an angle of view of about 23 degrees, whereas a 200mm lens's view is approximately only 12 degrees.

Because it magnifies the subject, a telephoto lens is especially useful when you can't get physically close enough—or when you don't want to—such as when you're photographing sports action from the sidelines or candid portraits, trying not to interfere with your subject. It also helps to make your subject stand out from the background (and/or foreground) because telephoto lenses don't produce a lot of background-to-foreground sharpness, also called depth of field.

Telephoto lenses also lead to image distortion. Your subjects appear closer to the camera and larger than they appear in real life. In addition, you will find that the background and foreground appear compressed or flattened out, as though they are closer to each other than they really are. Note that these distortions are the opposite of those caused by a wide-angle lens, where subjects appear further away, smaller, and curved rather than closer, larger, and flat.

The degree of such distortion varies with several factors, primarily the focal length of the telephoto lens you are using. The longer the lens, the more extreme the distortion. Keep in mind that such distortion can be used to good

Nan Goldin, *Ivy in the Boston Garden,* 1973

Most photographers focus so the subject is sharp, but some rules are made to be broken. Goldin's picture of a drag queen strolling through a city park feels dream-like, precisely because it is slightly out of focus. A sharper picture might convey more detailed information, but lack the impressionistic mood. © Nan Goldin; courtesy of Matthew Marks Gallery, New York, NY.

Image Distortion

Your choice of lens focal length determines both the angle of view and the relationship between the scene's foreground and background. Here a 28mm wide-angle lens takes in more of the scene and exaggerates the distance between the subject and the wall—but it's not very flattering, because it distorts the subject's features (left). A 105mm telephoto lens takes in less of the scene and compresses the distance, so the wall seems closer and the portrait subject looks more natural (right).

Steadying the camera: page 66

effect; for instance, the slight flattening effect of a short telephoto lens (85–105mm) often flatters portrait subjects.

Some telephoto lenses are large and bulky and therefore difficult to hold steadily by hand. Since camera or lens movement during exposure may cause blur in the resulting image, take extra care to steady the camera when using larger telephoto lenses. There are many ways to do this, but using a tripod is the most common method. Using a fast shutter speed also can reduce the chances of camera movement during exposure.

Zoom lens. **Zoom lenses,** unlike fixed-focal-length lenses, offer a range of focal lengths, from wide-angle to telephoto (35–80mm, 28–200mm, 35–300mm, and so forth). Many new cameras come equipped with a moderate wide-angle-to-telephoto zoom, such as 35–80mm. Zoom lenses also come in a range limited to wide-angle or, more commonly, telephoto focal lengths. Available **wide-angle zoom lenses** have ranges such as 17–35mm, 20–35mm, and 20–40mm; **telephoto zoom lenses** include such ranges as 70–200mm and 100–300mm.

Zoom lenses offer a broad range of focal lengths in a single package.

Zoom lenses can be set at any focal length within their range. So in theory you can use a 35–80mm lens at 38mm, 46mm, or 76mm, lengths that are not available at all in fixed-focal-length lenses. You may not know the exact focal length you've set, because the scale on your zoom lens, if there is one at all, can't be set that precisely. But this focal-length flexibility does allow you to

Teleconverter

A teleconverter fits between the camera body and lens to increase the effective focal length of the lens.

A **teleconverter** is a tubelike accessory that fits between the camera body and the lens to increase that lens's effective focal length. Converters usually come in two powers: 1.4X and 2X. A 1.4X converter makes the lens's angle of view comparable to that of a lens 1.4 times its actual focal length; for example, a 100mm lens effectively becomes a 140mm lens. A 2X converter doubles a lens's focal length, so the same 100mm lens acts like a 200mm lens.

The major advantage of a teleconverter is cost; it is generally cheaper to buy a teleconverter than to buy another telephoto lens. Also, teleconverters are small and light, so it's easier and lighter to carry one telephoto lens and a converter than two telephoto lenses. The major disadvantage of a teleconverter is that it reduces the light passing through the lens by about one f-stop (with a 1.4X model) or two f-stops (with a 2X). This makes the viewfinder darker, so viewing and focusing your subject may be more difficult; it also means you may need a slower shutter speed to make your exposure. You also may find that results are somewhat less sharp than you might get using a telephoto lens without a teleconverter.

compose a subject more critically without physically moving; you can loosen the composition by zooming back a bit to reduce the size of the subject (fitting in more of the overall scene) or tighten it by zooming closer to magnify the subject.

The biggest advantage of zoom lenses, however, is their convenience. You only need one or two lenses, say, a wide-angle zoom and a telephoto zoom, to cover a very wide range of focal lengths. This means less bulk and weight in your camera bag and less changing of lenses when photographing. This can be critical when photographing spontaneously or shooting quick-changing subjects, situations when you may otherwise lose the moment if you have to take the time to remove one lens and replace it with another.

The quality difference between fixed-focal-length lenses and zooms is a subject of some debate. Modern zoom lenses are optically excellent, though many older models are not. Zoom lenses typically may have more bulk and weight than your fixed-focal-length lenses. They also are often more expensive.

Maximum lens aperture: page 52

Possibly the biggest disadvantage of zoom lenses is that they are almost always relatively slow; they have smaller maximum apertures, which means they are not as useful when you are photographing in low-light situations without flash or other accessory lighting. Almost any 50mm fixed-focal-length normal lens, for example, will allow much more light in to the film when set at its maximum aperture than would a 35–80mm zoom set at 50mm. For example, a fixed-focal-length 50mm lens may have a maximum aperture of f/2, while an 35–80mm lens set at 50mm may have a maximum aperture of only f/4.

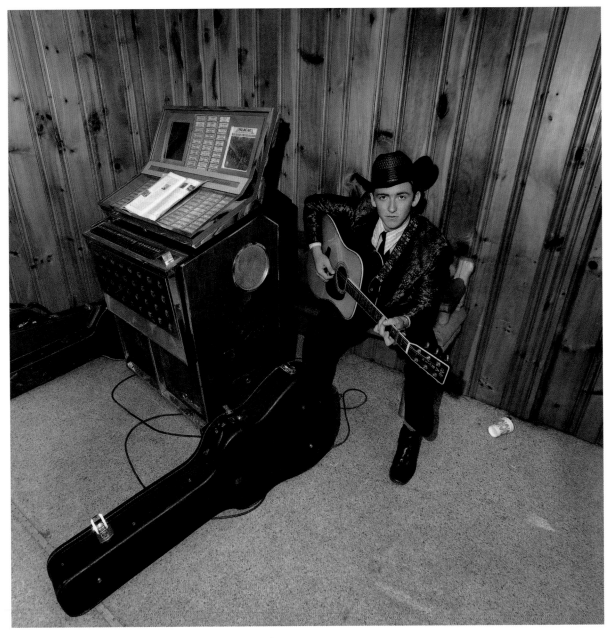

Lawson Little, *Keith Whitley,* Webster, Massachusetts, 1973

Based in Nashville, Little photographs the country music scene, from its glitzy stages to its mundane back rooms. Using a wide-angle lens in tight quarters allowed Little to show the late country singer Keith Whitley in his environment with everything in focus due to a wide-angle lens's inherently deep depth of field. Tilting the camera exaggerated the distinctive stretched-out appearance common to the wide-angle lens. © Lawson Little; courtesy of the artist.

Depth of Field

Depth of field is the area of sharpness from the closest part of the picture to the farthest part.

The term **depth of field** refers to the depth of the zone that is visibly sharp in the picture, from the closest to the farthest parts of the scene. Suppose you focus your lens on a tree 10 feet away. Even though you focus precisely on the tree, an area in front of and an area in back of the tree also will usually be sharp. The degree of that sharpness, from front to back, is the depth of field.

The depth of field of a picture may vary widely and is controlled by these factors: lens aperture, distance to subject, and lens focal length.

Lens aperture. The smaller the lens aperture you use, the greater the depth of field. Thus if you set your lens at f/16, you will produce an image with far greater depth of field than if you set the lens at f/2, other factors being equal. Lens aperture is probably the most understood factor in controlling depth of field, but the next two factors are just as important.

Distance to subject. The greater the focusing distance (from camera to subject), the greater the depth of field, assuming the lens aperture and focal length stay the same. If you use a 50mm lens and focus on a subject 20 feet away with the lens aperture set at f/8, you will get much more depth of field than if you focus with the same lens at f/8 on a subject five feet away.

Lens focal length. The shorter the focal length of the lens, the greater the depth of field. If you use a 28mm wide-angle lens, you will get far more depth of field than if you use a 200mm telephoto lens set at the same lens aperture and focused at the same distance; for example, a 24mm lens set at f/8 and focused 10 feet from the subject has greater depth of field than a 200mm lens that is also set at f/8 and focused at 10 feet. A zoom lens produces more or less the same depth of field at a certain setting as a fixed-focal-length lens of that same length; thus, a 28–80mm zoom lens set at 50mm will produce the same depth of field as a fixed 50mm lens.

You can increase or decrease depth of field by changing any of the above variables, but keep in mind that they are interrelated. For example, you can increase depth of field by closing down your lens aperture to a smaller f-stop. But if you move closer to the subject and refocus, you may actually end up decreasing the depth of field.

The ability to render your subject uniformly sharp is one of photography's great strengths, so most times you will want as much depth of field as the situation allows. However, there are times when you will want to have the subject (or another part of the image) sharp and the background or foreground blurred, such as when you focus on a portrait subject and let the background go out of focus.

Depth-of-Field Factors

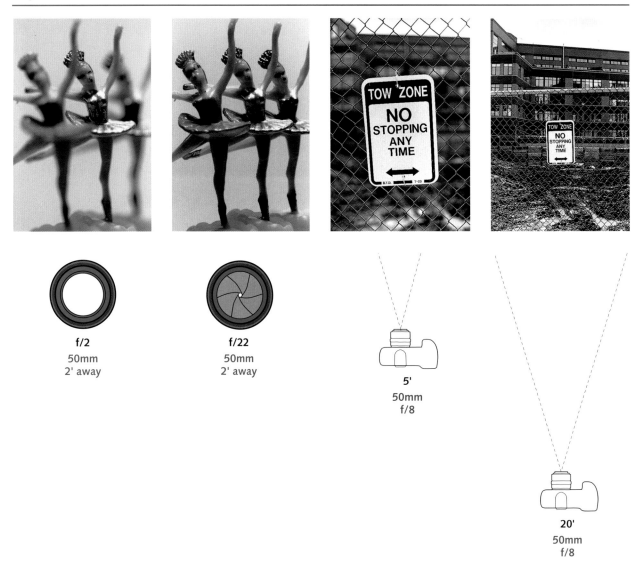

f/2
50mm
2' away

f/22
50mm
2' away

5'
50mm
f/8

20'
50mm
f/8

Lens aperture

The primary control of depth of field is the f-stop setting. Opening up to a wide lens aperture, here f/2, produces very little depth of field (left); closing down to a small lens aperture, here f/22, produces a lot of depth of field (right). Both photographs were made using the same focal-length lens (50mm) at the same distance to the subject (2').

Distance to subject

Depth of field also is affected by the distance from camera to subject. The further you are from your focused subject, the greater the depth of field. The shot taken from 5' away (left) produces much less depth of field than the shot taken from 20' away (right). Both photographs were made using the same lens aperture (f/8) and the same focal-length lens (50 mm).

Depth-of-Field Factors

Lens focal length

Depth of field also is affected by the lens focal length or zoom lens focal-length setting. The longer the focal length, the less depth of field. Here the shot taken with a 200mm lens (left) produces much less depth of field than the shot taken with a 24mm lens (right). Both photographs were made using the same lens aperture (f/8) from the same distance (10').

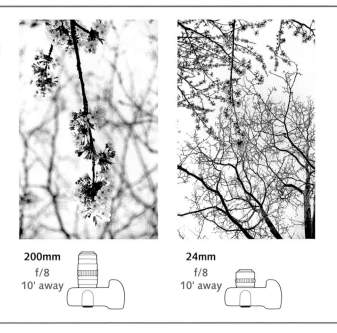

200mm
f/8
10' away

24mm
f/8
10' away

Within limits, you have the ability to vary the lens aperture, focusing distance, or focal length, either to maximize depth of field or to focus selectively. But sometimes additional limiting factors come into play. Subject lighting is one. Brighter lighting usually requires a smaller lens aperture, which delivers greater depth of field—whether you want it or not. Film speed is another consideration; slower-speed films require more light and thus larger lens apertures, which produce less depth of field.

Furthermore, a subject that requires you to move closer, such as a flower, decreases your depth of field because of the close focusing distance, while a subject that requires you to be further away, such as a landscape, results in greater depth of field. Your choice of composition also may weigh in. If you like to show a lot of the environment around your portrait subject, for example, you will create greater depth of field by moving further away or using a wide-angle lens; if you like framing your subject tightly by moving in closer or using a telephoto lens, you will get less depth of field.

Often you won't have to worry about having enough depth of field. Chances are you will have enough if you are using a medium-to-small f-stop and if you are far enough away from your subject, or if you are using a wide-angle lens (35mm or wider). With experience, you will learn to estimate the impact of these factors.

See bw-photography.net for methods of predicting depth of field.

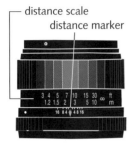

Focus distance is indicated on the distance scale; this lens is focused on a subject about 8 feet away.

Guess focusing is one method of using the depth-of-field factors that allows you to work quickly without ever looking through the camera to focus. Start by guessing how far the camera is from your subject and set that distance on the lens **distance scale,** the ring or window on the side of the lens that indicates how far away the lens is focused. Then choose the smallest lens aperture you can use that would still be practical for the lighting conditions (a large f-stop in low light or a small one in bright light). If your distance guess is close enough and the lens aperture small enough, your subject should be acceptably sharp— most of the time. Using a wide-angle lens makes guess focusing more accurate by providing inherently more depth of field.

Say your subject seems about 8 feet away. Set the distance scale at "8," set as small a lens aperture as you can, then quickly take the picture without looking through the viewfinder to focus. Quickly is the operative word, as guess focusing allows you to work so your subject will barely notice he or she is being photographed. You may make some bad guesses along the way and get a few out-of-focus pictures, but when you are successful your pictures will have a spontaneity and candidness that you may not get if you have to spend time focusing.

Maximum Aperture

· f/2

One way lenses are described is by their **maximum aperture**, which represents the maximum amount of light they will allow through. A lens with a maximum aperture of f/2 (called an f/2 lens) allows more light through (when set at f/2) than an f/4 lens. The larger the maximum aperture, the faster the lens.

Different model lenses of a particular focal length may have very different maximum apertures, even if they are made by the same manufacturer. There are very fast 50mm lenses, for example, that open up to f/1.2 and f/1.4, and there are slower 50mm lenses that open to only f/2 or f/2.8.

Zoom lenses usually have a smaller maximum aperture than fixed focal-length lenses. Also, many zoom lenses have a **variable maximum aperture**, which is dependent on the focal length that is set. Generally, the longer the focal length, the smaller the maximum aperture. A 35–135mm zoom, for example, may be designated as an f/4–5.6 lens; set at 35mm, it has a maximum aperture of f/4, but set at 135mm it has a slower maximum aperture of f/5.6. The maximum aperture varies at in-between settings, such as f/4.5 when set at 75mm.

Bulkier and more expensive zoom lenses may have a **fixed maximum aperture**. Some models of the popular 16–35mm focal-length lens, for example, open to a maximum of f/2.8 regardless of what focal length is set. One model zoom may open to f/2.8 and another offering the exact same zoom range may open to a variable f/4 –5.6, which is even the case with lenses from the same manufacturer.

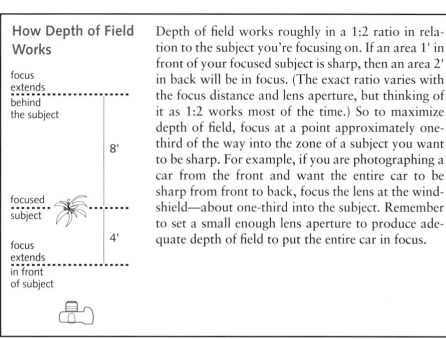

How Depth of Field Works

focus extends behind the subject

8'

focused subject

4'

focus extends in front of subject

Depth of field works roughly in a 1:2 ratio in relation to the subject you're focusing on. If an area 1' in front of your focused subject is sharp, then an area 2' in back will be in focus. (The exact ratio varies with the focus distance and lens aperture, but thinking of it as 1:2 works most of the time.) So to maximize depth of field, focus at a point approximately one-third of the way into the zone of a subject you want to be sharp. For example, if you are photographing a car from the front and want the entire car to be sharp from front to back, focus the lens at the windshield—about one-third into the subject. Remember to set a small enough lens aperture to produce adequate depth of field to put the entire car in focus.

Special Lenses

Macro lens example

Most photographers do all their work with standard fixed-focal-length or zoom lenses. But you also may want to explore one of several special lenses available for specific situations. Following are some of the most common.

Macro lens. Most lenses for SLR cameras focus no closer than about 12 to 18 inches (or even further) away, and you can't even get that close with longer SLR lenses and lenses for most point-and-shoots, rangefinders, and twin-lens-reflex cameras. There are accessories that allow you to focus more closely, but the simplest way is to use a **macro lens**, a lens specially designed for the task. There are fixed-focal-length macro lenses that focus quite close, as close as an inch or two away from the subject in some lengths; however, most macro zoom lenses don't focus as close.

You can use almost all macro lenses like any other lens to focus at any distance. But unless you plan to focus close up, buy a nonmacro lens instead. Macros are more expensive and often have a smaller maximum aperture than a comparable fixed-focal-length lens. True macro lenses are generally available in normal or slightly telephoto sizes, such as 55mm and 100mm.

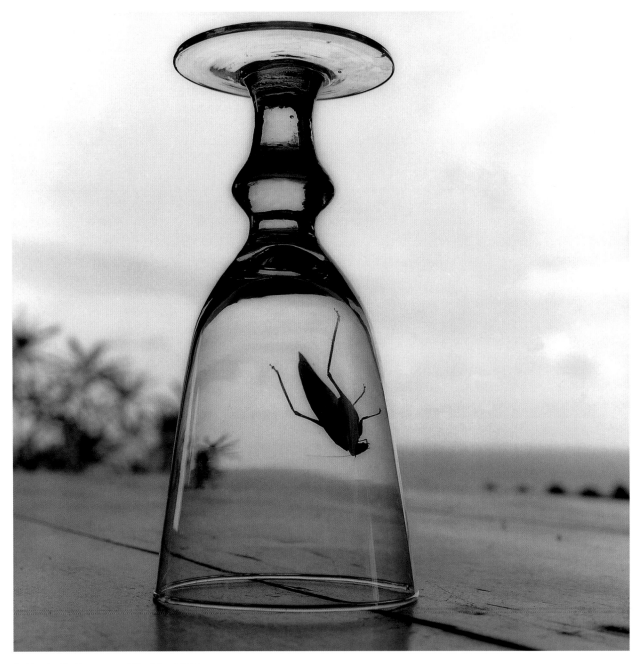

Sally Gall, *Between Worlds,* 1996

For this eerie still life, Gall uses lens aperture to her advantage. By setting a large f-stop, she limits the picture's depth of field, restricting sharpness to the area just in front of and behind the overturned glass. This adds emphasis to the subject, setting it off distinctly against the blurry background and sky. © Sally Gall; courtesy of the artist and Julie Saul Gallery, New York, NY.

Mirror lens example

Ultrafast lens example

Fisheye lens example

Mirror lens. A **mirror lens** is a special category of long lens that optically folds the focal length into a more compact lens package. It's usually available in focal lengths of 300mm, 500mm, and 1000mm. A standard lens of such a long focal length is heavy and bulky, but a mirror lens is much lighter and therefore much easier to handhold than its bulkier standard-focal-length equivalents. It also is much less expensive. While mirror lenses give good results in most cases, they are generally optically inferior to standard long telephoto and telephoto zoom lenses.

For the most part, you use a mirror lens like any other lens, except for one important difference. Mirror lenses are slow; usually f/8 or f/11 is the only aperture offered. Because you cannot vary the lens aperture, you have to control exposure by changing shutter speeds and/or by using a faster or slower film.

Ultrafast lens. Standard fixed-focal-length lenses generally open to a maximum aperture of f/2 or even smaller. (Most zoom lenses open to no more than f/3.5 or f/4.) But there are lenses that will open up especially wide to let in much more light. A 50mm lens that opens to f/1.8 or f/1.4 is fairly common, but there also are a few models that open even wider, to f/1.2 and even f/1.0. These are sometimes called **ultrafast lenses.** They allow you to photograph under very dim light, because they let in so much light when set at their maximum aperture. Ultrafast lenses also are relatively expensive and sometimes bulky.

Keep in mind that at such wide apertures you will get very little depth of field. This can be a problem if you need to get a lot of your subject in focus, but some photographers actually like the shallow focus effect.

Fisheye lens. A fisheye lens is a very short-focal-length lens, usually 8mm to 16mm, which provides an extreme wide-angle view, generally from about 100 degrees to as much as 180 degrees. The widest (and sometimes cheapest) fisheye lenses actually produce a circular image. All fisheyes produce a strong visual distortion in which the image appears convex, bulging out at the center, toward the edge of the image.

This distorted appearance is precisely the reason why some photographers use fisheye lenses. Another reason is that you can include an extremely wide subject area, even if you are shooting in extremely close quarters. Also, such a wide view means that the size of subjects in the foreground will be exaggerated. And fisheye lenses produce sharp focus in virtually all parts of the picture, even if you set the lens at a wide aperture, such as f/2.8, where the depth of field is usually minimal.

The effects of a fisheye lens are strong and can overwhelm the picture, so it's generally best to use it with discretion. Aiming the camera and lens roughly at a scene's horizon line will help keep distortion in check; tilting the camera and lens up or down will exaggerate the fisheye effect.

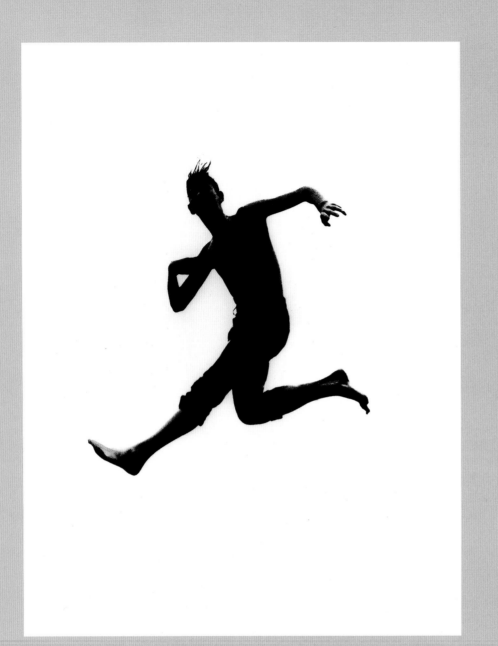

Aaron Siskind, *Pleasures and Terrors of Levitation #63,* 1956

Legendary photographer Siskind made photographs of divers leaping through the air. Positioned below the divers, he emphasized the abstract quality of their twisting shapes by isolating them against the sky's light, neutral background. To stop their motion, Siskind set his camera at a fast shutter speed, possibly 1/250 or 1/500, depending on how fast the figures were moving. © Aaron Siskind Foundation; courtesy of Robert Mann Gallery, New York, NY.

5 The Shutter

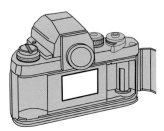

In a 35mm SLR, the shutter is a curtain located inside your camera.

Controlling Exposure

*Lens apertures:
pages 35, 38–41*

Shutter speed is determined in part by the lighting conditions: the more light there is, the faster the shutter speed you will need.

Cameras usually contain a **shutter,** a curtain (or set of blades) that blocks light from entering and striking the film. To take a picture, you press the **shutter button,** usually located on the top right of the camera. The shutter then opens and closes. Note that in some cameras the shutter is contained in the lens, not in the camera body.

On all but the very simplest cameras, the amount of time the shutter stays open is variable, an interval called the **shutter speed.** Most cameras either allow you to adjust the shutter speed or do it for you. With manual cameras, you must always choose the shutter speed yourself.

The shutter affects how the final image is rendered in two ways. It controls exposure (how long light is allowed to strike the film) and it determines the appearance of motion or movement (whether a moving subject looks sharp or blurred).

The amount of time the shutter remains open is as critical to correct film exposure as the size of the lens opening. After all, light traveling though the lens doesn't reach the film until the shutter opens. Thus, exposure is controlled by two key variables: the amount of time the shutter stays open and the size of the lens opening.

The correct shutter speed setting is determined first of all by the prevailing light conditions. You have to select a shutter speed that lets in the right amount of light; too much or too little light can affect overall image quality. In low light, you will usually need a long (also called **slow**) shutter speed; the shutter must remain open for a long enough interval to allow what light there is to reach the film. In bright light, you will usually need a short (**fast**) shutter speed to prevent too much light from reaching the film.

You generally make your shutter speed choice by rotating a dial located on the camera body, often on top. With manual cameras, choosing the shutter speed is as simple as rotating the dial to a mark that indicates the desired speed setting. Some automatic cameras show the selected shutter speed in an LCD display screen located on the camera. To change the setting you usually turn a **control wheel,** located on the camera's top or back. Rotate it with your thumb

or forefinger until the screen displays the desired shutter speed. Many cameras, both manual and automatic, display the chosen shutter speed in their viewfinders as well, so you can check the settings without moving your eye away from the camera.

Virtually all cameras offer these shutter speed choices, in fractions of a second from slow to fast:

1/2, 1/4, 1/8, 1/15, 1/30, 1/60, 1/125, 1/250, 1/500, 1/1000

These are generally represented as whole numbers, dropping the fractional 1/– for simplicity. Thus, 1/250 is indicated as "250" and 1/2 as "2," and so forth.

Many new cameras offer shutter speeds that are faster than 1/1000, such as 1/2000, 1/4000, and 1/8000, while older models may only go as fast as 1/250 or 1/500. Point-and-shoots and medium- and large-format cameras often have a relatively slow maximum shutter speed, such as 1/500.

You also may choose shutter speeds that are a full second or longer. Most cameras offer 1 second, represented as "1" on the camera dial or display, and some models offer settings as long as 2, 4, 8, or more seconds. On some cameras, the full-second shutter speeds are distinguished from the fractional shutter speeds by color. For example, 1/2 of a second may be shown as a black "2" and 2 seconds may be shown as a red "2." Or, in your camera's display, full seconds may have a mark (such as ") after them: 4" means 4 seconds, rather than 1/4. Consult your camera manual for specifics.

The relationship between shutter speeds is essential to understanding film exposure. The list above indicates full shutter speeds; each full, also called **whole,** shutter speed is double the time of the setting before it and half the time of the setting after it. Thus, "4" (1/4 of a second) represents half as much time

Most shutter speeds are fractions of a second, although exposures in full seconds may be needed for low-light conditions or with very small lens apertures.

Setting Shutter Speed

On most manual or older model cameras, the shutter speed is indicated on a dial located on top of the camera body (left). To set it, you turn the dial until the desired speed is indicated next to a marker. With many modern cameras, the shutter speed setting is displayed on an LCD screen; you change it by turning a control wheel (center). Many camera models show the selected shutter speed in the camera's viewfinder (right).

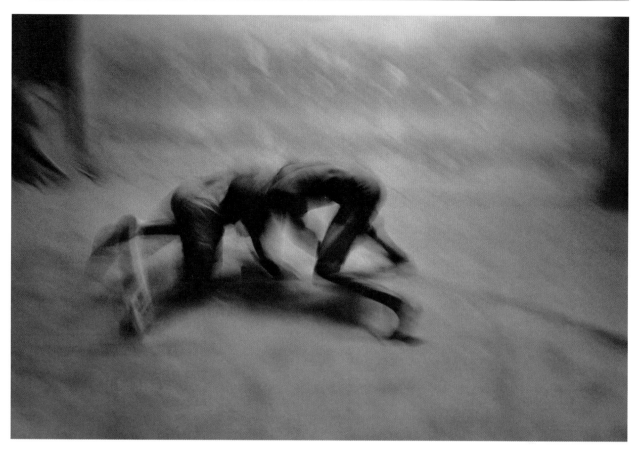

John Goodman, *Two Wrestlers, Havana, Cuba, 2000*

The choice of shutter speed controls subject movement. Goodman uses a shutter speed of 1/4 here, which means the shutter is open while the wrestlers are in motion and also the camera is in motion because that speed is too slow for steadily handholding it. The blurred effect serves to enhance the feeling of intensity of these Cuban athletes. © John Goodman; courtesy of June Bateman Gallery, New York, NY.

Full shutter speed settings let in half as much or double the light of the settings that precede and follow them.

Stop: page 71

as "2" (1/2 of a second), so it allows half as much light to reach the film. And "250" (1/250) is twice as much time as "500" (1/500), so it allows in double the light.

Each halving or doubling is called one **stop**. The half/double relationship is not coincidental; remember that f-stop settings have exactly the same relationship. You control exposure by balancing the combination of shutter speed and f-stop to permit the correct amount of light to enter the camera.

Some shutters are mechanical, driven by gears and springs, and others are electronic. Mechanical shutters can be set only for the speeds designated by the shutter-speed dial; even if you try to set the shutter between two designated speeds—say, 1/60 and 1/125—the camera will set one speed or the other. Some electronic shutters function only at designated full shutter speeds, but almost all provide intermediate choices in either half-stop increments, such as 1/90 (halfway between 1/60 and 1/125), or third-stop increments, such as 1/80 and 1/100 (between 1/60 and 1/125). Note that on these cameras, one click of the control wheel is not necessarily a full shutter speed adjustment. If you are trying to make a full, one-stop change, check the LCD panel to ensure that you have not set a half- or third-stop setting by mistake.

One clear advantage of mechanical shutters is they don't depend on batteries to work. If you have a camera with an electronic shutter, it won't work at all if the batteries are exhausted. However, electronic shutters are more accurate and generally quieter than mechanical shutters. And with half- or third-stop settings they allow more precise exposure control.

Almost all cameras offer a "B" (bulb) setting and a few offer a "T" (time) setting. Both permit the shutter to remain open for an indefinite period of time for very long exposures, often called **time exposures**. These settings are especially useful in dim lighting conditions, when adequate film exposure may require shutter speeds ranging from a few seconds to as long as several minutes.

When set at "B," the shutter remains open as long as you keep the shutter button pressed down. When you release the button, the shutter closes. When set at "T," the shutter remains open from the time you initially press the button, and then closes when you press the button a second time.

Controlling Movement

You can choose a shutter speed fast enough to stop motion or slow enough to blur it.

The shutter speed setting controls the appearance of a moving subject. Faster shutter speeds stop (freeze) movement, but if the shutter is open for a longer time, the moving subject may blur. Thus, you have the option of choosing a shutter speed fast enough to stop motion or slow enough to create blur, depending on the effect you're looking for.

Most of the time, you will want to stop movement, and this generally requires a fairly fast shutter speed. Just how fast depends to a large degree on

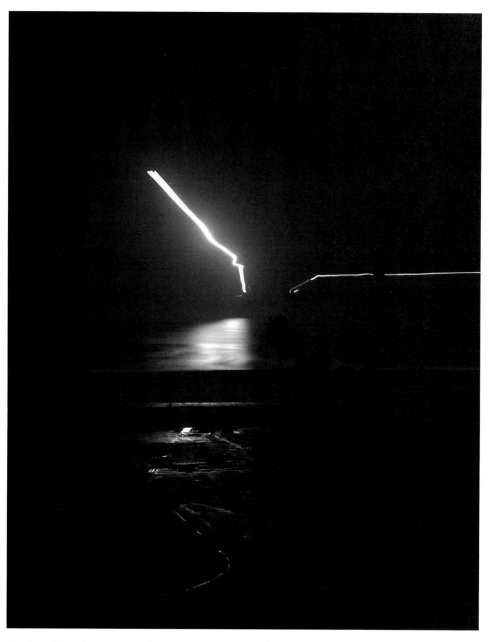

Stephen Tourlentes, *Landing, LAX, Los Angeles, CA, 2002*

Tourlentes makes very long exposures, often using the "T" or "B" shutter setting to achieve shutter speeds of several minutes, to photograph airplanes taking off at night. Because the shutter remains open as the planes take to the air, the film captures the bright, blurry trails of their lights moving across the dark sky. © Stephen Tourlentes; courtesy of Revolution Gallery, Ferndale, MI.

Controlling Movement

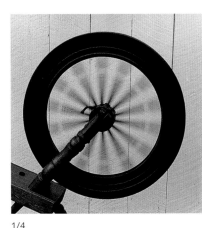 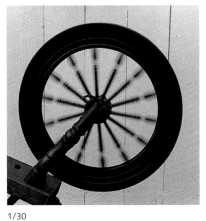 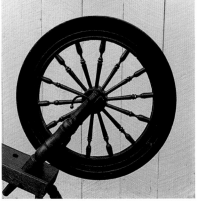

1/4 1/30 1/250

In each of these photographs the spinning wheel is turning at the same rate. Photographing with a slow shutter speed of 1/4 (left) causes the wheel to appear blurred. At 1/30, the blur is less evident (center); a relatively fast shutter speed of 1/250 (right) freezes the wheel's motion entirely.

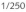

your subject. As a general rule, subjects that move quickly need the fastest shutter speeds; subjects that move slowly—or don't move at all, such as rocks and buildings—need slower speeds. You may be able to freeze the motion of a walking dog at 1/125, for example, but you may need 1/1000 or faster to stop the motion of a galloping horse. Or you may use a setting slower than 1/60 or 1/125 to deliberately blur your subject; the slower the speed, the greater the blurring effect. Note that at slow shutter speeds, blurry results also may be due to camera shake.

The direction and distance of the moving subject can prove as important as its speed. If the subject moves from side to side (left to right or right to left), its image will cross the film faster than if it travels directly toward or away from the camera. Therefore, you will need a faster shutter speed to freeze the movement of the horizontally moving subject than for the one that travels directly toward or away from you. (And you will need an in-between speed for subjects moving diagonally toward or away from you.)

Furthermore, if your camera is close to your subject, movement appears faster than if you are further away. Therefore, you will need a faster shutter speed to freeze close moving subjects than you will for distant ones.

Subtle subject movement is yet another factor. Generally, landscape subjects don't require fast shutter speeds since they don't appear to be in motion. However, a strong wind can easily move grass, foliage, or tree branches. On

Movement appears fastest when your subject moves from side to side and also when it is close to the camera.

Direction of Movement

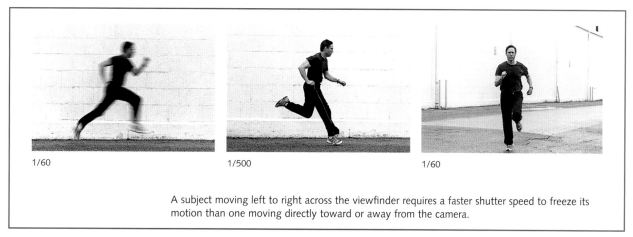

1/60 1/500 1/60

A subject moving left to right across the viewfinder requires a faster shutter speed to freeze its motion than one moving directly toward or away from the camera.

windy days especially, use a relatively fast shutter speed to guarantee a sharp image; or use a slow shutter speed to create blur, thereby emphasizing the motion.

Deliberately blurring some subjects within an otherwise sharp image is an effective way to show action, movement, or simply to create mood or atmosphere. Keep the shutter speed fast enough so that stationary parts of the subject (such as buildings, cars, and rocks) appear sharp, but slow enough so the moving parts of the subject (such as running water or animals and people in motion) blur. Or place the camera on a tripod, which will allow you to use a very slow shutter speed and still keep many stationary subjects from blurring.

You also might try moving the camera during exposure in the same direction as the subject's motion, a technique called **panning**. For example, suppose someone is riding past you on a bicycle, from left to right. By panning, you can render the bicycle and rider sharp and cause the foreground and background to blur.

As the subject moves past you, follow its motion by turning the camera while pressing the shutter button. For an effective pan, the camera movement must simulate the speed of the moving subject, which you can accomplish by keeping the subject in the same location in the viewfinder as you move the camera. Try panning at 1/8 or 1/15, then experiment with different speeds, but not faster than 1/30.

While panning is a choice you can make, any deliberate or accidental camera movement may cause image blurring. Accidental movement, sometimes called **camera shake**, is one of the most common factors in unwanted image blurring. Sometimes blur occurs because you are using a shutter speed that is too slow to hold the camera steady by hand. But blur may result at almost any shutter

Tripods: pages 99–101

When properly done, panning the camera makes a moving subject sharp and blurs the background.

Panning example: page 64

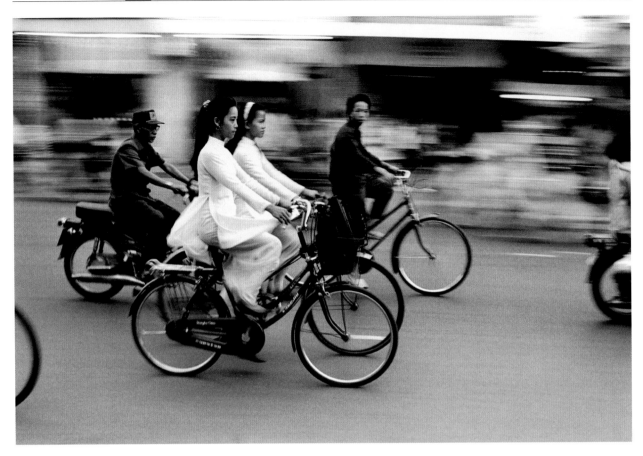

Ed Kashi, *Saigon on Wheels, Vietnam, 1994*

To recreate the hectic atmosphere of the streets of Saigon, Kashi moves his camera during exposure, following the bicycles as they move left to right, a technique called panning. Using a slow shutter speed, such as 1/8 or 1/15, the cyclists appear sharp and the background blurs. © *Ed Kashi; courtesy of the artist.*

speed (except the very fastest) when you're not careful to steady the camera before making an exposure. Note that the effect of camera shake isn't always an obvious blur; sometimes it will show as a more subtle lack of overall sharpness.

Be very conscious of camera shake when holding the camera to your eye. In particular, take pains to set yourself securely, and don't talk or move any more than necessary when taking a picture. Also, don't remove the camera from its eye-level position until you're sure the shutter has closed and the exposure is complete.

An individual's ability to hold a camera steady varies, but the faster the shutter speed, the less image blur there is—for everyone. To avoid the effects of camera shake, follow this general rule: Don't use shutter speeds slower than 1/30 or 1/60 when handholding your 35mm SLR when using normal or wide-angle focal lengths or zoom-lens settings. Bigger cameras and longer lenses require even faster shutter speeds.

As a simple rule of thumb, turn the focal length of your lens into a fractional number and use at least that speed when photographing with that lens. When using a 50mm lens or a 50mm setting on your zoom lens, for example, make sure your shutter speed is 1/50 or faster (usually 1/60, unless your shutter offers 1/50, which some electronic shutters do). When using a 200mm lens or zoom lens setting, make sure your shutter speed is 1/200, 1/250, or faster.

When you have to use a shutter speed that is slower than recommended above, use a tripod to steady the camera. If a tripod is unavailable, try bracing the camera against a tree, car roof, or on a countertop. A beanbag or small pillow placed between the camera and its brace will help cushion movement further.

A tripod or other means of steadying the camera is often a good idea whether you're using a slow shutter speed or not. It helps you frame the subject more carefully, and further reduces any chance of accidental camera movement. However, it also limits spontaneity and restricts your ability to adjust your camera position.

Don't handhold your 35mm SLR camera at speeds slower than 1/30 or 1/60; bulkier cameras and lenses require even faster shutter speeds.

Use a tripod or some other means for steadying the camera at slow shutter speeds.

Steadying the Camera

Accidental camera movement during exposure is called **camera shake** and results in an overall image blur (upper left). Camera shake most often occurs when you use shutter speeds that are too slow to handhold the camera steadily. To minimize unwanted blur, be sure to set a fast enough shutter speed (1/30 to 1/60 or faster), hold the camera correctly (upper right), or brace the camera against a support (lower left). Often the most reliable way to hold a camera steady is to place it on a tripod (lower right).

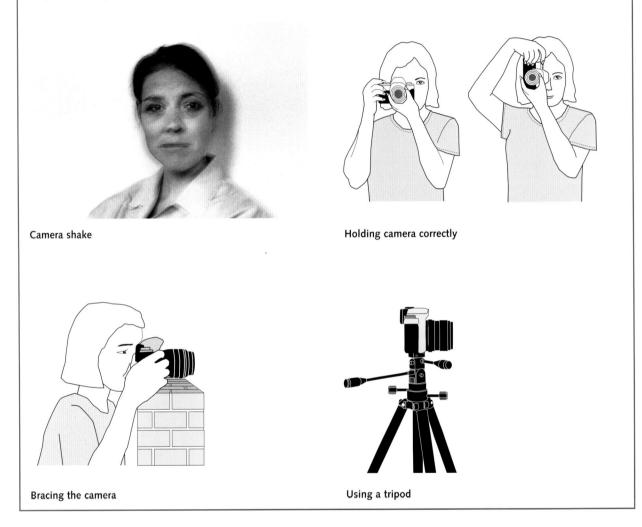

Camera shake

Holding camera correctly

Bracing the camera

Using a tripod

Shutter Types

Most 35mm SLR cameras have a **focal-plane shutter,** which is located inside the camera body, just in front of where the film sits. This type of shutter is typically made of cloth or thin metal curtains. When you press the shutter button, one curtain opens to uncover the film and expose it to light. Then a second curtain trails along behind the first, covering up the film.

Other cameras have a leaf shutter, which is located inside the camera lens and consists of several overlapping metal blades, or leaves, that open and close in a circular pattern when the shutter button is pressed. Leaf shutters are found in large-format camera lenses and cameras with noninterchangeable lenses, such as point-and-shoots, rangefinders, and twin-lens-reflex cameras. They also are used in some medium-format cameras.

Lenses are generally less expensive for cameras with a focal-plane shutter, because each lens does not have to include its own shutter. Also, focal-plane shutters accommodate very fast shutter speeds of 1/1000, 1/2000, or faster, as well as slower-calibrated settings such as 2, 4, 8 seconds or longer.

Flash and shutter speed: page 122

Leaf shutters are more limited, often offering a maximum shutter speed of 1/500. But they are quieter and less prone to vibration than focal-plane shutters, which means you can usually use slower shutter speeds when handholding the camera and still get a sharp image. In addition, you can use a flash at any shutter speed with a leaf shutter, whereas focal-plane shutters have a maximum shutter speed for flash use, usually 1/60 or 1/125 and sometimes 1/250.

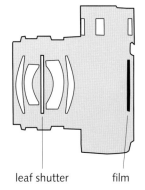

focal plane film leaf shutter film
shutter

A focal-plane shutter is located in the camera body, just in front of the film (left). A leaf shutter, which is in the camera's lens (center), consists of overlapping metal blades that open and close in a circular pattern (right).

Michael Kenna, *Hillside Fence, Study 2, Teshikaga, Hokkaido, Japan, 2002*

Kenna brings a bold and elegant style to all his photographs, whether he is photographing a winter landscape in Japan or an industrial power plant in England. But simple pictures are often the hardest to make, particularly when a subject is nearly all light or all dark. Here, Kenna's ability to control exposure is key to making this minimal picture effective. © Michael Kenna; courtesy of the artist.

6 Film Exposure

Film exposure refers to the amount of light that strikes the film when you press the shutter button to take a picture. Correct exposure generally means letting enough light enter the camera for the film to record the scene accurately. Too little light reaching the film is called **underexposure**; too much light is called **overexposure**. Both under- and overexposure can cause a range of problems and prevent you from making a good or even acceptable print from your negative.

Arguably your most important technical challenge is learning how to expose film. Once you understand exposure, you will be able to produce good negatives consistently, and good negatives are the key to making good prints. This point cannot be overstressed. With a good negative, you can produce a high-quality print with relative ease; with a poor negative, you may never be able to make even a passable print.

In this chapter you will learn about the factors that control film exposure, as well as how light meters work and the various ways you can read light to establish correct exposure. Finally, you will learn how to interpret and solve difficult lighting situations.

Well-exposed film helps produce good negatives, and you need good negatives to produce good prints.

Exposure Factors

There are many factors contributing to good film exposure. The key factors are discussed in some detail in other chapters, notably subject lighting, lens aperture, shutter speed, and film speed. Here's a brief review.

Lighting: chapter 8

Subject lighting. You will have to set your camera and lens according to the subject lighting. In dim light, you will have to let in more light to expose film than you will with bright light. While subject lighting is a critical element, you can't always control it. You generally have much more direct control over exposure by adjusting the settings on your camera.

Lens aperture: pages 35, 38–41

Lens aperture. The camera's lens aperture is adjustable to allow more or less light in through the lens to expose film. An f-stop is the measurement of that opening. The larger the f-stop number, the smaller the lens opening. For instance, a lens aperture set at f/11 lets in less light than one set at f/4.

Identifying a Good Negative

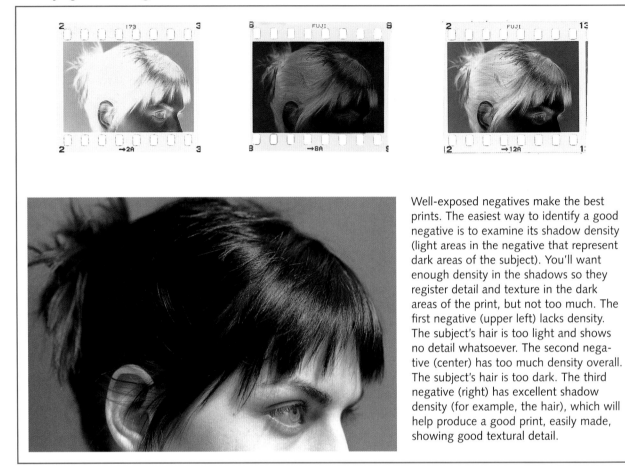

Well-exposed negatives make the best prints. The easiest way to identify a good negative is to examine its shadow density (light areas in the negative that represent dark areas of the subject). You'll want enough density in the shadows so they register detail and texture in the dark areas of the print, but not too much. The first negative (upper left) lacks density. The subject's hair is too light and shows no detail whatsoever. The second negative (center) has too much density overall. The subject's hair is too dark. The third negative (right) has excellent shadow density (for example, the hair), which will help produce a good print, easily made, showing good textural detail.

Shutter speed: pages 57–60

Shutter speed. The shutter is a curtain that opens for a certain amount of time when you press the shutter button to let in light to expose film. The shutter speed is the measurement of that time interval. For most subjects, you will use shutter speeds that are fractions of a second, such as 1/60, 1/125, 1/250, and 1/500. The faster the shutter speed, the shorter the interval and the less light that reaches the film. For instance, a shutter speed of 1/500 lets less light in than 1/60.

Film speed. Film speed refers to a film's sensitivity to light—how much or how little light is necessary to achieve correct exposure. The ISO rating is the

Film speed: pages 23–24

measurement of that sensitivity. A higher ISO number indicates greater film sensitivity. Highly sensitive film is called fast film; film with low sensitivity is called slow. For instance, ISO 400 film is relatively fast, and thus requires less light for good exposure than slower ISO 100 film.

It's important to understand that all of these factors are interrelated and of equal importance when establishing exposure. But shutter speed and lens aperture are the factors that are most often considered since they can be adjusted from shot to shot.

Combining Lens Aperture and Shutter Speed

Understanding the reciprocal relationship between f-stop and shutter speed is critical to achieving correct film exposure.

The relationship between the lens aperture and shutter speed is key to understanding good film exposure. The combination of these controls determines just how much light actually reaches the film.

Remember that each full f-stop or full shutter speed setting lets in half as much light as the full setting before it, and doubles the light of the full setting after it. Thus a lens aperture set at f/8 lets half as much light through the lens as one set at f/5.6 and twice as much as one set at f/11; a shutter speed of 1/125 lets in light for half as much time as 1/60 and twice as much time as 1/250. Each halving or doubling of light is called a stop. So changing the lens aperture from f/8 to f/11 is making a one-stop difference, as is changing the shutter speed from 1/125 to 1/60.

In short, the f-stop and shutter speed have a **reciprocal relationship**. By adjusting one setting in a particular direction, while adjusting the other by the same amount in the opposite direction, you keep the total quantity of light striking the film the same. Thus, you can make the lens aperture one stop smaller

Full f-stops	Full shutter speeds
f/2	1 sec.
f/2.8	1/2
f/4	1/4
f/5.6	1/8
f/8	1/15
f/11	1/30
f/16	1/60
f/22	1/125
	1/250
	1/500
	1/1000
	1/2000

Stop

The term **stop** is broadly used in photography to represent a doubling or halving of light. For example, you might hear someone say "give it one more stop" or "cut exposure by a couple of stops." Probably the most common use of this term is to indicate a change in the lens aperture, where each full f-stop adjustment is called one stop. But the term also is commonly used to refer to adjusting shutter speed or anything that will affect exposure by the equivalent of doubling or halving the amount of light striking the film.

Changing your shutter speed from 1/250 to 1/125 is referred to as increasing exposure by one stop, assuming you make no change in lens aperture. Setting it at 1/60 is a two-stop increase. ISO 400 film is one stop faster than ISO 200 film (because it provides twice the sensitivity to light) and two stops faster than ISO 100.

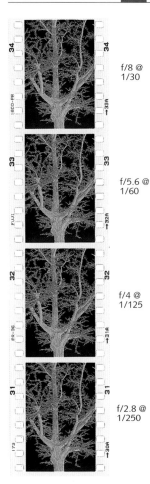

f/8 @ 1/30

f/5.6 @ 1/60

f/4 @ 1/125

f/2.8 @ 1/250

There is no one way to reach proper exposure for a given scene. Here, each frame received the same overall exposure, but was shot with a different combination of shutter speed and f/stop. Since each pair of settings lets in the same total amount of light, each frame looks the same when developed.

(letting in half as much light to strike the film), but lengthen the shutter speed by one stop (letting light strike the film for twice as long). If the correct exposure for a scene is f/8 at 1/125, all of the following combinations of f-stop and shutter speed settings will produce equivalent exposures:

> **f/22 at 1/15** (small lens aperture and slow shutter speed)
> **f/16 at 1/30**
> **f/11 at 1/60**
> **f/8 at 1/125**
> **f/5.6 at 1/250**
> **f/4 at 1/500**
> **f/2.8 at 1/1000** (large lens aperture and fast shutter speed)

For instance, by adjusting the settings from f/11 at 1/60 to f/8 at 1/125, you've opened up the lens aperture to let in twice the light (changing f/11 to f/8), but increased the shutter speed to let the light through only for half the time (changing 1/60 to 1/125).

Note that each setting may affect the look of the final image, so you must make your choice according to the needs of each picture, remembering that lens aperture controls depth of field, while shutter speed affects the appearance of movement or motion. For instance, if you want everything in a landscape to be in focus from near to far, maximize depth of field by choosing a small lens aperture, such as f/16 or f/22. Conversely, to stop the movement of a running horse, choose a fast shutter speed, such as 1/1000 or 1/2000.

Remember that each control also affects the total amount of light: The smaller you set the lens aperture, the slower you must set the shutter speed to maintain correct exposure; the larger the lens aperture, the faster the required shutter speed.

It's possible that your choice of one f-stop or shutter speed over another may affect the final results in a way you did not intend. Choosing a small lens aperture may require a slow shutter speed, which can lead to image blur if the camera or subject moves during exposure. For example, if the correct exposure is f/4 at 1/60 and you adjust the lens aperture to f/5.6 for more depth of field, you will need to slow the shutter speed to 1/30 to maintain correct exposure— and 1/30 may be slow enough to blur the image if your camera or subject moves during exposure.

Choosing a fast shutter speed may require a large lens aperture, which could result in shallow depth of field. In the same example, if the correct exposure is f/4 at 1/60 and you adjust the shutter speed to 1/125 to better freeze the action, you will need to open up the lens aperture to f/2.8 to maintain correct exposure—and f/2.8 may result in depth of field that's too shallow to keep the whole subject sharp.

The Film Speed Factor

Film speed is a primary factor in determining your f-stop and shutter speed settings.

Film speed has an important role in exposure, because it determines the f-stop and shutter speed settings. Fast films are more sensitive to light than slow films, so they require less light for proper exposure, meaning you can use a smaller lens aperture or a faster shutter speed.

Simple math will tell you just how much faster one film is than another. Film rated ISO 400 is four times faster (more sensitive to light) than ISO 100 film (400 ÷ 100 = 4). Four times more light is a difference of two stops: two f-stop increments, two shutter speed increments, or one of each. Thus, if the correct exposure is f/5.6 at 1/500 with ISO 400 film, it will be f/2.8 at 1/500, f/4 at 1/250, or f/5.6 at 1/125 with ISO 100 film.

Since fast films need less light, you're more able to use settings for greater depth of field and/or less camera or subject movement than with slow films. And the relatively large lens apertures and slow shutter speeds needed by slow films are likely to result in more shallow depth of field and/or more camera or subject movement.

While these are good reasons to choose one film speed over another, keep in mind another key consideration: Slow films produce images with finer grain than fast films.

Light Meters

A light meter measures light and recommends an f-stop and shutter speed combination for correct exposure.

Handheld light meters: pages 77–78

Before using a light meter you must set the film speed, or let the camera's DX-code sensor set it for you.

A **light meter** measures the subject lighting and suggests an f-stop and shutter speed that should produce the correct exposure for the film speed you are using. Most 35mm cameras have a built-in meter, called a **through-the-lens (TTL) meter,** because it measures the light that passes through the camera lens. TTL meters usually provide exposure recommendations on either an external LCD display and/or in the camera's viewfinder. Separate handheld light meters also are available.

To use a meter, you must first set the speed (ISO) of your film. The meter won't know what settings to recommend unless it knows how much light the film needs. Most modern 35mm cameras set the ISO automatically. When you load your film in the camera, an internal sensor reads a bar code printed on the film cassette that signals the ISO of that film. The bar code is known as a **DX code;** virtually all 35mm films have one.

If your camera does not have a DX-code reader, or if you're using a handheld meter, you will have to set the film speed manually. Check your camera or meter's instruction book for specifics on setting the ISO. On many older cameras, you set the film speed using a window located on the same dial as the shutter speed settings. On handheld meters you set the ISO on a dial, but on some newer model meters and cameras you use a button and a display panel.

Once the film speed is set, you're ready to take a light reading. Many TTL meters are activated once you turn on the camera, so you will get a reading just

Setting the ISO

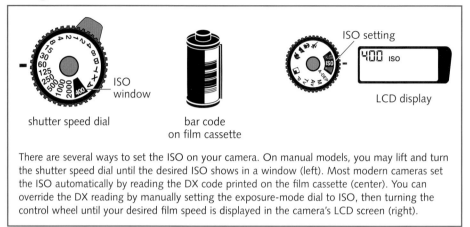

shutter speed dial

bar code
on film cassette

ISO setting

LCD display

There are several ways to set the ISO on your camera. On manual models, you may lift and turn the shutter speed dial until the desired ISO shows in a window (left). Most modern cameras set the ISO automatically by reading the DX code printed on the film cassette (center). You can override the DX reading by manually setting the exposure-mode dial to ISO, then turning the control wheel until your desired film speed is displayed in the camera's LCD screen (right).

A through-the-lens (TTL) meter is built into the camera and reads light after it passes through the lens (top); a hand-held light meter is independent of the camera (bottom). Both suggest f-stop and shutter speed settings for correct exposure.

by pointing the camera at the subject. Other in-camera meters must be manually activated, either by pressing the shutter button halfway down or by cocking the film advance lever partway.

Aim the camera at your subject, framing the scene the way you want it. The in-camera meter will display an f-stop and shutter speed setting suitable for the lighting conditions of the scene. The method of display varies with the camera model. Note that the exact location where you point your camera or meter may have a significant effect on the exposure settings.

If you have a fully automatic camera, you just have to compose the frame and press the shutter button; the camera does the rest. However, for maximum control, you will want to adjust either the f-stop or shutter speed (or sometimes both) yourself. Remember that you don't have to use the exact settings recommended by the camera. You can use other settings, as long as the overall quantity of light that strikes the film remains the same. Often, the camera will show you the equivalent exposure: when you change either the f-stop or shutter speed, the other adjusts on the meter display automatically. For example, if the meter recommends f/8 at 1/60, you can use f/5.6 at 1/125 or f/11 at 1/30 instead. You might want to use particular settings for creative effect—to achieve greater depth of field, freeze subject motion, or create a blurry result.

A TTL meter produces very accurate readings, because the light is read and evaluated after it passes into the camera. Therefore it reads only light that is reflected from your framed subject, and also takes into consideration any reduction of light reaching the film that sometimes occurs when you are using accessories such as filters.

However, you can still get inaccurate exposure recommendations, even if you are using a TTL meter. All meters can be fooled—and often are by certain

Noe DeWitt, *A Young Navy Sailor, Coronado Navy Base,*
Coronado, California, 1998

DeWitt brings a real-world quality to his fashion photographs for magazines such as
Vanity Fair *and clothing designers such as Polo/Ralph Lauren. For this backlit portrait,*
DeWitt paid special attention to the shadow areas of his subject, a real-life sailor, to
ensure they received adequate exposure. © Noe DeWitt; courtesy of the artist.

The light meter doesn't always provide the best exposure recommendation; sometimes you need to interpret and adjust it.

situations. They are only instruments that depend on the information fed to them; sometimes you must interpret this information and make adjustments.

Also, correct exposure is not an absolute; the meter's recommendations are not always the best settings for a given situation. Sometimes you may produce a negative that better suits your purposes by deliberately over- or underexposing your film.

How Light Meters Work

To know how best to use a light meter, you must understand how it is designed. Meters read the light in a scene and recommend an f-stop and shutter speed setting that produces a **middle gray,** which is defined as the average gray on a scale from white to black. In practice, this means that a meter is accurate only as long as a scene has a balanced mix of shadows, highlights, and grays that average out to middle gray. (Note that middle gray is sometimes called 18 percent gray, because it reflects 18 percent of the light that strikes it.

Middle-gray examples: page 87

Meters read for middle gray, the blend of light, mid-, and dark tones found in an average subject; if your subject consists mostly of light or dark tones, your meter reading may well produce inaccurate exposure unless you adjust it.

You may get very different f-stop and shutter speed suggestions from the same subject, depending on where you point your meter.

So, no matter what you point the meter at, it sees only gray. This average reading strategy works well enough most of the time. Look around you. Most scenes include a range of tones from light to dark. However, there are plenty of scenes that are not average, but are instead mostly light or mostly dark. For these scenes, an unadjusted meter reading is likely to produce incorrect exposure.

For example, if your subject is wearing a white sweater and standing against a white wall, the meter will still suggest f-stop and shutter speed settings to produce an average gray. The sweater and wall will be rendered as gray, rather than white. If your subject is all black, the meter still sees only gray, as well. This is why it's so important to consider which part of the scene you take a meter reading from.

Say your subject is a woman with black hair, a white sweater, and a gray skirt. If you were to get close up and fill the viewfinder with only her hair, the meter would only see a dark area of the subject and respond as if there were less light in the scene than there really is. The resulting indicated meter reading will suggest an f-stop and shutter speed combination to produce average gray, perhaps f/4 at 1/125. If you take a picture using these settings, the hair will get more exposure than necessary and therefore will be rendered as gray, not black.

If you fill the viewfinder with your subject's white sweater instead, the meter will see only a bright area of the subject and respond as if there is more light in the scene than there really is. The indicated meter reading will once again suggest an f-stop and shutter speed combination to produce average gray, say f/16 at 1/125. This time, however, the settings will not allow in enough light. If you take a picture using this combination, the sweater will get less exposure than necessary and will be rendered as gray, not white.

Finally, if you point your meter at the gray skirt, you would get still another exposure recommendation to produce an average gray result. This f-stop and

shutter speed combination will be somewhere in between the readings for the hair and the sweater—f/8 at 1/125 or so. If you take a picture using these settings, the skirt will be rendered correctly as gray. Other areas will also be rendered correctly; dark areas like the hair will be dark and the light areas like the sweater will be light.

So three entirely different readings are possible for the exact same subject, depending on which portion of the scene fills the viewfinder when you take a meter reading. In this case, the most correct exposure comes when the meter reads from the gray skirt. Note that most of the time, you don't have a gray subject to meter from; instead you are reading a blend of darks, grays, and lights and hoping they will average out to a middle gray—much like the skirt.

Handheld Meters

Most light meters read reflected light, which bounces off the subject and travels to the meter (top). Some handheld light meters read incident light, which is the light that falls onto the subject (bottom).

Most photographers use an in-camera TTL meter, but some use a separate, handheld meter and set the f-stop and shutter speed manually. A variety of models are available, ranging from simple and inexpensive to sophisticated and costly; some even cost more than a good basic 35mm SLR camera.

The most obvious reason to use a handheld meter is if your camera does not have a built-in meter. Many sophisticated medium-format models, and virtually all large-format models, are meterless. And some photographers use older 35mm cameras that don't have TTL meters. Even if your older camera has a meter, it may not be very accurate or in good working condition.

Because a handheld meter is independent of the camera, you can easily bring it up close to the subject for precise readings. This is particularly convenient

Handheld Light Meters

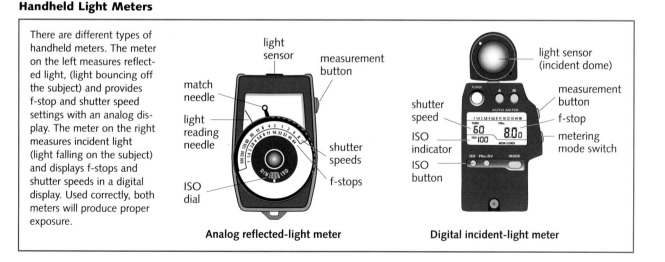

There are different types of handheld meters. The meter on the left measures reflected light, (light bouncing off the subject) and provides f-stop and shutter speed settings with an analog display. The meter on the right measures incident light (light falling on the subject) and displays f-stops and shutter speeds in a digital display. Used correctly, both meters will produce proper exposure.

Analog reflected-light meter Digital incident-light meter

when you use your camera on a tripod. If you use your camera's TTL meter, you may face situations in which you must take the camera off the tripod, bring it up close to the subject to take the reading, then reattach the camera to the tripod.

Most handheld meters also offer an entirely different way of reading light than TTL meters. All TTL meters measure **reflected light**—the light bouncing off the subject. Handheld meters also measure reflected light, but most are able to measure **incident light,** the light falling on the subject, as well.

Some photographers feel that a handheld meter can help provide more accurate film exposure, or that they have better control and understanding of exposure by working with a separate meter. This opinion is somewhat subjective, however. You should get good results if you use either type of meter correctly.

Metering Patterns

All meters are designed to produce middle gray, but they may measure light in very different ways. Modern cameras with TTL meters usually offer a variety of **metering patterns**, the meter's method of analyzing the light from a scene for good film exposure.

Be very careful which metering pattern you use. It's quite possible to get a different exposure recommendation from one pattern than from another, even with the same subject. Usually such differences are not extreme, but they may be enough to make the difference between a well-exposed negative and one that's hard to print.

All light meters are designed to produce middle gray, but TTL meters may use different metering patterns.

On some cameras you choose the metering pattern by setting a switch. On others you turn a dial. And on most modern models you turn a control wheel or press a button until you see the desired icon (or some other marking) displayed on a screen or in the viewfinder. Many, but not all, cameras offer the following metering patterns: centerweighted, multisegment, and spot.

Viewfinder:
Centerweighted metering

Centerweighted metering. Some camera meters use **centerweighted metering** as their default pattern. This means the meter averages all the light in the viewfinder, but gives more consideration to the center when calculating exposure. Centerweighted metering presumes that the main subject of the photograph is in the middle of the frame—a reasonable assumption, as most photographs are more or less composed that way.

Different camera models have varying methods of centerweighting. Some might assign 60 percent of their exposure calculation to the center of the viewfinder, while others might assign 80 percent, leaving the rest of the viewfinder to contribute 20–40 percent to the exposure calculation.

Choose a centerweighted metering pattern for normal subjects. Such subjects include those positioned more or less in the middle of the frame, where there

are no unusually bright or dark areas and/or the overall tones average out more or less to middle gray.

Multisegment metering. Multisegment metering, also called matrix or evaluative metering, relies heavily on computer technology. The viewfinder is divided into segments of varying shapes and sizes, and the meter analyzes each segment individually to suggest a suitable f-stop and shutter speed for the overall exposure. Multisegment meters can be quite sophisticated, even comparing the light values of the current scene in the viewfinder against preprogrammed patterns stored in memory.

Viewfinder:
Multisegment metering

Backlighting: pages 94–95

Multisegment meters are particularly useful for scenes where light and dark areas are not evenly distributed, such as when your subject is backlit or when you have extreme light or dark areas in any part of your picture. For instance, if your picture includes very bright sky in one corner, the multisegment meter discounts this corner's importance when recommending exposure settings.

Some multisegment meters divide the viewfinder into three or four segments, while others divide it into dozens of segments or more. The segmented areas are not equal; some are larger than others and some are shaped differently.

Some cameras link multisegment metering to their autofocus system, giving more weight to the segments that are close to the focused area. The presumption is that most of the time you are focused on the main subject, and that is the subject needing the most attention. This feature helps provide accurate exposure readings even when a subject is off-center in the viewfinder.

Such features make multisegmenting the most accurate metering option in most cases, especially when you are photographing quickly and in automatic exposure mode. However, it is not foolproof. For example, you may still have to adjust your exposure at times, particularly when your main subject is strongly backlit or when it is a relatively small part of the picture.

Viewfinder:
Spot metering

Adjusting your meter reading: pages 90–91

Spot metering. Spot metering, a useful metering option not available on all cameras, concentrates its reading in a small circle located in the center of the viewfinder. It will take a reading only in the area of the subject in the circle and ignore the rest of the viewfinder when making its f-stop and shutter speed recommendations. For example, if your subject is wearing a black sweater and you point the camera so that the sweater fills the circle, the meter will read only the sweater's black tones, even if the rest of the picture is a balanced combination of light and dark areas.

Thus you must be very careful where you point the spot meter or you may get an inaccurate reading for the overall picture. If the circle doesn't contain a gray tone, you will have to adjust the meter reading to compensate.

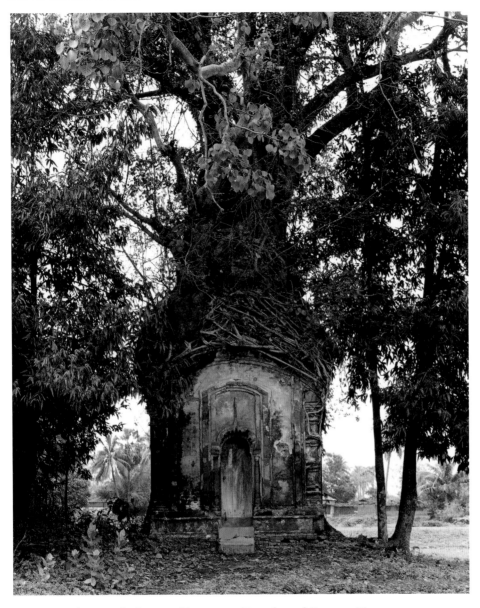

Laura McPhee, *16th-Century Terracotta Temple and Banyan Tree,*
West Bengal, India, 1998

McPhee has traveled repeatedly to India to record its culture as reflected in its architecture and landscape—or where they intersect, such as in this fusion of temple and tree. McPhee was careful to concentrate her meter on the temple, avoiding the light coming from behind, which could have thrown her reading off and caused her film to be underexposed. © Laura McPhee; courtesy of Bernard Toale Gallery, Boston, MA.

The spot metering pattern is great for taking very specific readings of small portions of the image area, particularly if your main subject is darker or lighter than the rest of the scene—for example, a brightly lit musician against a dark stage at a concert or an indoor subject silhouetted against a window.

Handheld spot meters also are available. These are widely used by craft oriented medium- and large-format photographers who are especially fussy about their exposure. Most handheld spot meters take a reading from an even smaller area (a narrower angle) than in-camera spot meters. For example, a camera's spot meter may read a 5° angle of light whereas a handheld spot meter might read 1° or less.

Spot metering is best for making readings of specific areas of a scene.

Setting Exposure

Once you understand the factors that lead to good film exposure, you are ready to actually set f-stops and shutter speed—or to interpret or override the choices that the camera makes for you, when necessary. This section describes a number of ways to choose settings and various methods to deal with tricky photographic situations that can make achieving good exposure difficult.

Exposure Modes

Metering patterns are the meter's method of analyzing the light from a scene for good film exposure. But it's the **exposure mode** that determines how a suitable f-stop and shutter speed are set. Most modern 35mm cameras (and many medium-format models) offer a variety of exposure modes; most commonly manual exposure, program autoexposure, aperture-priority autoexposure, shutter-priority autoexposure, subject-program autoexposure.

Keep in mind that the various exposure modes are only options. You may find that you consistently prefer one or another or that you use different modes for different situations. Whatever you choose, each mode used correctly (and adjusted, if necessary) should yield the correct exposure.

Depending on your camera, you set the exposure mode in different ways. Many cameras have a dial on the top deck of the camera body, and you simply turn a marked dial to set the desired mode. Other cameras show exposure modes in an LCD display on the top of the camera body. Push a button or turn the control wheel to get to the desired mode. Different cameras use different display systems, but most will show the chosen exposure mode somewhere along the edge of the viewfinder.

Many cameras offer a choice of different exposure modes for setting the correct combination of f-stop and shutter speed.

Manual exposure mode (M). The "M" setting stands for **manual exposure mode** on most cameras. In this mode, you set both the f-stop and shutter speed yourself, guided by recommendations from the light meter. The camera's meter is linked to the lens aperture and shutter speed controls; as you set different

Manual exposure involves setting the f-stop and shutter speed yourself, with help from a light meter.

combinations of f-stop and shutter speed, you can see results displayed in the viewfinder or LCD panel, guiding you to correct exposure.

The following methods of displaying exposure in manual mode are most common. But the system on your particular camera might be slightly different than that on another, so refer to your camera's instruction book if in doubt.

Match-needle systems are usually displayed on one side of the viewfinder. As you change f-stop or shutter speed, one or two needles move. You know you've achieved the recommended exposure when the two needles match up or when the single needle lines up to a notch or gap in the middle of the side on the viewfinder.

LED display systems have different types of illuminated displays, such as plus and minus signs with a circle between them, a pair of arrows, or some other indicator on one side of the viewfinder. As you set different f-stops and shutter speeds, the pluses, minuses, circle, or arrows light up. Recommended exposure is generally indicated when the circle is the only lit mark, or when the plus and minus signs or the two arrows light up at the same time.

Some cameras in manual exposure mode display a scale of f-stops, illuminated in the viewfinder and/or on the camera's external LCD panel, if there is one. They also may show the selected f-stop and shutter speed. Changing f-stops and shutter speeds moves an arrow or other mark along this scale. The recommended exposure is indicated when the arrow reaches a center point.

Manual Exposure Displays

Using your camera's TTL meter in manual mode, you set different f-stops and shutter speeds until the viewfinder display indicates correct exposure. The method of display varies from one camera to another. These are some common types.

Match needle: correct exposure when two moving needles match up.

LED display: for camera's with aperture-priority, when the f-stop is set the corresponding shutter speed is displayed in the scale on the left.

LED display: correct exposure when circle on right lights up.

LED display: correct exposure when mark is positioned in the middle of the scale on the right.

Working in manual exposure mode teaches you a lot about how exposure works, as you must set the f-stop and shutter speed yourself, while providing you with a lot of control over exposure. In particular, manual exposure mode works well for making subtle adjustments in individual exposures for those times when you want just a little more or a little less light than the meter suggests. Adjust the f-stop and shutter speed until you reach the recommended exposure, and then tweak one setting slightly to allow a little more or less light in.

Program autoexposure mode (P). In **program autoexposure mode**, usually indicated by a "P," the camera automatically sets the f-stop and shutter speed for you. You simply point the camera, compose your picture, focus (or allow the lens to focus automatically), and press the shutter button. The chosen f-stop and shutter speed are displayed as you look through the viewfinder and/or look at the camera's external LCD display. In theory, you will get the same exposure recommendation that you would get in manual mode, except that in program mode the camera sets them for you, while in manual mode you set them yourself (with the meter's help).

The most obvious advantage of program mode is its simplicity. All you have to do is set "P" on the camera and take your picture. You are yielding control over the exposure settings to the camera, but this mode works very well for most quick, spontaneous picture taking and for subjects with average lighting and tonal ranges—a good balance of darks, middle tones, and lights.

Note that in program mode, you can gain an extra measure of exposure control by using **program shift**, an option that allows you to choose a specific f-stop or shutter speed, usually by rotating a dial. For example, suppose the meter sets exposure automatically at f/8 at 1/250, but you want more depth of field (for a landscape subject) or a faster shutter speed (to stop the action of a dancer in motion). Simply change the lens aperture opening to f/11 for greater depth of field, and program shift will automatically change the shutter speed to 1/125 to compensate; or change the shutter speed to 1/1000 to stop motion, and program shift will automatically reset the lens aperture to f/4. You must activate program shift with each exposure; after you take a picture, the camera will revert to the program's set f-stop/shutter speed settings.

Aperture-priority autoexposure mode (A or Av). With **aperture-priority autoexposure mode**, indicated by "A" or "Av" on your camera, you choose the f-stop you want, and the camera automatically sets the corresponding shutter speed needed for good exposure. This mode gives you the advantages of autoexposure—simple and quick operation—but with more immediate control over depth of field. For example, you can set the lens aperture at f/16, which will provide a lot of depth of field when photographing a landscape subject, or

With program autoexposure, the camera sets both the f-stop and shutter speed automatically.

With aperture-priority auto-exposure, you set the f-stop and the camera sets the shutter speed automatically.

at f/2 for reduced depth of field when making a portrait, and the camera will set the shutter speed for you.

Aperture priority also is very useful when you are photographing in low light. Knowing you will need a lot of light for adequate exposure, you can set the camera to "A" or "Av" and set the lens to its largest opening, perhaps to f/2.8 (depending on the maximum aperture of your lens), and let the camera adjust the shutter speed as needed.

Be careful you don't set your aperture too small or too large for the lighting situation. If you close down to a small lens opening, for example, to f/16 in dim light, your meter may have to set a very slow shutter speed, perhaps 1/2, which could result in a blurred image. Or if you open up your lens aperture in bright light, for example, to f/4, your meter may not be able to set a fast enough shutter speed. Many cameras will beep or display a warning in the viewfinder if the needed shutter speed is faster than the camera can set. Or, they may not allow you to take the photograph at all. Note that most cameras don't alert you when you've set a shutter speed too slow to hold the camera steady.

With shutter-priority auto-exposure, you set the shutter speed and the camera sets the f-stop automatically.

Shutter-priority autoexposure mode (S or Tv). With **shutter-priority autoexposure,** indicated by "S" or "Tv" on your camera, you choose the shutter speed you want for your subject, and the camera automatically sets the corresponding f-stop needed for good exposure. Like aperture-priority, this mode offers the simplicity and quickness of autoexposure, but with more immediate control over subject or camera movement.

Perhaps the best use of shutter priority is when a fast shutter speed is required to stop action. Knowing you will need to freeze the movement of a runner at a track meet, set the shutter speed to 1/1000 or faster—letting the camera automatically adjust the f-stop as needed. Alternatively you can deliberately choose to make the runner a blur by setting 1/4 or some other slow shutter speed.

However, be careful you don't set your shutter speed too fast or too slow for the lighting situation. In low light, your lens aperture may not open wide enough to accommodate a fast shutter speed, for example 1/1000, and in bright light it may not close down small enough to accommodate a very slow speed, such as 1/4. As with aperture priority, either problem may set off a beep or a display warning, while some cameras won't even allow you to take the picture unless you've set a workable shutter speed.

With subject-program auto-exposure, you set the subject and the camera sets the f-stop and shutter speed accordingly.

Subject-program autoexposure mode. Some cameras offer a **subject-program autoexposure mode** designed to optimize settings for specific subjects. You choose the subject by setting icons on a dial on the camera body or on its LCD display (and sometimes in the viewfinder). Then the camera determines both

the f-stop and shutter speed automatically, according to what it presumes is best for the chosen subject.

Typical modes include **portrait mode** (usually indicated by an icon of a head and shoulders), for which the camera will choose a large lens aperture to produce less depth of field and soften distracting backgrounds; **landscape mode** (usually a mountain icon), for which the camera will choose a small lens aperture for greater depth of field; **sports** or **action mode** (usually a running figure), for which the camera will choose a fast shutter speed to stop motion; and **macro mode** (often a flower icon) for faster, more accurate focus when photographing close up.

You can accomplish the same results using any of the other available exposure modes. However, some photographers prefer to allow the camera to make these kinds of subject-based decisions for them.

portrait
landscape
close-up
sports

Setting the subject-program autoexposure mode.

Exposure Strategies

There are several strategies available for calculating exposure, whether you are using an in-camera meter or a handheld model. When used correctly, each strategy will lead to more or less the same f-stop and shutter speed recommendation. However, you may prefer one method or another or find some approaches are more suited to certain types of equipment or lighting situations.

Take an overall meter reading. The most common exposure strategy is just to take an overall meter reading. Simply point your camera (or your handheld meter) at an entire scene and use the indicated f-stop and shutter speed settings. Much of the time, this simple technique works just fine. But before you accept that reading, examine your subject carefully. Visualize the scene as it might look in black-and-white, then decide whether the dark, middle, and light tones roughly average out. If they do, you can probably use the indicated f-stop and shutter speed to achieve correct exposure. If they don't, you will have to make an adjustment.

Using an overall meter reading works well if all the tones in a scene, from the light to dark areas, average out to gray.

If the scene has mostly light areas, add a little more light than the meter suggests, either by opening up the lens aperture or using a slower shutter speed. Adding light with a light subject may seem counterintuitive. But remember that the meter always provides a reading to produce middle-gray—and here, you want tones that are lighter than that. Exposing the film for more time will make bright areas denser (darker) than gray on the negative and lighter (whiter) in the print.

With light areas usually an adjustment of one-stop increase (or even less) is all you will need. So if the meter suggests f/8 at 1/500, use /f5.6 at 1/500 or f/8 at 1/250 or some other equivalent instead. If the scene contains predominantly white tones—for example, when it is mostly bright sky, snow, or sand—you

| Autoexposure Lock | When your TTL meter is in an autoexposure mode, it is continually reading the light and changing its exposure recommendations as you move the camera. In most cases, this leads to the best possible results. However, there are times when you will want to establish an f-stop and shutter speed based on reading one or another specific area of the scene, and maintain these settings as you recompose and shoot the picture. For these times, you can use **autoexposure lock (AE lock)**, a feature available on most current 35mm SLRs and some other camera models. |

You usually activate AE lock with a button or a switch of some sort on the front or back of your camera. Take your exposure reading in the area of the scene that is most important to you, hold the button down or press the switch to lock the settings in, then compose and take the picture. On some camera models, you also can lock autoexposure settings with light pressure on the shutter button.

Here are some examples of when you will want to use AE lock. If your portrait subject is backlit against a bright sky, read the light from your subject only, avoiding the sky, by pointing your camera down until the sky doesn't show up in the viewfinder; hold that reading with AE lock, recompose the scene so the sky is in the viewfinder, and take the picture.

Or if you want to compose your subject so it is on the edge of the frame, point the camera so the subject is in the center of the viewfinder, take the exposure reading, and lock in the recommended f-stop and shutter speed. Then recompose the scene any way you want and take the picture.

might have to add two stops more exposure: f/4 at 1/500 or f/8 at 1/125 (or the equivalent).

If the scene has mostly dark areas, reduce the exposure a little from what the meter suggests, either by making the lens aperture smaller or making the shutter speed faster. Here, too, using less exposure with a mostly dark subject may seem counterintuitive. But again the meter always provides settings that render the subject middle-gray—and here, you want dark tones, not grays. Exposing the film for less time will make dark areas lighter than gray on the negative and darker (denser) in the print.

With dark areas, usually a one-stop decrease or less from the indicated meter reading is all you will need; cutting back by more might lead to underexposed, hard-to-print negatives. So if the meter suggests f/4 at 1/60, use f5.6 at 1/60 or f/4 at 1/125 (or some other equivalent) instead.

Meter readings from a dark area of your subject require an adjustment of one or two stops less for correct exposure.

Note that some photographers are reluctant to deviate from the meter's suggested exposure, but it's important to understand that adjusting the meter reading by decreasing or increasing exposure in such cases does not mean you are necessarily underexposing or overexposing your film. Rather, you are simply adjusting exposure to compensate for a meter reading that would otherwise be inaccurate.

Meters Read for Gray

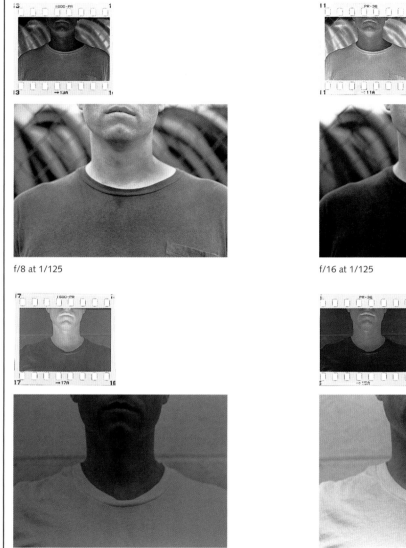

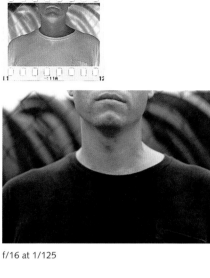

f/8 at 1/125

f/16 at 1/125

f/11 at 1/250

f/5.6 at 1/250

Light meters are designed for subjects that consist of a balance of darks and lights, more or less. If your subject has mostly dark areas, such as this black T-shirt and dark background, an unadjusted meter reading of f/8 at 1/125 produces an overexposed negative which renders the T-shirt middle gray (top left). Adjust the settings so the film will get less light (top right).

If your subject has mostly light areas, such as this white T-shirt and light background, an unadjusted meter reading of f/11 at 1/250 produces an underexposed negative which renders the T-shirt middle gray (bottom left). Adjust the settings so the film will get more light (bottom right).

A gray card represents the middle-gray tone that light meters are designed to read.

Taking a meter reading with a gray card.

Use a gray card. You can use a gray card to provide a middle-gray tone for your meter to read, thus entirely avoiding the issue of whether it is reading mostly light or dark areas of your subject. Available from most camera stores and suppliers, a gray card is usually an 8½" x 11" or smaller piece of cardboard colored middle gray on one side.

Since light meters read for middle gray, a reading based on a gray card should give you accurate exposure every time. To use a gray card, place it in front of the subject, aimed toward the camera. Take the meter reading from the card only; make sure you don't read light from the area around the card and that you don't cast a shadow on the card while taking the reading. There's no need to focus.

Gray cards are most useful when you're photographing still-life arrangements, formal portraits, and other stationary subjects. You'll need enough time to approach the subject, position the card, and take the meter reading.

After you take your meter reading, step back from the card and compose your subject. In manual mode, set the f-stop and shutter speed on the camera, as recommended by the meter. In any autoexposure mode, you must use the autoexposure lock to prevent the f-stop and shutter speed from changing when you move the card away from the subject to take the picture.

Thus, if the meter suggests settings of f/8 at 1/125 when pointed at the gray card, use this combination when you take the picture even if the meter suggests, say, f/4 at 1/125 for the same scene without the gray card.

Reflected and incident light: page 77

Take an incident-light reading. Almost all meters measure reflected light—the light bouncing from the subject—and for this reason they are sometimes called **reflected-light meters.** But many handheld meters also can measure **incident light,** light as it falls on the subject.

Used correctly, both types of metering will suggest the same combination of f-stop and shutter speed, even though their reading methods differ. An incident reading is more generalized than a reflected-light reading; it doesn't measure specific areas of the scene, so it can't be fooled by areas that are mostly light or dark. In this regard, it's like using a gray card.

To measure incident light, the meter generally has a dome or diffusing panel over its light sensor. Position the meter at the subject and point the dome or panel back toward the camera, allowing the meter to read the light that falls on the subject. Use manual exposure mode on your camera and take the picture using the meter-recommended f-stop and shutter speed, ignoring the suggested settings of the camera's TTL meter. If the incident meter suggests settings of f/11 at 1/250, use this combination even if a reflected reading suggests f/8 at 1/250 or some other combination.

Bracket exposures. One popular strategy for dealing with difficult lighting conditions or with particularly important subjects is to take more than one exposure at a range of settings. Called **bracketing**, this technique helps ensure that you will get at least one correctly exposed negative. First make an initial exposure at the meter-recommended f-stop and shutter speed. Then make at least two additional exposures: one to allow more light in and one to allow in less. This gives you a range of three exposures, one of which is likely to best capture the scene.

Try bracketing a full stop either way, for a three-shot bracket. For example, suppose the meter's suggested settings are f/8 at 1/125. Take your first exposure at that reading, and then take a second exposure to let in one stop more (twice as much) light, such as f/5.6 at 1/125 or f/8 at 1/60. Then take a third exposure letting one stop less (half as much) light in than your initial setting, such as f/11 at 1/125 or f/8 at 1/250. If you want a broader range, make a five-stop bracket by shooting extra frames two stops either way.

You must ordinarily bracket in manual exposure mode, because in autoexposure mode the camera will adjust one setting when you change the other. However, many cameras offer **autobracketing** in autoexposure mode. When the camera is set for autobracketing, you press the shutter button once, the camera takes three different exposures (or more for even broader bracketing, if you choose) in rapid succession. You can even vary the amount of the bracketed exposures, usually up to two stops (and in fractional increments) in either direction.

You also might consider partial bracketing, which involves making extra exposures in only one direction—usually one at the initial f-stop and shutter speed, and the other to allow in double the light. So if the meter's indicated exposure is f/8 at 1/125, take a picture at that exposure and a second one at f/8 at 1/60 or f/5.6 at 1/125.

Bracketing Exposures

Bracketing goes a long way toward ensuring well-exposed negatives. To bracket, make a range of exposures: one at the camera's recommended settings (left), a second at one stop more light (center), and a third at one stop less light (right).

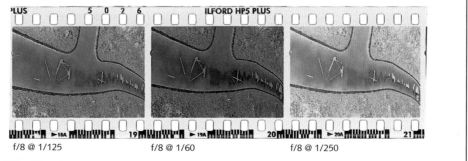

f/8 @ 1/125 f/8 @ 1/60 f/8 @ 1/250

Methods of Adjusting Exposure

For best exposure, you will often want to adjust your camera settings to let in more or less light than your meter suggests. Such cases include when your subject contains more light tones than darks, when it is backlit, or when you simply want a slightly denser negative to absolutely guarantee you'll have full detail in the shadow areas. Here are three common methods of adjusting your exposure.

Manual adjustment. In manual mode, you can simply choose to let in more or less light by adjusting the f-stop or shutter speed (or both) for every picture. Suppose the meter recommends an exposure of f/8 at 1/125 for a particular scene. To add more light, open up your lens aperture to f/5.6 at 1/125 (a one-stop adjustment) or f/4 at 1/125 (two stops). Or use a slower shutter speed, perhaps f/8 at 1/60 (one stop) or f/8 at 1/30 (two stops)—or some equivalent combination of settings.

Alternatively, to reduce exposure, close down your lens to f/11 at 1/125 (a one-stop adjustment) or f/16 at 1/125 (two stops). Or use a faster shutter speed, perhaps f/8 at 1/250 (one stop) or f/8 at 1/500 (two stops)—or some equivalent combination of settings. Manual adjustment is easy to do, but not always convenient because you may have to change the settings for every exposure.

Autoexposure (AE) compensation setting. Many cameras offer an autoexposure compensation setting that lets you depart from the automatically set f-stop and shutter speed. You indicate the number of stops (or fractions of a stop) you want to increase or decrease exposure by, and the camera adjusts the exposure accordingly every time you take a picture. You can change the exposure compensation for each picture you take, but this method of adjusting exposure is especially useful for multiple shots or for an entire roll. Once the desired compensation is set, it applies to all subsequent exposures on the roll of film until it is reset.

Autoexposure Compensation

You can adjust automatic exposure by using exposure compensation. Different cameras use different methods for setting compensation. Some use a dial and others use a scale in the LCD display. On the left, the dial and scale are set at zero—no compensation from the camera provided settings of f/5.6 at 1/125. On the right, the dial and scale are set at +1, providing one stop more light with every exposure—here, f/4 at 1/125.

On some cameras the compensation you set also applies to subsequent rolls and on others you must reset it with every roll. You also may have to reset your desired compensation if you turn off your camera before completing a roll of film.

Not all cameras offer exposure compensation, but for those that do, it works in all automatic modes (program, aperture priority, or shutter priority). Adjustments are allowed in full stops: marked as +1 or +2 (for a one- or two-stop exposure increase) or −1 or −2 (for a one- or two-stop exposure decrease), and also in half and/or third stops in between. You set the compensation increments with a dial or button, and they may be displayed either in the camera's viewfinder, LCD display, or both.

Suppose the camera-selected exposure is f/8 at 1/125. Set the exposure compensation dial for +1 and the settings will automatically adjust to f/5.6 at 1/125 (in shutter-priority mode) or f/8 at 1/60 (in aperture-priority mode); or set −1 and the settings will adjust to f/11 at 1/125 (in shutter-priority mode) or f/8 at 1/250 (in aperture-priority mode). In program autoexposure mode, it may change either f-stop or shutter speed.

Film speed adjustment. Still another way to adjust exposure is by changing the ISO setting on your meter. Since the meter needs to know the film speed to determine the necessary f-stop and shutter speed settings, adjusting the speed fools the meter into recommending more or less light than the film requires at its standard ISO rating.

Like changing the exposure compensation setting, changing film speed is best for situations in which you want to adjust the exposure for multiple shots or an entire roll. This method works in either manual or automatic mode and on cameras with and without DX-code readers. With most cameras, you can override the DX-code setting and set the ISO at any speed you choose. If the camera has no DX-code reader, simply set the ISO at any speed.

For example, if you are using ISO 400 film, set ISO 200 instead, telling the meter that the film is half as sensitive as it really is. As a result, the meter will recommend one stop more light than would otherwise be required. The camera will continue to make the same adjustment for as long as you leave the ISO rating at its changed setting. However, with some camera models, you must reset the adjusted ISO at the beginning of each new roll of film.

Suppose when your meter is set at ISO 400 the recommended f-stop and shutter speed setting is f/8 at 1/250. If you want to allow one stop more light in, halve the ISO. At ISO 200, the new reading will be f/5.6 at 1/250 or f/8 at 1/125. For a two-stop exposure increase, divide the ISO by four, setting the meter for ISO 100 instead, and you will get a reading of f/4 at 1/250 or f/8 at 1/60 (or the equivalent). Make the opposite adjustment to allow in one stop less light, double the ISO; at ISO 800 the above reading will be f/11 at 1/250 or f/8 at 1/500.

Photographing in low light: pages 95, 97

Partial bracketing is usually safe because negatives with a little more exposure are almost always easier to print than negatives with a little less exposure. In particularly tricky lighting, such as hard-to-capture low light, you might even partially bracket in one direction two or three times—by increasing exposure one stop, then increasing it again by two or more stops.

Bracketing works best for still subjects; candid or moving subjects usually will not sit still long enough to maintain the exact same framing in all your brackets (although if you use autobracketing you can get off three shots very quickly). At any rate, it's best not to use bracketing as a crutch. Learn to expose film correctly and confidently, and then bracket only those very tough exposure situations or critically important subjects, for which you must make absolutely sure you have a good exposure.

Expose for the shadows and compensate. For precise exposure control, take a meter reading in the darkest part of the scene in which you want to render good detail. Once you've made the reading, adjust the f-stop and shutter speed to let less light in by one or two stops—to guarantee the shadows will be rendered black, not middle gray.

For example, if your portrait subject has a black sweater, point your meter so it only reads light reflecting from the sweater. To do this, move your camera or handheld light meter close to the sweater to take the reading. Suppose the meter suggests a reading of f/2.8 at 1/60. If the sweater is fairly dark, adjust the f-stop and shutter speed combination so it allows in one stop less light, such as f/4 at 1/60 or f/2.8 at 1/125. If the sweater is very dark, reduce exposure from the recommended reading by two stops to f/5.6 at 1/60, f/4 at 1/125, or f/2.8 at 1/250.

Scene with mostly dark areas: pages 86–87

The logic is the same as when taking a general reading of a scene with mostly dark areas. When you read light from dark areas, the meter suggests an f-stop and shutter speed that produces middle-gray tones, not darks. Decreasing the exposure will make these areas lighter (less dense) in the negative and darker (denser) on the print.

This exposure strategy is based on an old photographic adage:

Expose for the shadows.

By guaranteeing that the dark areas of your scene have good exposure, all the other areas should be adequately exposed. This strategy is really a stripped-down variation of the **Zone System**, a sophisticated exposure and film development system popularized by the legendary photographer Ansel Adams in the 1930s. Among other Zone System tenets is this one: the very darkest important areas of a scene should measure two stops darker than middle gray, so require two stops less exposure than a meter reading suggests. It follows that if the dark areas are not extremely dark, one stop less exposure should be adequate.

Expose for the Shadows

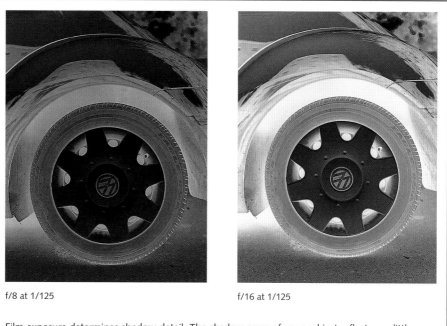

f/8 at 1/125 f/16 at 1/125

Film exposure determines shadow detail. The shadow areas of your subject reflect very little light. Therefore, it is particularly important to ensure that they receive adequate exposure. One method is to take a meter reading in an important shadow area of your subject only, but adjust that reading to prevent the shadow from rendering middle gray. Here, the first exposure (left) was made according to a meter reading taken in the shadows, f/8 at 1/125; the resulting negative is too dense. The second exposure (right) was adjusted to provide two stops less light, f/16 at 1/125; the shadows in the negative render with less density, but adequate textured detail.

Common Exposure Problems

Incorrect film exposure can occur for a variety of reasons. Sometimes your equipment might need repair; for instance, the shutter speed might be inaccurate or the meter might need adjustment. Other times, user error is the problem; perhaps you've made a mistake in metering your subject or setting the camera controls. But there are many situations when incorrect exposure occurs even though the camera and meter are working fine and you seem to be doing everything right. It's important to understand these problematic situations, so when you encounter one—and you will from time to time—you can use the meter intelligently, rather than relying on it absolutely. Here are some common exposure problems and suggested solutions.

Backlighting. A scene is effectively **backlit** any time the light behind the subject is brighter than the light in front. Backlighting, one of the trickiest and most common exposure problems, causes the foreground subject to render too dark and sometimes as a silhouette.

If you take a picture of a backlit subject without adjusting the meter's suggested exposure, the overall scene may be well exposed, but the foreground might lack adequate exposure. This is because the foreground is darker than the background and will reflect less light back to the film. Thus the foreground will be rendered too light (clear) on the negative and too dark when printed. Sometimes backlighting creates an interesting silhouette or evocative mood, but most often it causes disappointment, because you lack good detail in the most important part of the scene.

The classic backlit situation occurs when the sun is shining at the back of your subject and toward the camera. To avoid this, make sure the sun lights your subject adequately from the front or side. However, backlit situations are not always obvious, and they don't always happen when the sun is out. If the scene includes a lot of bright sky, your subject may be effectively backlit, with the bulk of the light coming from the sky—located behind the subject and not falling on it. A similar situation may occur indoors when your subject is positioned in front of a window.

The simplest way to avoid backlighting is to reposition yourself so the sun is behind you and facing the subject.

The simplest way to handle a backlit subject is to give the film more exposure than the meter recommends. This will produce a darker negative overall, which will produce more density and thus better better detail in the subject area. The amount of extra exposure needed depends on how backlit the subject is. Generally you will need to add one or more stops—perhaps one stop if the backlight is subtle, two stops if it is more evident, and as much as three or more stops if it is severe.

Start by taking a meter reading of the entire scene. If the meter recommends an exposure of f/11 at 1/125, use f/8 at 1/125 or f/5.6 at 1/125 instead —or an equivalent combination to add more light. While adding exposure in this way will produce better detail in your backlit subjects, it also will cause the lightest areas of your subject (sky, window light, and so forth) to become even brighter. In some cases they will become so bright that they may be rendered with little or no detail in the negative and subsequent print. As discussed later, reducing the developing time when processing film can help correct this problem by keeping the highlight (light) areas from becoming too dense.

Adjusting film developing times: pages 152–57

Another method of dealing with backlighting is to walk right up to the main subject to take your meter reading, or use a spot meter reading, so you will be measuring only the light reflected from the subject—not the light reflected from the brighter background. In any autoexposure mode, use AE lock to hold that exposure, then move back and take your picture. Or, set the f-stop and shutter

Backlighting

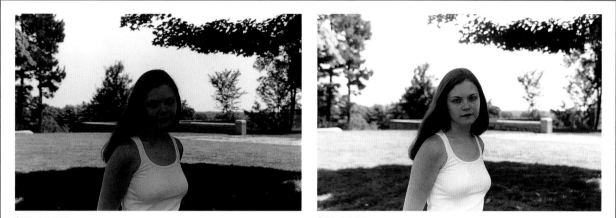

f/11 at 1/250 f/11 at 1/60

Backlighting is when the primary light source comes from in back of the subject. Here, the backlit subject was in shadow and silhouetted (left), because the general meter reading was thrown off by the bright skylight, causing her to be underexposed. To compensate (right), take a general meter reading and add two stops of exposure; you'll get approximately the same results by moving closer to the subject, then taking a reading that excludes the background light. Step back to recompose the image and use the settings indicated by your close-up reading to make your picture.

Lighting: chapter 8

speed in manual mode, then take your exposure at those settings regardless of what your camera meter says when you've moved back to take the picture.

Still another way to handle a backlit scene is to physically add light in front of your subject, so it will be in better balance with, or even overcome, the strong light coming from behind. You can do that by using flash, hot lights, or a reflector panel positioned in front of or to the side of the subject.

Backlighting is so common that many cameras, especially automatic point-and-shoot models, offer a backlight option. When you activate it, usually with a switch on the body, the camera automatically provides more exposure than it otherwise would to provide better exposure of your backlit subject.

Low light. In theory, you can take a picture in almost all light conditions, even when the light is very low. But in practice, dimly lit scenes often present a real challenge. After all, exposure depends on the amount of light that reaches the film. And if there isn't much light, your film can easily be underexposed—and very often is—even if you seem to be doing everything right when metering your subject and setting your f-stop and shutter speed.

To photograph in low existing light, use artificial lighting or fast film, or set a wide lens aperture and/or a slow shutter speed.

You can often get around this problem by adding light to the scene, using flash or other artificial lighting. This should improve your chances of achieving good exposure, but it also will change the mood of the picture. Ambient or

Claudio Cambon, *Ghost Horse, Spring Blizzard,* 1999

Cambon's "ghost horse" is high in contrast, giving the photograph a strong graphic quality, as the dark horse stands out boldly against the bright snow. The photograph also is effectively backlit with most of the light reflecting from the snow, throwing the horse mostly in shadow—a stunning visual effect but a situation that can make good exposure difficult. © Claudio Cambon; courtesy of the artist.

existing light can be atmospheric, mysterious, and subtle, whereas light from an on-camera flash can be bright, flattening, and generic. Also, there are times when for practical reasons you can't use auxiliary lights or when you simply don't have any lights available. Here are some hints on how to photograph effectively in low-light situations without using additional lighting.

Low light requires a large lens aperture, slow shutter speed, and/or fast film.

Use fast (ISO 400) or ultrafast (ISO 1600 or 3200) films, because they require less light than slower-speed films to make a good exposure. Use both a large lens aperture and a slow shutter speed to let in as much light as possible. Keep in mind the potential disadvantages. Using fast film usually leads to grainier results; large lens apertures create shallower depth of field; and slow shutter speeds increase the chance that you will blur the subject.

Tripod: pages 99–101

One solution to increased graininess and limited depth of field is to put your camera on a tripod, so it won't move during exposure. This will allow you to use long shutter speeds, which in turn means you can use slower-speed films for finer-grain results. Long shutter speeds also allow you to set smaller lens apertures for greater depth of field. However, this will limit your ability to capture moving subjects without blur.

When handholding the camera in low light, you will generally have more success with fixed-focal-length lenses than with zoom lenses. This is because they almost always have a larger maximum aperture than zooms. Also, normal fixed-focal-length lenses (about 50mm for 35mm cameras) almost always offer wider maximum apertures than fixed-wide-angle or fixed-telephoto lenses.

Photographing in low light is much more likely to lead to underexposed negatives than overexposed negatives.

Note that some light meters are more likely to provide inaccurate readings in very low light conditions than they are with brightly lit scenes. They may effectively underestimate the amount of light you will really need. If you are not using a tripod, consider ignoring the light meter altogether. Just use fast or ultrafast film, open your lens to its maximum f-stop, and set your shutter for the slowest speed you can safely handhold without moving the camera—usually 1/30 or 1/60. Don't worry about overexposing the film, because in low light it's much more likely that you will underexpose your film.

Pushing film: pages 152–55

Despite your best efforts, you may still end up underexposing your film. If you suspect you might be underexposing, you can compensate somewhat by overdeveloping your film, a technique called **pushing film,** which is discussed later in the text.

Neal Rantoul, *West Tisbury, Massachusetts,* 1990

To create the sense that this lush, grassy field extends far into the distance, Rantoul sets a small lens aperture for maximum depth of field. A small aperture often requires a shutter speed that is too slow to handhold even a lightweight 35mm SLR. But regardless of shutter speed, Rantoul needs a tripod to hold his cumbersome 8" x 10" view camera.
© *Neal Rantoul; courtesy of the artist.*

Camera Accessories

An almost endless array of accessories and add-ons are available to photographers. This chapter describes the camera accessories, such as tripods, filters, close-up equipment, and others, that are most helpful when you're taking pictures. Another important category of accessories, flash and lighting equipment, is described in chapter 8.

Tripods

A tripod may prove to be your most important camera accessory.

Shutter speeds: pages 57–60

A **tripod** is an adjustable three-legged stand used primarily to hold a camera steady. Every photographer should own a tripod. It allows you to make pictures with a maximum amount of sharpness, especially when photographing at low shutter speeds—slower than 1/30 or 1/60, the slowest speeds at which most photographers can steadily handhold a camera. Even at faster shutter speeds, you can generally steady the camera better with a tripod than without.

Parts of a Tripod

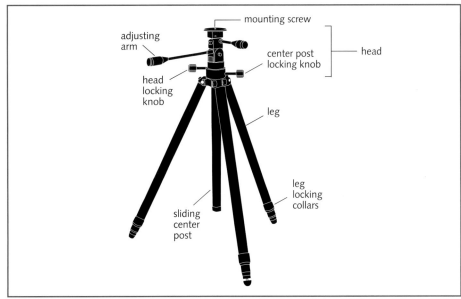

Holding the camera steady: page 66

Because it holds the camera in position, a tripod also helps retain precise composition. When you handhold a camera, it's more likely to move than when it's steadied on a tripod—and any movement, no matter how slight, can throw off the exact framing of your picture.

Most tripods are made of metal, carbon fiber, or graphite, though some are made of wood. The top of the tripod has a screw that fits into a threaded hole located in the bottom of the camera body. Once the camera is secure on the tripod, you are ready to compose and take your picture.

A tripod is especially useful when you are magnifying a subject in close-up photography, for example, or using a long telephoto or telephoto zoom lens. When an image is magnified, even the smallest amount of camera movement may appear exaggerated. You also need a tripod when you use larger, bulkier cameras, such as many medium-format and almost all large-format cameras. These types of cameras are either too unwieldy to handhold, or, especially with large-format cameras, always require the tripod to maintain precise framing and focus.

You may find working with a tripod takes longer, which makes it undesirable for spontaneous and candid pictures. Furthermore, it may attract unwanted attention to the photographer.

Tripods are available in many different sizes and models, all of which have adjustments for lifting, turning, and tilting the camera. There are two main parts—the **legs** and the **head,** which is the part that attaches to the camera. The legs and head come as a package on most tripods, but on others they are sold separately. The most common type of head is the **pan/tilt head,** which rotates on an axis for panning, plus allows you to adjust the camera using one lever for tilting from side to side and a second lever for tilting backward and forward.

Tripods usually work best for still subjects, not candids.

The most important consideration when buying a tripod is that it is sturdy enough to hold the camera steady. A small, inexpensive tripod is adequate to hold most 35mm cameras, but you will need a heavier model for larger cameras. Although it provides more stability, a heavier tripod is less convenient to carry around and set up—and is almost always more expensive.

A tripod is most stable with its legs spread wide apart. First extend the legs and then the center post, the pole the camera sits on; when setting up, don't raise the camera any higher than you need to. It's best to position one leg facing the same direction as the lens; this helps prevent the camera from falling forward and gives you enough space to stand comfortably between the other two legs as you work.

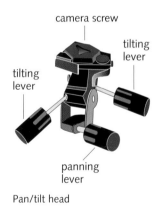

camera screw

tilting lever

tilting lever

panning lever

Pan/tilt head

Once you're ready to photograph, wait a few seconds after making adjustments before taking a picture to make sure the tripod is perfectly still. Any ground vibration, even trucks rumbling by, can cause the tripod and the camera to shake.

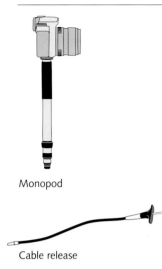

Monopod

Cable release

For photographers who need to steady the camera but maintain the ability to work fast, there are even one-leg devices called **monopods**. They help steady the camera when you are using a slow shutter speed. Because they only have one leg, you still have to hold the camera in your hands for support; but they are helpful for certain situations, such as to add a little extra stability when a tripod is not practical or to help balance extremely bulky telephoto lenses, such as those used by many sports or wildlife photographers.

Whenever possible, use a **cable release** with a camera on a tripod. A cable release is a flexible tube or wire that allows you to take pictures with gentle and even pressure without ever touching the shutter button, an action that might cause the camera to move slightly. A cable release is particularly useful with slow shutter speeds, when camera movement is most likely to occur.

There are two types of cable releases in common use: mechanical and electronic. A mechanical cable release is typically a rubber or cloth-covered tube with a wire inside that attaches to the camera's shutter; this type nearly always attaches by screwing the end into a threaded hole on the shutter release button, although some models connect on the lens or camera body. Note that cheap mechanical models can jam easily, so you may even want to carry a backup cable release. Electronic cable releases attach in different places on the camera body, depending on the model. They are more expensive than mechanical releases, but are generally more reliable. However, you will need one that is specifically designed for your camera.

Filters

Glass filters

Plastic filters and holder

Camera **filters** attach directly to the front of your lens and have a variety of purposes. Many photographers use a filter simply to protect the front of their lenses from scratching or other damage. You also can use filters to modify exposure or the quality of the light entering the camera in order to control contrast, tonality, glare, and reflection, or to produce a special visual effect.

The most commonly used filters are made of glass and are mounted inside a threaded rim that allows you to screw the filter onto the front of the lens. Less common are gelatin and optical-quality plastic filters that fit into a special holder that generally attaches to the front of the lens.

Glass filters are sized in millimeters according to their diameter. This size must correspond with the diameter of the front of the lens. Common glass filter sizes include 49mm, 52mm, 55mm, 58mm, 62mm, 67mm, and 72mm. But be careful not to confuse this measurement with the focal length of the lens. A 55mm filter, for example, may fit onto a 50mm lens—or onto a 35mm, 85mm, or many other focal-length lenses.

Check the diameter of the front of your lens before purchasing a filter. The size is often printed on the front of the lens, but you can always find it in your

Glass Filters

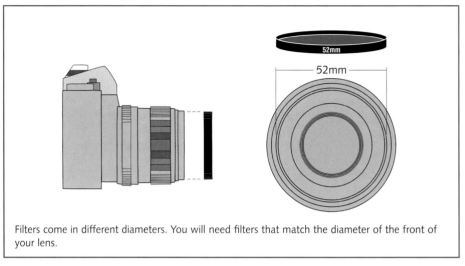

Filters come in different diameters. You will need filters that match the diameter of the front of your lens.

lens instruction book or by bringing the lens to your camera store. Ideally, all of your lenses (if you have more than one) will take the same filter size, so you will only have to buy one set of filters. However, in practice, some lenses have a larger or smaller front diameter than others; if you do own several different lenses, you may have to buy more than one set of filters.

There are times when you might want to **stack** (combine) filters, but be careful. Stacking glass filters can lead to reduced image quality, possibly less sharpness, vignetting on the image's edges, or other problems.

Filter Types

There are several filters made specifically for photographing in black-and-white. Most are used to affect the rendition of skies or to adjust subject contrast within the image, while some have more specialized uses.

Lens-protecting filters. Lens-protecting filters (clear, UV, and skylight) are probably the most common filters in use. The front of your lens is highly vulnerable to physical damage from dirt, dust, fingerprints, moisture, and other elements. To minimize damage, many photographers keep a clear filter on the front of all their lenses at all times, figuring that it's better to scratch or damage an inexpensive filter than a costly lens. You can clean dirty filters the same way you clean lenses: with clean, soft, lintless tissues or cloth and lens cleaning solution, if necessary.

The filters most commonly used for this purpose are a UV and a skylight. Neither has an appreciable effect on film exposure or the way the picture looks, although a UV filter may render hazy subjects a tiny bit clearer.

Colored filters. Colored filters change the black-and-white appearance of colors in the original scene, often increasing image contrast. In practice, a filter lightens its own color and similar colors in the final print, and darkens opposite colors. Most filters are available in a variety of densities—light, medium, and dark. The denser the filter, the more pronounced the effect.

Colored filters lighten their own color in the final print and darken opposite colors.

Filters let light of their own color through and partially block light from opposite colors. Here, a red filter lets much more red light pass than blue or green light.

Filters work this way because they allow more light of their own color to pass through to the film than light of opposite colors. Therefore, those parts of the subject that are the same or similar color as the filter are rendered denser (darker) on the negative and lighter on the print. For example, a red filter allows more light through to the film reflected from a red car than from its green background, which means the car renders denser on the negative and lighter when printed than if no filter had been used.

Light that is opposite in color from the filter is partially blocked before traveling through the lens, so those parts of the subject render less dense, or lighter, on the negative and darker on the print. For example, the same red filter blocks light from a blue sky, making the sky lighter on the negative and darker on the subsequent print.

You can use colored filters to darken or lighten many different parts of a photograph, but they are most commonly used in photographing blue skies and water. To darken blues, place a yellow, green, orange, or red filter over the lens. All these colors partially block blue light to different degrees, thus rendering skies darker in the print.

By darkening sky tones, these filters also emphasize cloud formations. Without a filter, clouds may barely show up because the sky may reproduce lighter than it appears to the naked eye. By darkening the sky, the filter makes the clouds more visible and may even exaggerate them, but only when the sky is blue. Gray and heavily overcast skies will not be appreciably affected.

Certain colors that are clearly different in real life may appear as similar shades of gray when captured on black-and-white film. To produce more contrast between gray subjects, use colored filters to lighten or darken particular colors. For example, if your subject is wearing blue jeans and a red T-shirt, both the jeans and shirt may reflect the same amount of light, despite being very different colors. Thus both will be rendered as equal densities on the negative and print as the same gray tone. Colored filters can differentiate these tones, increasing contrast between red and blue.

By placing a red filter on the lens, you will let more red light through to the film, which will render the T-shirt denser in the negative and lighter in the print

Filters for Blue Skies

No Filter

Yellow Filter

Red Filter

Colored filters darken blue skies to make white clouds stand out. Just how dark depends on the color of the filter. Yellow produces a moderate darkening of the sky and red produces a more dramatic darkening.

Filters for Contrast

No Filter

Red Filter

Blue Filter

Colored filters create contrast in subject colors that render as the same gray tone in black-and-white. They do so by lightening similar colors and darkening opposite colors. Here strawberries and blueberries look similar when photographed without a filter. Using a red filter increases contrast by lightening the strawberries and darkening the blueberries. Using a blue filter has the opposite effect.

than the blue jeans. The filter also will partially block blue light, rendering the jeans less dense in the negative and darker when printed. Using a blue filter in this situation will produce the opposite effect. Either method will increase contrast, making the color difference between the jeans and T-shirt clearer.

Following is a chart that illustrates the effect of various filters on a black-and-white print:

Filter Color	Similar Colors Lightened	Opposite Colors Darkened	Uses
yellow	yellow, orange	blue	Use when shooting landscapes—darkens skies
green	green	red, blue, purple	Creates a bit more dramatic and darker sky; lightens foliage
orange	orange, red	blue, green	Adds more contrast than yellow or green; darkens skies more
red	red, orange	blue, green	Creates most contrast, darkens skies most; not recommended for portraits

Polarizing filters reduce glare and reflection and darken blue skies and water.

Polarizing filters. A **polarizing filter** can reduce subject glare or reflection from smooth surfaces, such as glass, plastic, and water. The filter fits on the front of the camera lens like any other filter but you rotate it until you see the glare or reflection reduced or eliminated. You also can use a polarizing filter to darken blue skies and water—an effect that becomes more dramatic when you stack a red filter with a polarizing filter.

Polarizing Filters

No Filter Polarizing Filter

Polarizing filters minimize subject glare or reflection. Rotating the front of the filter varies the polarizing effect, as does changing your angle to the subject.

Keith Carter, *Sleeping Swan, 1995*

Unlike some photographers, Carter doesn't have a preferred subject matter, such as portraits or landscapes. Rather, almost anything he sees is raw material for his mysterious and beautiful pictures. Here, he added a red filter to his lens to darken the green grass, thus increasing the overall image contrast. In so doing, he accentuated the lyrical form of the swan. © Keith Carter; courtesy of Howard Greenberg Gallery, New York, NY.

Polarizing filters do not have much effect when you point them directly at the surface of your subject. If you are trying to eliminate reflection from a store window, for example, don't point your camera directly at the window; stand to the side and shoot obliquely. A 30–35-degree angle maximizes the polarizing effect.

There are two types of polarizing filters; both accomplish the same results. A **linear polarizer** is compatible with many through-the-lens (TTL) meters, allowing accurate automatic exposure. However, linear polarizers adversely affect the metering systems and autofocus function of some cameras. For these models, you will need a **circular polarizer.** Your camera's instruction manual or your camera store can tell you which type you need for your camera model.

Neutral-density filters. A **neutral-density (ND) filter** uniformly blocks some of the light that reaches the film, without affecting the tones or contrast of the final print. You may want to use an ND filter when there is too much light in a scene for a desired effect or for your chosen film speed. Because ND filters cut the light reaching the film, you must open the lens aperture or slow the shutter speed when using them. This decreases depth of field and/or increases blurring due to subject movement, both of which can be desirable effects for certain types of pictures. ND filters are rated in third stops; an ND.1 filter cuts exposure by 1/3 stop, an ND.3 cuts exposure by 1 stop, an ND.6 cuts it by 2 stops, and so forth.

Special effects filters. Filters also are available for a wide variety of special effects. One example previously discussed is the various filters that maximize the eerie effect and contrast of **infrared films.**

A **diffusion filter** reduces the overall sharpness of the image, while lowering contrast and decreasing the sense of detail. This ordinarily makes subjects appear more dreamy and romantic, and with portrait subjects helps hide skin blemishes and wrinkles.

A **fog filter** is a type of diffusion filter that simulates the effects of a foggy day, producing a misty glow from highlight areas of the subject—as well as lowering contrast and sharpness.

A **graduated filter** selectively reduces exposure in portions of an image. Half of the filter is clear and the other half is either colored and/or neutral density, with the two halves gradually blending together. There are many types of graduated filters, and the abruptness of the blending varies with the type used. Among their other effects, graduated filters darken skies that would otherwise print too light without affecting the rest of the scene, making them useful for landscape photography.

A **multi-image filter** has contoured prismatic surfaces that create repeating images. The shape and amount of repetition depends on the type of multi-image filter you use.

An ND filter reduces exposure of the film with no appreciable visual effect.

See bw-photography.net for more on neutral density filters.

Infrared film and filters: pages 209–11

A **star filter** produces streaks of light that appear to emanate from bright highlights within the image. The effects assume various shapes and levels of exaggeration, depending on the type of star filter you use.

Exposure and Filters

Except for lens-protecting filters, most filters block some of the light that would otherwise pass through the lens and reach the film. Thus, when using most filters you will need to add exposure to compensate. This means setting a larger lens aperture opening and/or a slower shutter speed.

Fortunately, with most modern cameras, TTL meters automatically compensate for such light reduction because they measure light after it has traveled through the filter. If you use a camera without TTL metering or a handheld meter, however, you will have to do the calculations manually, using a **filter factor.**

Filter factors may be indicated on the rim of glass filters or in package instructions. Otherwise you will have to contact the filter manufacturer or refer to charts such as the one below. The manufacturers' information will be most reliable because similar filters from different companies may have slightly different factors.

A filter factor is expressed as a number followed by X, such as 2X. You will need to increase exposure by one stop for every factor of 2. For example, if your yellow filter has a 2X factor, you will need to give your film one stop more exposure, so if the meter suggests f/8 at 1/250, use f/5.6 at 1/250, f/8 at 1/125, or the equivalent instead; with a green filter (4X), you will need to give your film two stops more exposure—f/4 at 1/250, f/8 at 1/60, or the equivalent.

Filter Factor	Exposure Adjustment Required
1.2X	+1/3 stop
1.5X	+2/3 stop
2X	+1 stop
4X	+2 stops
8X	+3 stops
16X	+4 stops

Here are typical filter factors for common black-and-white filters. Note that they can vary widely with the density of the color and the manufacturer.

Filter	Filter Factor
UV, skylight	none
yellow	2X
green	4X
orange	2.5X
red	8X
polarizing	2.5X

Cameras with TTL meters adjust exposure automatically to compensate for filters.

Close-up Equipment

For close-up photography, you will need a macro lens, supplementary close-up lens, extension tube, or extension bellows.

See bw-photography.net for more on close-up photography.

50mm

Macro lens

Supplementary close-up lenses

Most of the time, your camera will allow you to focus as close to your subject as you'd like. But if you want to get even closer, you may need additional equipment. Specific cameras and lenses vary, but lenses made for 35mm SLRs usually allow you to focus no closer than 12" to 15" away, and often farther with longer focal lengths. You can usually focus quite close up with a view camera, but you can't easily focus very close with snapshot, rangefinder, and twin-lens-reflex models—all cameras that don't offer viewing and focusing through a single lens.

If you want to focus very close up with your 35mm SLR, you will probably need a macro lens, supplementary close-up lens, extension tube, or extension bellows—all of which are described below. Regardless of your equipment, use a tripod to hold the camera steady whenever possible, because any camera shake or vibration will show more than if the subject were shot from a greater distance.

Keep in mind that close-up photographs have an inherently shallow depth of field. Set the smallest possible lens aperture to maximize depth of field. You might consider using a fast film and/or a slow shutter speed (definitely with the camera on a tripod), both of which allow you to close down your lens aperture for increased depth of field.

Macro lens. A **macro lens** looks and acts much like any other lens, except it allows you to focus more closely. It's arguably the best close-up option for a number of reasons, including its ability to focus at any distance—from inches away to infinity. With the other close-up options, you can focus only at limited close ranges.

Some so-called macro lenses allow you to focus closer than a normal lens, but with a true macro lens you can usually focus as close as an inch or two away from your subject. Expect to pay more for a macro lens. They are available in a variety of focal lengths, including zoom models, but most true macros are fixed-focal-length lenses—usually normal (50–60mm) and moderate telephoto (90–105mm).

Supplementary close-up lenses. A supplementary **close-up lens** is a clear, magnifying lens, placed in front of the camera lens, like a filter, that allows you to focus close to your subject. Close-up lenses are rated according to their close focusing capability. A +1 close-up lens allows you to focus up close; a +2 allows you to focus even closer; and so forth. Choices typically range from +1 to +5.

When using a close-up lens, you can focus only at a specified range of distances—not closer and not farther away. (That range should be noted in the instructions packaged with the close-up lens.) This is a significant difference between a close-up lens and a macro lens, which you can focus at any distance.

Supplementary close-up lenses are the least expensive close-up option. They are typically sold individually and in sets of three, sized according to the diameter of the lens (such as 52mm, 55mm, and so forth)—the same as filters.

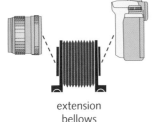

extension
tube

Extension tube. An **extension tube** is literally a tube-shaped accessory that fits between the lens and the camera body, increasing the distance between lens and film to allow closer focusing. To use an extension tube, attach one end to your camera body and the other end to the back of your lens. Place the camera, tube, and lens on a tripod, then focus on the subject. If you can't get the subject in focus, use a different extension tube. As with close-up lenses, you can only focus at the close distances specified in the instruction material that comes with the tubes, not closer and not farther away.

Extension bellows. An extension bellows is an accordion-like cardboard or cloth tube mounted on an adjustable rail. Like an extension tube, it fits between the lens and the camera body, increasing the distance between lens and film for closer focus.

extension
bellows

To use an extension bellows, attach one end to your camera body and the other end to your lens. Place the camera, bellows, and lens on a tripod; the tripod typically attaches to a hole in the bottom of the bellows rail. Then focus on the subject, using a knob on the bellows. You can only focus at close distances with a bellows—not further away.

Miscellaneous Accessories

There are many other useful accessories available for your camera. You are already familiar with some of the most common ones, such as extra lenses, handheld light meters, and flash and other lighting equipment. Following are a few more.

Camera bag

Cases and bags. There is a wide variety of cases and bags for protecting and carrying camera equipment. Fitted cases that come with many cameras offer excellent protection, but often have to be removed in order to load and unload film, which can be annoying if you use several rolls of film in a single session.

One good substitute for a fitted case is a **camera wrap**, a soft, padded cloth used to cover a camera, accessory lens, flash, or any other piece of equipment. The cloth has Velcro to keep it tightly attached, and wraps and unwraps easily.

You also should have a camera bag to hold your camera (with or without a fitted case or wrap), lenses, film, and other accessories. There are many models available, varying in style and rigidity. The best camera bags should be just big enough to carry the equipment you typically need—or maybe a little bigger for when you add equipment in the future. Buy a sturdy model that's well padded,

but consider weight as well. Carrying equipment and a bag can be tiring, especially if you must walk or climb a lot to take your pictures.

Lens- and camera-cleaning materials. There are a number of products made for cleaning your lens, camera, and other equipment. Often, compressed (canned) air will do the trick; use it to blow off dust from the front of your camera lens and various parts of the camera. Take care if you are using compressed air inside the camera, however, as the air pressure can damage delicate mechanisms, such as an SLR's reflex mirror and focal-plane shutter. Note that if compressed air is tilted or shaken it can emit a chemical propellant rather than air.

Compressed air

There are various other cleaning products and blowers, including one with a rubber bulb attached to a brush. In general, any wide brush or antistatic cloth will work well to remove loose dirt or dust from lenses and cameras, but be careful to keep the brush or cloth clean. Storing them in a plastic bag between uses is probably the simplest way to do this.

Lens-cleaning solution and soft disposable tissues also are commonly used to remove dirt, grime, grease and fingerprints from the front and rear lens glass. Use solution sparingly; apply it to the tissue, not the lens, and rub gently to avoid scratching the lens surface. It's a good idea to blow off potentially abrasive particles before wiping. Lens-cleaning cloths made of microfibers, which don't require solution of any kind, are a common alternative. Since they do not use a liquid, it's even more important to make the lens surface free from abrasive grit before wiping.

Rubber blower

Be especially careful if you are carrying or storing camera equipment in dusty, dirty, sandy, or wet conditions, such as at the beach. Keeping your equipment sealed in a sturdy plastic bag will help keep out the elements.

Diopter lenses. A **diopter** is a vision-correcting lens, available for many camera models, that attaches to your viewfinder eyepiece to let you compose and focus the picture without wearing eyeglasses. You may have trouble composing accurately with glasses; for most accuracy, you need to position your viewing eye right up to the viewfinder, and wearing glasses will keep you from getting that close.

Diopters are rated like reading glasses, such as +1, +2, +3, and −1, −2, −3; in-between prescriptions also are available. Some camera models have diopters with a range of correction built in; you adjust a dial next to the viewfinder until you can see your subject more clearly.

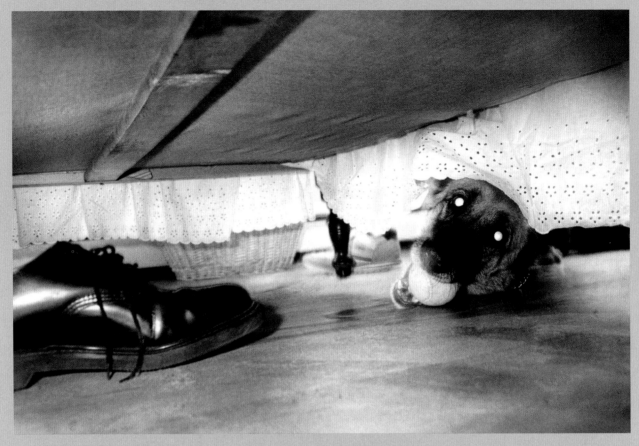

Karl Baden, *Charlotte,* 1992

Baden works hard to make his photographs reflect his humorous worldview, even if it means crawling under his bed. To get the shot in this low-light situation, Baden used an on-camera flash to surprise his dog with a quick burst of light and hard-edged, even illumination. © *Karl Baden; courtesy of Robert Mann Gallery, New York, NY, and Howard Yezerski, Boston, MA.*

8 Lighting

Light is the most fundamental component of a photograph. It not only causes the image to form, but its visual quality goes a long way toward establishing the look and feel of the picture. Learning to see and work with the subject lighting is a critical skill for making effective photographs.

Characteristics of Light

Some of light's most important characteristics include its strength, quality, and direction.

Strength. Some light sources are inherently stronger than others. For example, a midday sun is brighter than an evening sun; stadium lights are stronger than candlelight. The strength of light has important visual consequences. Bright sunshine provides plenty of light to reveal detail and information about your subject; a dimly lit nightclub scene, on the other hand, may have mostly shadows with a few bright patches, contributing to a mysterious, romantic, or even edgy mood.

The amount of light in a scene also has important technical consequences when you are taking pictures. For instance, bright light may allow you to set a faster shutter speed, whereas low light may require that you use a high-speed film.

Shutter speeds: pages 57–60
Film speeds: pages 23–24

Quality. The type of light falling on your subject also has a major impact on the look and mood of your photograph. Light is often characterized as either hard or soft. **Hard light** travels uninterrupted from the source to the subject, as happens with bright sunshine or a spotlight, and produces sharp and relatively high-contrast photographs. By creating bright highlights and deep shadows, hard light also emphasizes the textural and three-dimensional qualities of a subject. For example, in late afternoon, sunlight on a portrait subject's face may be bright on one side and dark on the other, with all the features defined by light and shade.

Soft light is diffused, or interrupted, as it travels from the source to the subject. It produces less contrast and a relatively shadowless effect, such as when

Light Quality

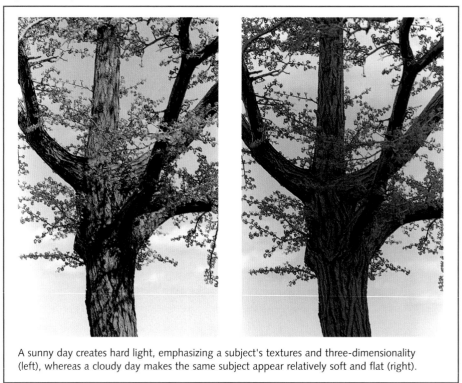

A sunny day creates hard light, emphasizing a subject's textures and three-dimensionality (left), whereas a cloudy day makes the same subject appear relatively soft and flat (right).

sunlight is scattered by clouds on an overcast day. In soft light, a portrait subject's face is more evenly illuminated and only generally defined, with softer edges and little difference between both sides of the face.

Direction. The direction of the light relative to the subject is yet another important factor to consider. Depending on the angle at which it strikes, light can flatten your subject's appearance, enhance texture, or create a dramatic effect.

Most of the time, you will want light to strike your subject more or less from the front. Frontal lighting illuminates what's important in the scene and often reveals the most information about it. However, different types of frontal lighting produce different effects. Lighting that strikes the subject directly flattens its appearance and obscures its textural qualities. Light striking the front at an angle can emphasize a subject's three-dimensional qualities and texture. On the other hand, **backlighting**, when light strikes the subject from behind, can create an interesting, silhouetted appearance.

You must consider all of these characteristics of light relative to your subject when taking a picture. While it may sound complicated, by paying more care-

Backlight

If the primary light comes from behind, the subject is often in shadow. This silhouetted effect can be effective for some photographs, but usually you want light coming from the front or side to illuminate subject detail.

ful attention to light, you will soon develop a more intuitive sense of what works best for a particular scene.

These lighting characteristics apply whether you are photographing outdoors or indoors. Outdoors, you have limited control over the light, short of moving yourself or your subject to change position relative to the light or moving from direct sunlight into the shade. Or, you can wait for the light to change, if you're patient enough, or come back to photograph at another time or on another day. For instance, if you are photographing a house and it's backlit in the morning, come back in the afternoon and it may be lit from the front or side. If it's cloudy, you can return and make your picture on a sunny day.

Of course, you may not be able to exercise any of these controls in natural light. If you must take a photograph in a specific place at a specific time, you have to make do with the light you find. That's partly why some photographers prefer to work with artificial light; they can exercise much more control over the look of the subject and get the picture they want, while circumventing the vagaries of natural light.

Artificial light is a general term that includes common household lamps or other interior illumination, as well as certain lights made especially for photography. The most common is on-camera flash, but a lot of photographers use various types of studio lighting equipment to create their pictures.

On-camera flash: pages 120–26

Studio Light

Many professional photographers work entirely with artificial light in a **studio,** usually an open room used for controlled picture taking. One of the biggest advantages of working in a studio is it allows you to set up the lighting exactly as you want it.

Good studio photography requires a high degree of craft and (often) expensive, specialized equipment. However, not all studio work takes place in a dedicated room. Often, photographers employ studio lighting and techniques when working on location, for subjects ranging from architecture to portraiture.

Many photographers also combine natural and artificial light. If you understand some simple rules about lighting and have a basic grip of some of the available tools, you can gain a measure of control over the final look of your pictures that you can't get when working only with natural light. And you might even learn more about the general principles and effects of lighting, which can serve you with whatever light you are using.

Keep in mind that working with artificial light can limit your ability to work spontaneously. It's difficult to photograph as freely or candidly when you have to set up lights and other equipment. For instance, your subjects may act self-conscious or mug for the camera when they know they are being photographed. Therefore, artificial lighting often works best for formal subjects, such as portraits, interiors, and still lifes.

Types of lights. There are two types of lights used in studios: hot lights and strobe lights. **Hot lights** are named for the heat they generate when turned on. They provide continuous illumination, like household light bulbs. In fact, the least expensive type, called **photofloods** (or simply "floods"), looks like an oversized light bulb. But at 250 or 500 watts or more it is much more powerful than an ordinary bulb. High-end professional hot lights also are available for stronger light and more consistent illumination, but they are more expensive and fit into a more elaborate housing.

A basic hot light consists of a bulb set inside a reflective housing that directs the light forward. Advanced models attach to a light stand that holds them in position, but you can buy a simple reflector with a clamp that attaches to the back of a chair, a countertop, or other such surface to hold the light steady. Such clamp lights are affordable and found in many camera stores, hardware stores, and stores selling household goods. They are rated according to the maximum power bulb (in watts) they will take; for safety's sake, make sure your bulb does not exceed this rating. Clamp lights from camera stores should take bright photofloods, but you will probably be limited to less powerful household bulbs with units from nonphotographic suppliers.

Photoflood with reflector on light stand

Clamp light

David Mussina, *View of Grand Canyon Looking West, Grand Canyon National Park, 1992*

Mussina's photographs portray the American landscape as a theme park organized for tourists, rather than pristine wilderness. To contrast the majesty of the Grand Canyon with this cluttered gift shop, Mussina used on-camera flash to illuminate the dark interior so the indoors is as brightly lit as the window view. © David Mussina; courtesy of the artist.

Positioning Light

Probably your most important lighting decision is where to position the lights in relation to your subject. This will have a critical impact on your picture, regardless of whether you are using powerful studio strobes or 60-watt household bulbs—or on-camera flash or even natural light. In fact, most of the time good artificial light should closely simulate natural light.

Key light. The **key light**, or **main light**, is the light that provides most of the illumination and sets the overall tone when lighting a scene. Because it's the strongest light, it should be positioned first. The most common position for a key light is where it can shine down on the subject from the front and the side, at approximately a three-quarter angle. If the key light aims at your subject head-on, it will create a flat,

two-dimensional effect, such as what occurs with on-camera flash. Placing the key light at an angle to the subject will brighten one side and create shadows on the other, producing a more three-dimensional and usually more pleasing effect.

If you position the key light so it illuminates the subject from one side, you will get a more dramatic, high-contrast effect. Called **sidelighting**, this placement also emphasizes textural qualities of the subject. Some photographers also use **backlighting**, where the key is positioned behind the subject, creating a silhouetted effect. Experiment with your key light's placement—try high and low, front and back, and to the side—to see how it changes the visual appearance of your subject, and, if necessary, add other lights or reflecting surfaces to produce the desired effect.

Front, direct

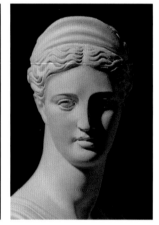

45-degree

Side or 90-degree

Side with reflector fill

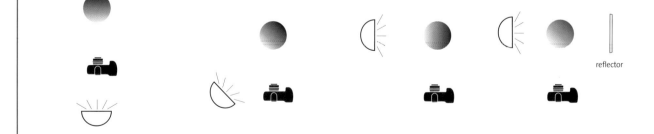

reflector

Fill light. Sometimes a single key light is all the light you need, but if the shadows it creates appear too dark, add an additional **fill light** (or more than one) to provide balance. A fill is usually an additional light source positioned opposite the key light. It is weaker than the key light in power, so it complements rather than competes.

Sometimes you can produce an adequate fill with a simple reflector. Commercially made reflectors are available, but a piece of white poster board or foam core also may work to reflect light back toward the subject. Place the reflector opposite the key light, leaned against a chair, wall, or other surface—or ask someone to hold it for you.

Other positions. The main and fill lights are most important, but there are times when you may want to add additional lights. For example, if the area behind the subject is too dark, brighten it with a separate **background light.** You also can use a separate light unit to brighten small, specific areas of your subject; such lights are called **accent lights.**

As you position your lights, look carefully at their effect. With hot lights, you can see the subject and build the light. But don't make the mistake of lighting too much. Most of the time a minimal setup is all you need to create the look you want. The accompanying illustrations show how much you can accomplish with a single key light positioned and used in a variety of ways.

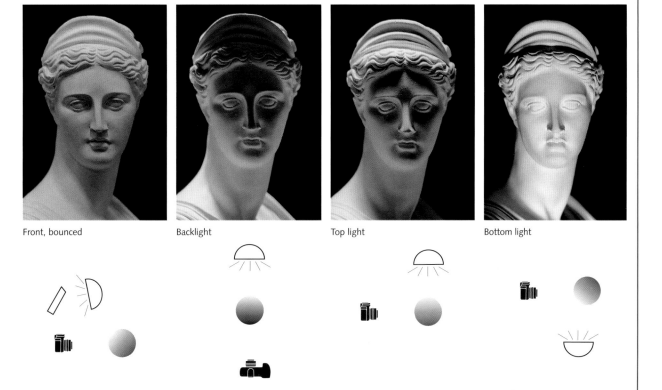

Front, bounced Backlight Top light Bottom light

Studio strobe

Hot lights are useful, in large part because of their constant illumination. Once you turn them on, what you see is pretty much what you get. However, their high heat makes them dangerous to handle and also potentially uncomfortable for the subject and the photographer.

To avoid such problems, professional photographers often use **strobe** lights. Another name for electronic flash, strobes provide all the light necessary to illuminate a scene in a fraction of a second. You probably are familiar with on-camera strobes, which are lightweight, portable, and offer a high degree of automation. Studio strobes are much more powerful and often have a separate battery pack unit to help provide that power. One disadvantage of strobes is that their brief burst of light means you can't see their effect when they go off. Good studio strobes, however, have a built-in modeling light, a relatively low-powered lamp for previewing the lighting.

Electronic Flash

Built-in flash

Hot shoe

On-camera flash

The most commonly used type of artificial lighting is **electronic flash.** Most of the time, flash is used in low-light situations when you otherwise don't have enough light to get a good exposure. Other uses of flash include freezing the motion of a subject and lowering contrast, such as might occur on a bright, sunny day, by lightening dark shadow areas.

Electronic flash is linked to your camera's shutter. When you press the shutter button, a gas-filled tube inside the flash emits a powerful burst of light for a very short time, often 1/5000 or even shorter. A reflector behind the tube helps direct the light forward toward the subject.

Many cameras have an electronic flash built in, but most cameras need a separate unit. Called **on-camera flash,** these units slide into a bracket, called a **shoe,** located on top of the camera. A shoe often provides an electrical connection to the shutter and is thus called a **hot shoe.** But if your shoe is not hot, or if you use the flash off-camera, you need to use a cable, sometimes called a **pc** or **synch** (for synchronization) cord to connect flash and shutter.

Flash types. There are many flash models available, but almost all can be generally classified as follows: TTL autoflash, non-TTL autoflash, and manual.

TTL (through-the-lens) **autoflash** units are part of a dedicated camera system and measure light as it's about to strike the film. They are designed to work seamlessly with a camera's meter to provide a high degree of automation, precise exposure, and a variety of advanced options.

Non-TTL autoflash units offer some automated features, but their light-measuring sensor is on the flash unit, rather than inside the camera. This means non-TTL autoflash is not fully integrated with the camera's exposure system, so its operation is not as seamless or precise as TTL flash units.

Ernest Withers, *Tina Turner and Ikette, Paradise Club, Memphis,* 1960s

*Withers's photographs are a precious record of the Memphis music scene in the 1950s
and 1960s. In dark clubs, Withers used flash not only to provide illumination, but also to
freeze motion with the extremely brief burst of light. Without a flash, Withers would have
needed a shutter speed too slow to stop the action onstage. © Ernest Withers; courtesy of
Panopticon Gallery, Waltham, MA.*

Manual flash models are available, and there is a manual mode option on most TTL and non-TTL autoflashes. With these units you have to calculate exposure and settings yourself.

Flash synch. When a flash burst goes off, the shutter must open to completely expose the film; in other words, it must synchronize ("synch") with the flash. If it doesn't synch, the shutter may only be partially open when the flash fires, resulting in a negative that is only partly exposed.

Cameras with a leaf shutter, which includes most non-SLR (single-lens-reflex) models, synch with flash at any shutter speed. But because they use a focal-plane shutter, SLR cameras are more limited. With most SLRs, the maximum **synch speed** is 1/60 or 1/125, though some models synch at other shutter speeds, such as 1/250. You can set a slower shutter speed, such as 1/15 or 1/30, for flash synch, but you cannot set a faster speed, such as 1/1000.

In many camera models the maximum synch speed is highlighted in color or indicated by a flash symbol on the shutter dial or in the camera's LCD display.

You don't really have to worry about the synch speed if you are using a TTL flash on an automatic setting, because the camera sets the shutter speed for you. But with a non-TTL autoflash or when using a manual flash or manual mode, double-check to make sure your shutter speed is set correctly before photographing.

On many cameras, the shutter won't sync with the flash when the shutter is set at too fast a speed. Here, the shutter speed was 1/500, causing only half the film to be fully exposed.

Exposing with Flash

Exposing film with flash is somewhat different than exposing without flash. With flash, you must consider the following factors: flash output, flash-to-subject distance, lens aperture, and film speed.

Flash output includes the power of the flash (the strength of the light it provides), as well as the duration of the flash (how long the burst of light lasts). TTL and non-TTL autoflash units vary their flash output to accommodate different lighting and exposure situations, whereas manual flash provides a constant burst of light every time it goes off.

Flash-to-subject distance has to do with how far that flash is from the subject. When it's close to your subject, it will have a stronger effect than when it's farther away. This is because flash light diminishes in strength as it travels over distance, just like any light source.

A **lens aperture** set at a large f-stop provides more film exposure than a lens aperture set at a small f-stop. So, if the flash output is strong or the flash is close to the subject, you will need a smaller f-stop than when the output is weak and/or the flash is farther away.

The faster the **film speed**, the less flash output you need for good exposure, because fast films need less light than slow films. Faster films also allow you to

use flash at greater distances (when the output may be weaker) and with a smaller lens aperture (which lets in less light).

Film speed: pages 23–24

Your flash must be set for the film speed you are using in order to provide good exposure. With a TTL autoflash, the ISO is set automatically by the camera and flash. With non-TTL and manual modes or flash units, you usually have to set the ISO yourself, often by turning a dial or pushing a button on the flash unit.

Using TTL autoflash. Automatic flash units combine all the above exposure factors when calculating exposure. TTL autoflash is the most integrated; the camera's meter works in conjunction with the flash to determine how much light the film needs for good exposure of a particular scene. The flash will provide more power when needed, such as when the subject is farther away, when the lens aperture is set at a small f-stop, and/or when you use a slow speed film; it will provide less power with closer subjects, larger lens apertures, and/or faster film.

If your TTL autoflash is built into the camera, simply set the camera on "P" (program). If you are using a separate on-camera TTL autoflash in its default (totally automatic) mode, set the camera on "P" and the flash on "TTL," and you are ready to take pictures without worrying about exposure.

Using non-TTL autoflash. Non-TTL autoflash has a light sensor located on the flash unit, not in the camera. It varies the flash output to produce good exposure of your subject, but not as automatically as TTL autoflash; first you have to prompt it with the help of a scale located on the flash. The scale helps you determine what lens aperture you can use when the flash is positioned at a specified range of distances from the subject. For instance, it might indicate f/8 when you are 6–9 feet away and f/4 when you are 12–18 feet away; the scale changes when you set different film speeds. Then you manually set the indicated f-stop on your lens, and the flash will automatically provide enough power for good exposure at that f-stop within the corresponding range of distances. If you or your subject changes position and moves closer or further away, you must consult the scale again.

With many non-TTL autoflash models, the scale offers more than one choice of distance range. You manually choose the one you want to work with, set the corresponding f-stop on your lens, and the flash provides the automatic exposure.

Using manual flash. In an autoflash's manual flash mode, or with a manual flash unit, the output is constant. The only exposure factors to consider are flash distance, lens aperture, and film speed. Since flash light diminishes with distance, you have to set a relatively large f-stop if the flash is far away from the subject and a relatively small f-stop if the flash is close.

To calculate flash exposure manually, you read a chart usually located on the flash unit or in the flash's instruction book. The chart will tell you what f-stop to use when the flash is a certain distance away with a particular film speed. For ISO 100 film, the chart might look something like this:

Flash-to-Subject Distance	Lens Aperture
32'	f/2.8
22'	f/4
16'	f/5.6
11'	f/8
8'	f/11
5.5'	f/16
4'	f/22

Thus, for a portrait of someone 4 feet away at a crowded party, set the f-stop at f/22; for a performer 20 or more feet away at a club, set the f-stop at f/4. Because of space limitations, the chart on the flash will not indicate all the possible choices at every film speed; you may have to interpolate. For instance, if the chart says use f/8 at 11 feet away with ISO 100 film, you should use f/16 with ISO 400 film, which is two stops faster than ISO 100.

Instead of using an exposure chart with manual flash, you can use the flash's **guide number**, a rating of its output at a specified film speed: The higher the guide number, the more powerful the flash. To determine the lens aperture needed for correct exposure, divide the guide number by the distance from the flash to the subject. For instance, if your flash has a guide number of 40 with ISO 100 film, and you are 10 feet from your subject, use f/4 (40 ÷ 10 = 4); if you are 20 feet from your subject, use f/2 (40 ÷ 20 = 2). The guide number of the same flash unit is twice as high with ISO 400 film (80), so use f/8 when your flash is 10 feet away (80 ÷ 10 = 8) and f/4 at 20 feet (80 ÷ 20 = 4) accordingly.

Modifying the Flash

On-camera flash produces a distinctive look—harsh, flat, and usually brighter in the foreground than in the background. This works well enough for many pictures, but if you want a subtler look, there are many techniques to modify and soften flash light.

Bounced/diffused flash. One reason on-camera flash looks the way it does is because it points directly at the front of the subject. For a softer, more diffuse light, you can bounce the light by aiming it where it will reflect off a surface, such as a ceiling or wall, before it strikes the subject. To do this, you need a white or light surface and a flash unit that can be adjusted to bounce light, such as those that tilt upward for bouncing off the ceiling.

You can bounce in a variety of ways if the flash is not attached to the camera. Take the unit off the camera and use a pc cord or cable to synch with the camera's shutter. You now have the freedom to move the flash in many directions and at various angles to the subject. Point the flash at the ceiling so the light bounces down to the subject, or aim it at a wall so it reflects obliquely to the subject.

There also are various accessory reflector units that attach to the flash unit to reflect light indirectly toward the subject or diffuse it somehow. One type consists of a reflector card that sits in the back of the flash head; the burst of light hits the card first and then bounces toward the subject. Another type consists of diffusing material that fits around the flash head; the diffusing material softens the flash light on its way to the subject, just as bouncing does.

When bouncing light, exposure depends on the distance the light travels—for instance, from flash to ceiling to subject—which is generally much farther than the direct flash-to-subject distance. You don't have to worry about this with TTL autoflash, which does all the calculations for you. With non-TTL autoflash, you need to work with a longer distance range on the flash's scale. And

Flash Position

On-camera: direct flash

On-camera: bounced flash

Off-camera: direct flash (45-degree angle)

Off-camera: direct flash, from side (90-degree angle)

Most photographers use an on-camera flash pointed directly at the subject, resulting in flat, harsh light. But on many cameras flash can be bounced or used off the camera to modify the light.

with manual flash, you have to measure or estimate the increased distance and do the calculations yourself. Whatever type of flash you use, you will probably have to use a larger f-stop and/or faster film speed when bouncing flash, because of the increased distance the light must travel.

Fill Flash. Even if you have a ceiling, wall, or other surface from which to bounce your flash, it may not soften the light as much as you'd like. Perhaps the best way to soften light is to use a technique called **fill flash**, which mixes flash with the existing light to lighten shadow areas, thus lowering the overall picture contrast. A typical fill-flash situation is a brightly lit portrait, usually in high-contrast outdoor light, which produces dark shadows on the subject's face; fill flash can lighten the shadows without affecting the rest of the picture.

TTL autoflash accomplishes fill flash automatically. Just set the fill flash mode on the unit, and the camera's meter and flash work together to mix flash and existing light for a seamless fill effect. If you have a non-TTL autoflash or use manual mode or a manual flash, fill flash requires more complicated calculations.

See **bw-photography.net** for more on fill flash.

Slowing your shutter speed provides a simple way to fill-in (brighten) indoor backgrounds that would otherwise go dark. Using your flash on manual, set the f-stop for the correct flash exposure—say, f/11. Then, set a shutter speed that is slower than the synch speed of your camera. Let's say your camera synchs at 1/60; set the shutter at 1/8 instead. The longer shutter speed lets in more light, thus brightening up the background without affecting the fore-ground (which gets its exposure mostly from the flash). Any shutter speed slower than 1/60 will brighten the background, but the slower the speed the greater the effect. Try shutter speeds of 1/8 to 1/15 for average indoor situations, but bracket, if you can, for best results. Use your camera on a tripod, if possible, or the slow shutter speed may cause camera shake and a partially blurred result; and, as always, be careful of moving subjects which also may create blur when you use a longer shutter speed.

Using Shutter Speed to Lighten the Background

Using a flash typically produces a brighter foreground than background (left). By using a slow shutter speed, for instance, 1/8 instead of 1/60 or 1/125, the existing light has a stronger influence, filling in the background (right).

Lisa Kessler, *Brian,* Newton, Mass., 1999

Simple lighting often produces the best results by emphasizing the subject over the technique. For this portrait from the series "Face of our Future," Kessler photographed Christian, Muslim, and Jewish teenagers in an Anti-Defamation League program. She lit the subject with one strobe aimed at the subject, positioned above and to the side of the camera, and a second strobe aimed at the background to brighten it. © Lisa Kessler; courtesy of the artist.

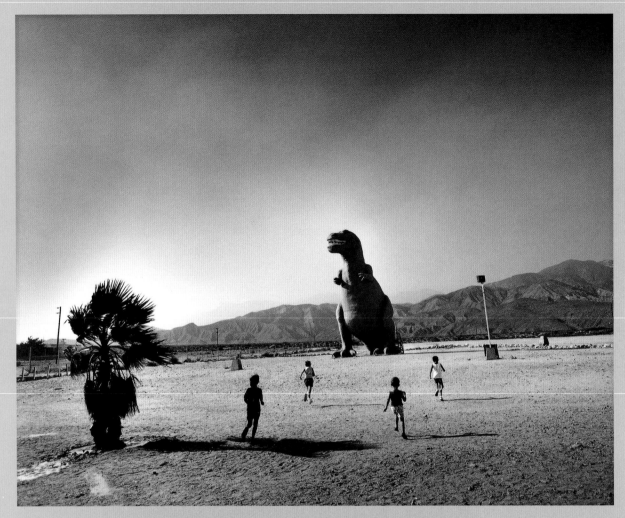

Jennifer Bishop, *Route 10, California,* 1990

Some of Bishop's best photographs depict quintessential childhood memories. She has to be in the right place at the right time to get the shot, but taking the picture is only part of her job. To preserve the moment forever, Bishop also has to take special care to correctly develop her film. © Jennifer Bishop; courtesy of the artist.

Latent image: page 25

Developing film is relatively straightforward, but there are variables that can affect your final results.

The Darkroom

See bw-photography.net for more on darkroom health problems.

Developing your film is a relatively straightforward and easy process. You treat the exposed film in a succession of chemical solutions to make the latent image visible and permanent. However, the logistics are a little more complicated. To begin with, film is light sensitive, so you will need a darkroom (literally a room with no light whatsoever) to load the film into a processing tank. This tank is designed to keep light out, but allows you to pour the developing solutions in and out of it until processing is complete.

Best results usually come from consistency and standardization. However, there are some variables that can either cause problems or improve the final results. Following is a discussion of the routine steps, as well as potential trouble spots and creative controls you can use.

A photographic **darkroom** is a lighttight room containing the equipment needed for developing film and/or making prints. In theory, you can use any room that can be made completely dark, even a bathroom or large closet. (You often can block window light with a black shade made of foam core, opaque plastic, or plywood.) You should always use a room with good ventilation—or one in which a ventilation system can be installed—because fumes from certain chemicals can irritate some individuals or potentially cause other health problems.

Furthermore, you will need tables or countertops to hold the developing and printing equipment. Running water is ideal, but not absolutely required; you can use pails or other containers to bring water into the darkroom and take used chemical solutions out of it, if necessary. Spaces that are not heavily used are best, such as a spare bedroom, bathroom, or a room in the basement or attic. This will allow you to keep the equipment ready for use; otherwise you will have to set up and take down the darkroom for each working session.

You should keep your darkroom as clean as possible. Spilled chemicals may cause contamination. They also may form dry residue that can be inhaled. So take special care to leave the darkroom spotless after each use, particularly if the darkroom is in your living space. Even well-cleaned areas may retain unpleasant stains or odors, so never use a kitchen or dining room for a darkroom. Also, avoid areas that children or pets can easily access.

A home darkroom is convenient because it's generally available when you need it, but most photographers find darkrooms outside the home more affordable, practical, and healthy. Look for a good, well-ventilated darkroom at a local school, camera club, or community center. There may even be a conveniently located school, art space, or business that rents darkroom time. It might even be worth enrolling in a class at your local art school, community college, or adult education program, just to secure darkroom access. Ask the staff at your local camera store if they know of any available darkroom space.

A darkroom outside your home may eliminate problems of space and odor, and shared or rental facilities are more likely to be well equipped than any home darkroom you build yourself. You also may meet a group of interested individuals with ideas, information, and photographs to share. All this could make your darkroom time more informative and engaging.

It's a good idea to air out the darkroom you use, whether it's well ventilated or not. If possible, open windows and doors from time to time. When working, take a break every couple of hours to walk around and breathe fresh air for a few minutes before returning to the darkroom.

You can build a home darkroom, but a darkroom outside the home is preferred.

Film Processing Equipment

Film developing does not require complicated or expensive equipment. Following is a list of equipment typically used for processing 35mm and medium-format films.

What you will need

processing reels and tank
rubber gloves
apron
thermometer
timer
stirring rod
scissors
bottle opener
graduated cylinders,
 beakers, or other
 measuring containers
storage bottles
funnel
film washer
photo sponge or chamois
film drying cabinet
 and/or string with film
 clips or clothespins
negative storage
 protectors
changing bag

Processing reels and tank. Since film is light sensitive, you must develop it in total darkness. To do this safely and efficiently, you turn off the lights and load exposed film onto a spiral **reel**. You then place the reel in a lighttight **processing tank**. Once the film is in the tank with the top secured, you can turn on the room lights; the top of the processing tank has a **light trap**, an opening designed to allow processing solutions in and out without letting in light.

Reels and tanks are made of either plastic or stainless steel. Plastic reels are arguably easier to load. Stainless steel reels are more difficult to load at first, but are generally more durable. Note that both plastic and stainless steel reels can break or warp. This is especially true of equipment in a **gang darkroom,** a school or other darkroom shared by many people. If possible, buy your own reels and tank, preferably heavy-duty models that are less prone to damage than lower-quality models.

Stainless steel reels fit only one size of film—usually 35mm or 120 (medium format). If you shoot both kinds of film, you will need to purchase two separate reels. Most models of plastic reels are adjustable to accommodate either size.

Processing tanks are available in several sizes to hold one, two, four, and even more reels. The larger tanks are more expensive and a little unwieldy, but they allow you to save time by processing multiple rolls of film at once.

Processing Reels and Tanks

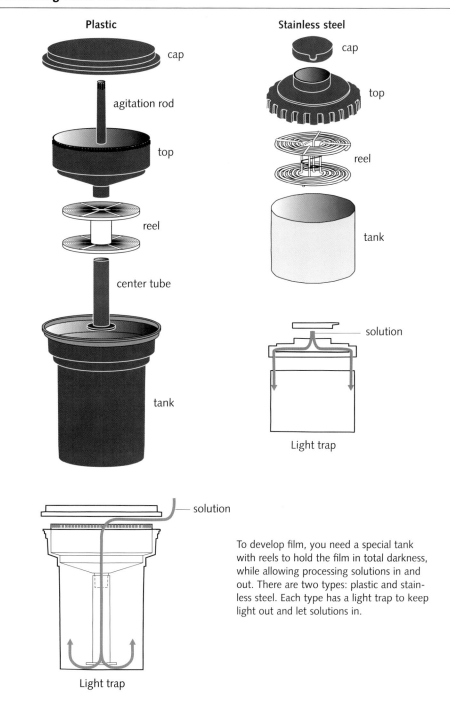

To develop film, you need a special tank with reels to hold the film in total darkness, while allowing processing solutions in and out. There are two types: plastic and stainless steel. Each type has a light trap to keep light out and let solutions in.

Rubber gloves. Handling most black-and-white photography chemicals is safe, but some degree of skin sensitivity is fairly common—drying and chafing in particular. (On rare occasions, chemicals can cause skin or other allergies.) To best protect your skin, use rubber gloves when mixing and handling chemical solutions.

Apron. Photographic chemicals can stain clothes (or whatever else they come in contact with). A plastic, rubber, or cloth apron (dedicated to darkroom use) will reduce that likelihood.

Thermometer. You will need a good thermometer because the temperature of the processing solutions is critical for best results and must be monitored regularly. Thermometers range in price and style, from expensive glass tubes containing mercury to stainless steel units with a dial face to digital models. Most types measure a wide temperature range (such as 30°F to 120°F). Analog models have a scale in increments of 1°F, while digital models measure even more precisely—and generally more accurately.

Thermometer

Timer. All processing steps must be timed with care, so you will need a timer that measures accurately in minutes and seconds. Any clock or watch will do the job, but an analog or digital photographic timer work best. Most models emit an audible beep when the time is up.

Stirring rod. Use a stirring rod made for photographic processing to mix solutions thoroughly.

Scissors. You will need to cut the film from the spool after winding it on a reel, and you will have to cut dry film into strips for storage and handling. Blunt-end scissors are safest, particularly because you will often be cutting in the dark.

Bottle opener

Bottle opener. When processing 35mm film, you will need a bottle opener to pry open the film cartridge. Photo stores sell film cartridge openers specifically made for this purpose, but inexpensive church-key models from the hardware store or supermarket work just as well.

Graduates, beakers, or other measuring containers. Before developing film, you should mix and measure all the processing solutions so they'll be ready when you need them. Use glass or chemical-resistant plastic graduates, beakers, and containers. Make sure there is a measuring scale on the side, preferably one that gives you solution volumes in ounces and milliliters. You will need at least one

Graduate

Storage bottle

Film washer

Negative protectors

As soon as they are dry, store your processed negatives safely in plastic negative protectors.

large (32–64 ounce or 1000–2000 milliliter) and one small (about 4–8 ounce or 125–250 milliliter) model; the small one should measure 1/2 ounce or 25 milliliters or less of solution accurately. If you have multiple large-size graduates, beakers, or containers, you will be able to set up all the solutions before processing, which will make the job easier.

Storage bottles. To keep processing solutions fresh, store them in tightly capped bottles made of chemical-resistant plastic or dark glass. Bottles that collapse or can be squeezed to eliminate excess air are especially good for extending the life of your chemicals.

Funnel. You may need a funnel, usually made of chemical-resistant plastic, to pour solutions into storage bottles that have narrow necks.

Film washer. A film washer is an acrylic tank that attaches with a hose to a water outlet. You place processed film in the tank for a highly efficient wash. Note that a film washer is an optional accessory, as there are ways to wash film without one.

Photo sponge or chamois. To facilitate drying, you can use a sponge, chamois, or other soft cloth to wipe processed film. If you do, be sure to use a product made for this purpose. Otherwise, you risk scratching the film as you wipe it down.

Film drying cabinet, or string or wire with film clips or clothespins. After washing your film, dry in a space with as little dust as possible. Some darkrooms have a dedicated drying cabinet with film clips for this purpose, but you can use an empty cabinet, closet, or other contained space with string or wire stretched taut from one side to another and spring-type clothespins to hang the film.

Negative protectors. Negatives are vulnerable to scratching or other physical damage from contaminants, such as dust and dirt, and careless handling. As a safeguard, use some sort of negative protector. There are several types available. A popular choice is clear plastic pages containing individual sleeves for strips of negatives. There are different sizes for different film formats. Most pages hold an entire roll of film, which you must first cut in strips of five or six 35mm frames, or some other number, depending on the page type and film format, and then slide into the sleeves—one strip per sleeve.

These protectors are generally made of chemically inert plastic, and may come with prepunched holes so you can file them away in three-ring binders for convenient storage. Many photographers use a binder box, a type of three-ring binder that seals shut to keep out dirt and moisture.

Changing bag. When a darkroom is not available, you can load film onto your processing reels and tank in a collapsible, lighttight sack called a changing bag. It has a zipper opening and two holes that let you put your hands inside while keeping light out. You use the zipper opening to put the film, reel, and tank in, and then place your hands through the holes to load the film, without having to turn off the room lights.

Chemicals

You will need several different chemicals for processing film. All are packaged in either powder or liquid form, depending on type and brand. Although they are often more expensive, liquids are more convenient, easier to use, and generally safer to handle than powders. Powders must be mixed with water to make a **stock solution**, the form in which chemicals are generally stored. Chemicals that come packaged as liquids are, in effect, premixed stock solutions.

Some stock solutions are used straight (undiluted) but more often you must dilute the stock solution with water for use. The usable form of the chemical (whether diluted or undiluted) is called a **working solution**. Stock solutions generally stay fresh longer than working solutions, although many working solutions can stay fresh for months as long as they are stored in containers without much excess air inside.

Stock and Working Solutions

A stock solution is the form in which a chemical is stored; a working solution is the form in which the chemical is used. If the chemical is packaged in liquid form, you dilute it once with water to make a working solution. Powdered chemicals often need to be diluted with water twice: first to make a liquid stock solution and then again to make a working solution. Some stock solutions are used undiluted.

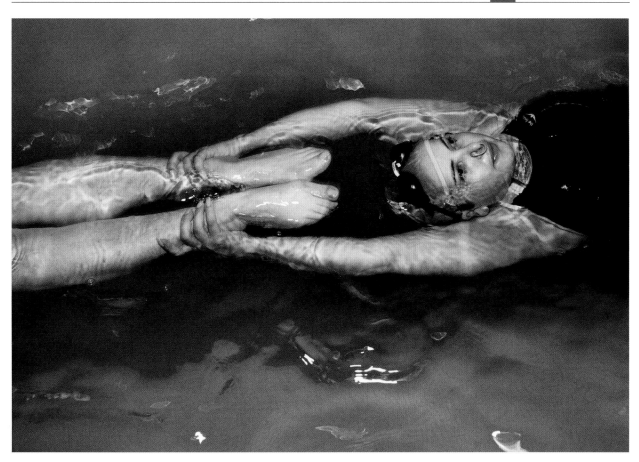

Christine Osinski, *Swimmers,* Staten Island, New York, 1987

Good photographers make effective use of the frame to compose their pictures. For this shot from her series on a women's synchronized swimming team, Osinski focused on the connection between two swimmers, isolating them in a way that is at once amusing and surreal. © Christine Osinski; courtesy of the artist.

Film developer forms the image by reacting to exposed silver crystals in the film emulsion.

Grain: pages 24–25

Following are the required film-processing chemicals, in order of use. Note that print processing requires most of the same chemicals, with slight variations. For example, there are different developers for film and paper.

Film developer. The **developer** is the most important processing chemical because it forms the image, turning exposed film into negatives. It does so by reacting with the film emulsion's light-sensitive crystals and converting them to black, metallic silver. The greater the film exposure, the denser the concentration of developed silver. Areas of the film that received a lot of exposure (light subject areas) turn darkest; areas that received less exposure (dark subject areas) appear proportionally lighter or clearer on the negative.

There are many different brands of film developer, in powder and liquid form, each with its own characteristics. Some developers produce finer or coarser grain than others, while others produce greater or less contrast. Whatever their properties, all film developers do develop film effectively.

Depending on the brand, you must prepare and use stock solutions of developer in various ways. With some, you don't dilute the stock solution at all; the stock solution, in effect, also is the working solution. With others, you dilute the stock solution with water, to make the working solution, for example, 1:1 (1 part developer to 1 part water). Still others require a heavy dilution, as much as 1:25 (1 part developer to 25 parts water) or even more. You can use different dilutions for most brands of developer, but the dilution you choose has an important effect on the developing time. Refer to instructions on the developer package or label for proper handling and dilution recommendations. Such information also will be on the film and developer manufacturer's Web site.

Many film developers are one-use, meant to be discarded after processing. Some types can be chemically replenished and used for months or even longer.

Time-Temperature Chart

Film Type:	Temperature	Time
Kodak Tri-X	65°F (18°C)	11 min
Film Developer:	68°F (20°C)	10 min
Kodak D-76	70°F (21°C)	9½ min
Developer dilution:	72°F (22°C)	9 min
1:1 (one part D-76 to one part water)	75°F (24°C)	8 min

If the developer solution is 70°F (21°C), develop for 9½ minutes. If the developer temperature falls between temperatures listed, adjust the time accordingly: For example, at 71°F (21.5°C), use 9¼ minutes.

Some developers work quickly, while others take much longer. Developing time is determined by several factors. These include the type of film and film developer, developer dilution, and solution temperature. All are critical. Most packages of film and developer include a **time-temperature chart,** which takes the above factors into consideration and recommends a developing time. But not all films or developers include such charts; the ones that do list only a few film and developer choices. Many school and other gang darkrooms have time-temperature charts posted, but if you can't find one for the type of film and developer you use, you can get it from the manufacturer's Web site.

Varying film developing time: pages 152–157

Note that developing times are important, but minor variations are not fatal. If the recommended developing time is 10 minutes and you develop instead for 11 minutes, you will still get a printable negative. In fact, it's best to think of times from a time-temperature chart as recommendations; they are not set in stone. Still, you shouldn't vary from recommended times unless you have a specific reason to do so.

Stop bath is a mild acid solution that halts development.

Stop bath. The developer continues developing film until neutralized by a **stop bath,** which usually consists of a very mild solution of acetic acid. You can use a plain water rinse to end the developing action, but an acid stop bath is more effective and helps preserve the next solution, the fixer, which is far more critical to the developing process (and more expensive) than the stop bath.

Stop bath comes packaged as a liquid and is available in several forms. It's easier to use a prepared stock solution, consisting of acetic acid. All you have to do is mix this solution with water for use. With one popular brand you mix 1 part prepared stop to 9 parts water; for example, mix 3 oz of stop to 27 oz of water to yield 30 oz of working solution, or mix 100 ml of stop to 900 ml of water to yield 1000 ml (1 liter) of working solution.

Many prepared brands, sometimes called **indicator stop baths,** contain a dye to indicate the freshness of the stop bath. For example, the color of a fresh solution may be yellow, but turn purplish-blue as it becomes depleted, at which point it's time to mix a fresh batch.

Be very careful when handling any concentrated form of stop bath. When diluting an acid, add the acid to the water, to avoid spattering; never add water to an acid. The fumes may be strong and the solution caustic. Use rubber gloves when mixing, wear an apron or other protective clothing, and avoid breathing fumes directly. Don't use glass bottles or containers to store stop bath; use plastic instead to avoid breakage.

You can store stock and working solutions of acetic acid for a very long time—months and even years. The capacity of a working solution varies from brand to brand, but generally 1 quart or liter of working solution should be used for no more than 20 rolls of 36-exposure 35mm film (or 40 rolls of 24-exposure 35mm film) or 20 rolls of 120 medium-format film.

Fixer removes unexposed
particles from the film.

Fixer. After treatment in the developer and stop bath, all silver particles that were exposed to light in camera have darkened to form the image. However, the film still contains silver particles that were not exposed to light in camera. **Fixer,** sometimes called hypo, is the chemical that removes this unexposed (and thus undeveloped) silver, allowing the film to be viewed safely in the light. Left unfixed, unexposed areas will eventually darken with exposure to light and ruin the results.

Fixers come in powder and liquid form. Powdered fixers are usually less expensive and slower acting than liquid fixers. After you dilute the powder with the specified amount of water, you use the same mixture for fixing either film or prints. To avoid inhaling any concentrated powders that may become airborne, slowly add the fixer to water while gently stirring.

Rapid fixers come as liquid
solutions and work more
quickly than standard fixers.

Many liquid fixers are **rapid fixers:** They work about twice as fast as powdered fixers. Moreover, they are safer to handle, as you don't have to worry about airborne powders, and more convenient to use. With a powdered fixer, you generally mix the entire package and store it in a bottle between uses. Using liquid fixer allows you to make a small batch of solution as you need it. However, make sure you read the package directions carefully. Liquid fixers often require different dilutions, one for film and one for paper.

With one particular brand of liquid fixer, you mix film fixer in a ratio of 2:8—2 parts fixer concentrate to 8 parts water; for example, mix 6 oz of concentrate to 24 oz of water to yield 30 oz of working solution, or mix 200 ml of concentrate to 800 ml of water to yield 1000 ml (1 liter) of working solution.

Working solutions of fixer can last a long time when properly stored—several weeks when used and several months when unused. Check the package instructions or manufacturer's Web site for recommendations.

Take care not to overuse the fixer, as weakened or depleted solutions may not work effectively. If in doubt about a fixer's freshness, use a **fixer check** (also called hypo check). Squeeze just a few drops of fixer check solution into a small container of used fixer. If a white, cloudy precipitate forms, the fixer is depleted and should be discarded; if no precipitate forms, the fixer is still fresh.

Another way to judge fixer strength is to use a piece of unexposed, unprocessed film. If you soak the piece in the used fixer, the film should completely clear in less than one minute. If it doesn't, mix and use fresh fixer.

Hardener is a fixer additive that toughens the film emulsion, making it more resistant to scratching and minor damage from handling. It is not absolutely required when fixing film, but it is highly recommended. Hardener usually comes premixed with powdered fixers or in a separate bottle to add to most liquid fixers. Some brands of liquid fixers have hardener built in.

Fixer remover. After treatment in fixer, film is fully processed; you can view it safely in the light. However, any remaining byproducts of the fixing process can lead to image deterioration, so you must always thoroughly wash the film.

This is no easy task. You can wash the fixer away with water; however, unaided it will take a long time because fixer is not totally water soluble. To expedite washing, use a **fixer remover**, a chemical that converts fixer to a compound that washes away more easily. After the film has been treated in fixer remover, you complete the wash with a short rinse under running water.

Fixer removers come in powder form, but they are packaged most commonly as liquid solutions. Dilutions vary, so follow instructions on the package or bottle. Some fixer removers come with an indicator dye that changes color as the solution gets depleted.

To wash film thoroughly, you need a fixer remover, followed by a final water wash.

Wetting agent. After you have thoroughly washed the film, you can hang it by a clip or spring-type clothespin to dry. However, water may cling to the film as it dries and leave streaks or spots on the surface. To minimize this residue, use a wetting agent so it does not bead up and form droplets.

The wetting agent, also known by the popular brand name Photo Flo, comes as a highly concentrated liquid. Dilute it heavily, using about half a capful for a 32-oz or 1-liter working solution.

Setting Up the Chemicals

Set up five containers of working solutions: one each of developer, stop bath, fixer, fixer remover, and wetting agent. Use graduates or beakers for this purpose, if they are available, because they have markings on the side for easy measuring. And be sure to mix enough of each solution to fully fill your processing tank. Instructions that are packaged with your tank, or printed on the bottom of some plastic models, indicate how much solution you need. If your tank has no instructions, fill the tank with empty reels and water. Then pour the water into a beaker to see what volume of solution is needed to fill the tank. Even if you are processing fewer rolls than a tank allows, it's a good idea to fill the tank fully with solution.

You can use various solution temperatures to process film. It's best to keep within a range of 68–72°F (20–22°C), but anywhere from 65–75°F (18–24°C) is usually okay. The temperature has an important effect on processing times; the warmer the solution, the shorter the time.

For best results, keep all solution temperatures as consistent as possible.

Try hard to keep all solution temperatures consistent, from developer through fixer and even in the final wash steps. A variation of a few degrees probably won't matter, but too much variation can lead to noticeably increased grain in

Setting Up Chemicals

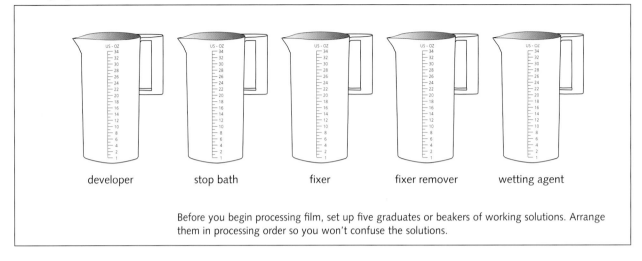

| developer | stop bath | fixer | fixer remover | wetting agent |

Before you begin processing film, set up five graduates or beakers of working solutions. Arrange them in processing order so you won't confuse the solutions.

Detail of a print showing the cracked pattern of a reticulated negative.

See **bw-photography.net** for more on darkroom health and safety.

the negative, and in rare cases **reticulation,** a condition that appears as cracks in the film emulsion.

There are many ways to keep solution temperatures consistent. The simplest is to let solutions stand unused for a while after mixing, until they all reach room temperature. When diluting stock solutions with water, it helps if you measure and adjust the water temperature constantly. Some darkrooms have a mixing valve—similar to those in many showers—attached to a temperature gauge, which allows you to set and control the temperature more easily.

Alternatively, put all the containers of solution in a **water bath**, a deep tray partially filled with 68–72°F (20–22°C) water. Keep the containers in the bath for a few minutes until the solutions reach the desired temperature. Make sure the containers are heavy enough to avoid floating while in the water bath.

Handle processing solutions with care. Read and heed the hazard warnings printed on chemical packages. Avoid inhaling fumes as much as possible by working in a ventilated darkroom or processing film near an open window. Even a common window or bathroom fan can help pull fumes away from you as you process film. Also, avoid touching solutions when mixing and handling them. Use rubber gloves whenever possible to minimize skin contact.

Loading Film for Processing

Loading film onto the reel in darkness may be the most difficult part of film processing.

Before processing you must load the film onto a processing reel and place the reel in a tank. You will then pour processing solutions in and out of that tank. For some, the most difficult part of film developing is loading film onto the reel. The rest of the process is fairly routine, but loading film does take getting used to. And it can be frustrating.

The processing reel is basically a spiral that holds film. When properly loaded onto the reel, no section of the film touches any other section, which allows processing solutions to reach all parts of the film evenly. When improperly loaded onto the reel, some sections of the film will stick together and will therefore not develop.

Reels are made of either plastic or stainless steel. Each works a little differently, but the principle is the same: You wind the film onto the reel until the entire roll is loaded. When using a plastic reel, you slide the end of the film into a slot on the outside of the spiral, then work the roll toward the middle of the reel by ratcheting the sides of the reel back and forth in opposite directions. When using a stainless steel reel, you insert the end of the film into the middle, and then turn the entire reel in a circular motion so the spool of film unwinds onto the spiral.

Remember that film is light sensitive, so you will have to load it in total darkness. Buy a roll of film and practice with the lights on. Once you get the hang of it, close your eyes and try again until you feel confident you can work in the dark. Keep the used film around and practice with it from time to time.

Once you have loaded the film, place the reel in the processing tank and attach the lighttight top. Then you are ready for processing. If you use a plastic reel, you will need a plastic tank; if your reel is stainless steel, you will need a stainless steel tank. The two types are not compatible.

Loading Reels: Step by Step

Before you begin loading film onto a processing reel, check the room to make sure it is lighttight. Gang darkrooms often have dedicated film-loading rooms for just this purpose. If you are working at home or elsewhere use any room you can make lighttight, such as a closet, bathroom, or some other small, windowless space. Turn off the lights and check for any light leaking in. If there are light leaks, block them. You can shove a towel against the bottom of the door if the light is coming from there (and it often is). If it's coming from some other source, you may have to tape up or otherwise block it out. When you are ready to load your film, follow these steps:

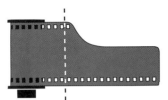
Step 5

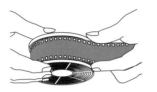
Step 9

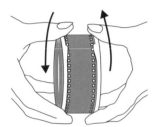
Step 10

Step 11

Step 12

Plastic Reels and Tanks

1. *With lights on, clear off a counter top,* making sure it is dry and clean.

2. *Arrange your film and all the needed equipment on the counter,* so you can find everything when the lights go out. Aside from your film, you will need reels, a processing tank, a bottle opener, and a pair of scissors. Make sure the processing tank is open and ready to receive the reels after they are loaded with film.

3. *Open the film cassette.* Use the bottle opener to lift off the end of the cassette; you can open either end, but the flat end (not the one with the film spool protruding) usually lifts off most easily.

4. *Push the spool holding the film out of the cassette.* The film is tightly wound onto the spool, so it may unravel when removed from the cassette. You will have an easier time handling the film if it doesn't unravel, so tuck the spool in the palm of your hand to try to prevent this. But if it does unravel, don't panic; you can still successfully load the film onto the reel.

5. *Cut off the film leader,* the half-width curved tab at the end of the film, preferably between sprockets, so the end is as straight and even as possible. It is possible to load film without cutting off the leader, but it is easier if you do make the cut—and the film is less likely to jam as it loads onto the reel.

6. *Hold the spool of film in the palm of one hand, with the end of the film between your thumb and forefinger.* The film will naturally curve toward its emulsion side. While holding the film by the edges, pinch it slightly to produce a very gentle curve with the emulsion side facing down. This may feel a little awkward and take some getting used to. Use whichever hand feels most comfortable.

7. *With your other hand, pick up the plastic reel* and position it so the open slot located on the outer rim of the reel faces the film.

8. *Insert the cut end of the film into the slot* so that the emulsion side faces the center of the reel.

9. *Gently push the film into the slot* until you feel its sprocket holes engage with ball bearings inside the rim of the reel. The ball bearings help pull the film into the reel in subsequent steps. Hold the reel in both hands. It's okay if it hangs loose, but try to keep it from touching the floor or rubbing against the counter's edge.

10. *Rotate the sides of the reel back and forth in a ratchetlike movement,* in opposite directions. This movement, with the help of the ball bearings, pulls the film into the reel. Stop when you reach the end of the roll.

11. *Remove the spool from the end of the film.* The film is usually attached with tape so cut it off with a pair of scissors. Make the cut close to the tape so you don't cut into the last exposure on the roll.

Step 14　　　Step 15　　　Step 16

12. *Slide the reel, now loaded with film, onto the plastic center tube* that comes with the tank.

13. *If you have another roll to develop, load it onto a second reel.* Repeat steps 3 to 11.

14. *Place the second loaded reel onto the center tube.* If you only have one roll to develop, place an empty reel on the tube above the loaded reel. Putting one or more empty reels in the tank holds the loaded reels in place during processing. Many models of plastic tanks take two reels, but if your tank takes only one, skip steps 13 and 14; if it takes more than two reels, continue loading film, as above.

15. *Place the center tube with reels into the processing tank.* If any of the reels are empty, they should be positioned on top of the loaded reels. The end of the center tube with a flared protrusion goes into the tank first.

Light trap: page 131

16. *Screw the tank top in place,* making sure it clicks in securely. The center tube and tank top work together to provide a light trap that keeps light from entering the tank. Now it's safe to turn on the room lights.

Agitation rod: drawing, page 131

17. *Put the watertight cap on the top of the tank,* and you're ready for processing. Many plastic tanks come with an agitation rod, which is not really useful; feel free to toss it out.

Stainless Steel Reels and Tanks

1. *Follow steps 1–6 above* for loading plastic reels and tanks.

2. *Pick up the stainless steel reel in your other hand,* and position it so the end of the spiral on the outer rim of the reel faces the film. The film will not roll onto the reel if the end of the coil faces away from the film.

Step 2

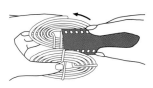

Step 3

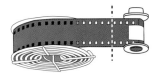

Step 6

Step 7

Step 10

3. *Insert the cut end of the film into the center of the reel.* Some reels have a slot or a clip in their center to hold the end of the film in place. Other models have prongs that fit into the sprocket holes on each side. Since the film is the same width as the reel, you will have to keep it pinched slightly to insert it into the reel; pinching too much could damage the film or make it difficult to load. Hold the film so that its natural curve follows the curve of the reel.

4. *Place the reel standing upright on a counter,* and position it and the film for loading. Imagine the reel is a clock, and the film is entering the reel at 3 o'clock (if you are holding the film in your right hand) or 9 o'clock (if it's in your left hand).

5. *Keeping the reel on the counter, slowly rotate it in a counterclockwise direction* (clockwise, if you are holding the film in your left hand). Keep the film slightly pinched and don't try to wrap the film around the reel, but let the rotating movement guide the film onto the reel. Stop when the film is fully loaded. A 36-exposure roll will fill the entire reel and finish at the outer rim; a 24-exposure roll will only partially fill it.

6. *Take off the end of the film from the spool.* If the film is attached with tape, you will have to cut it off with a pair of scissors. Make the cut close to the tape so you don't cut into the last exposure on the roll.

7. *Drop the loaded reel into the processing tank.* Unlike plastic tanks, there is no center tube in stainless steel tanks.

8. *Load another roll of film onto a second reel,* if you have another roll to develop. Repeat steps 2–7.

9. *Place the second loaded reel on top of the first reel in the tank.* Many models of stainless steel tanks take two reels, but if your tank takes only one, skip steps 8 and 9. If your tank takes more than two rolls, continue loading film, as above. If you are processing fewer rolls than the tank can hold, fill the tank with empty reels on top of the loaded ones to help hold them in place.

10. *Put the waterproof top on the processing tank,* making sure it fits securely. The top has a light trap that keeps light from entering the tank. Now it's safe to turn on the room lights.

The same basic instructions apply when loading medium-format film onto reels for processing—with some important differences. Note that both plastic and stainless steel tanks take either 35mm or 120 roll film. For example, a tank that holds two 35mm reels also holds a single 120 reel, while a four-reel tank holds four rolls of 35 mm and two of 120.

If you use stainless steel, you will have to buy separate reels for 35mm and 120 film, but plastic reels usually expand to handle both film sizes. If you're using a plastic reel, twist the spirals in opposite directions past the point where

the ratcheting motion stops until they loosen, then pull the two halves apart. Align the ends of the reel's center column and ratchet them back in place to accommodate the size of the film you are processing.

With size 120 medium-format film there is no cassette and no film leader. However, there is a paper backing to protect film from light. As you load the film onto the reel, you must separate this backing, which is attached to the rest of the spool with a band of tape. It's a little tricky, so practice first in room light with a spare roll.

Roll films are wider than 35mm film and are more prone to physical damage when handled. If you pinch the film too much, you may crimp it, which can result in crescent-shape marks.

The Developing Process

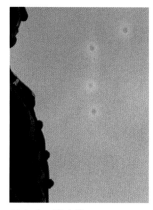

Air belles (detail)

Once film is loaded on a reel and placed safely in the processing tank with the lid secured, you can turn on the lights and begin processing. Pour solutions in and out of the tank in the following order: presoak (optional), developer, stop bath, and fixer. Then wash the film, preferably with a short water rinse, followed by a fixer remover and final wash. Finally, treat the film in a solution of wetting agent and hang it to dry.

With each chemical step, you must properly agitate the tank to keep the solution in motion so it evenly treats the film for consistent results. Good agitation technique requires both rotating and inverting the tank. Monitor solution temperatures and time the process with care, moving smoothly from step to step. Best results come when solution temperatures are consistent throughout. Exact consistency may be difficult to maintain, but try your best. Don't rush yourself, but don't hesitate between steps either. It helps if you keep separate containers of solutions accessible and in their proper order, so you can move quickly through the process, without having to stop to mix solutions. Follow these steps for developing film.

Developing Film: Step by Step

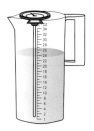

Step 2

1. *Presoak (optional).* Pour plain water into the loaded processing tank and soak the film for 1 minute to soften the emulsion and promote even development. After you pour in the water, gently tap the bottom of the tank a few times against a table, counter, or sink to help dislodge air bubbles that may otherwise settle on the film. Air bubbles may lead to **air belles,** circular marks of uneven development, in the final negative.

2. *Take the temperature of the developer and determine the correct developing time* by referring to the time-temperature chart for the film and developer you are using. For this example, suppose normal development time is 8 minutes.

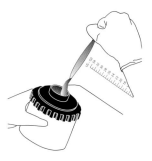

Step 3

Step 4

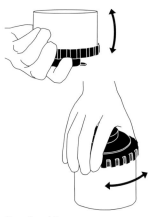

Steps 5 and 6

3. *Pour the developer into the processing tank,* holding the tank at a slight angle to facilitate pouring. Start timing the development when about half of the solution is poured in, 5 seconds or so after you begin pouring. When the solution is in the tank, tap the bottom of the tank gently against the sink or counter a few times.

4. *Put the cap on the top of the tank.* Remove the cap when you need to dump or add solutions, but remember to put it back on when you are agitating the tank to prevent leaking.

5. *Agitate the tank for the first 30 seconds of development.* To agitate, gently rotate the tank in a circular direction two or three times, and then invert it once or twice. Repeat this rotation and inversion for the full 30 seconds—no more or less. After 30 seconds, stop agitating and put the tank down and gently tap the bottom of the tank.

6. *Thirty seconds later, pick up the tank and agitate for 5 seconds only.* For the remaining time in the developer, agitate for 5 of every 30 seconds. Tap the tank gently when you put it down each time.

 Whatever method of agitation you choose, be careful to agitate consistently and regularly during the development step. Underagitation (less than the recommended time or no agitation at all) or overagitation (more than the recommended time or constant agitation) may lead to under- or over-developed film, uneven development, or possibly image streaking.

7. *Pour the developer out of the processing tank.* Start pouring 5 to 10 seconds before the developing time is up, taking into consideration that the film continues to develop until you add the next solution (stop bath). If you're using a one-use developer, discard the used solution.

8. *Pour stop bath into the processing tank* as soon as all of the developer is poured out. Start timing when you have entirely filled the tank with stop bath. Soak the film in this solution for 30 seconds to 1 minute.

9. *Agitate the tank for at least half the time required for the stop bath* by rotating and inverting the tank as in steps 5 and 6. Make sure the cap of the tank is on before inverting.

10. *When the time is up, pour the stop bath out of the processing tank.* Start pouring 5 to 10 seconds before time is up. Store the solution for reuse in a clean bottle or storage container marked "used stop bath." Mark the number of rolls treated on the side of the container so you can discard the solution before it exceeds its capacity.

11. *Pour in the fixer.* Fix the film for 3 to 5 minutes with rapid fixers or 5 to 10 minutes with standard fixers, depending on the brand of fixer, the freshness of the solution, and the film type. Certain films may require a longer fixing time: about 5 to 8 minutes for rapid fixers and 8 to 10 minutes for standard fixers.

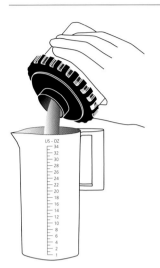

Step 10

Fixer check: page 138

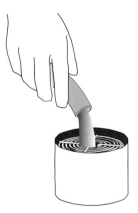

Step 14

*Washing film:
pages 148, 150*

12. *Agitate the tank for at least half the time required for the fixer*—or even for the entire time—by rotating and inverting the tank as in steps 5 and 6. Make sure the cap of the tank is on before inverting.

13. *When the time is up, pour the fixer out of the processing tank.* Store the solution for reuse in a clean bottle or storage container marked "used fixer." Before reusing the fixer (at a later date), use a fixer-check solution to test its freshness, or mark the number of rolls fixed on the side of the container. Discard the solution before it exceeds its capacity.

After film has been fixed, you can safely view it in light if you are anxious to see it. Open the top of the tank, remove a reel, and unwind a few inches of the film to see how it looks. It's best not to unwind the whole roll, however, as you should keep film on the reel for an efficient wash. Moreover, rolling the film back onto a wet reel, especially a plastic one, can be difficult. When unwinding, handle the film with great care, as it's easily scratched or otherwise physically damaged when wet.

14. *Take the top off the tank and rinse the film with water.* Rinsing (also called first wash) usually takes 5 minutes and washes away some of the chemicals and other contaminants that may harm the long-term life of your film.

15. *Empty the water from the processing tank* and put the top back on, after the first wash is complete.

16. *Pour fixer remover into the processing tank.* Treat the film with fixer remover for 2 to 5 minutes, depending on the brand of fixer remover you use and the freshness of the solution. This solution removes residual contaminants left over from the fixer, and shortens the required time for the final wash.

17. *Agitate the tank for at least half the time required for the fixer remover*—or even for the entire time—by rotating and inverting the tank as in steps 5 and 6. Make sure the cap of the tank is on before inverting.

18. *When the time is up, pour the fixer remover out of the processing tank.* Store the solution for reuse in a clean bottle or storage container marked "used fixer remover."

19. *Take the top off the tank and wash the film.* This final wash usually takes 5 to 10 minutes.

20. *Empty the water from the processing tank after the final wash is complete.*

21. *Pour wetting agent into the processing tank.* Soak the film for 30 seconds to 1 minute. Pour in the wetting agent gently, and don't agitate the tank. Agitation may cause soapy bubbles, which can result in streaks or scum on the surface of the dried film.

22. *When the time is up, pour the wetting agent out of the processing tank.* Store the solution for reuse in a clean bottle or storage container marked "used wetting agent."

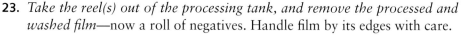

Step 24

23. *Take the reel(s) out of the processing tank, and remove the processed and washed film*—now a roll of negatives. Handle film by its edges with care.

24. *Hang the film to dry* in either a film-drying cabinet or from a string or wire, using a film clip or spring-type clothespin. Weight the film at the bottom with another clip or clothespin to prevent the film from curling as it dries. Dry film in a dust-free environment. Otherwise, your film may pick up dust, scratches, and other defects when drying—a very common problem in a school or other gang darkroom.

25. *(Optional) Gently wipe hanging film* from top to bottom on both sides with a very clean photo sponge, chamois, or other soft cloth dipped in wetting agent. This helps film dry more quickly and with less streaking. Note that not everyone recommends wiping, as it also can scratch film if you are not careful. Do not squeeze the film as you wipe or you may scratch it. After you are finished, store the sponge, chamois, or cloth in a plastic bag (such as a sandwich bag) to keep it clean until you use it again. If you see scratches and/or streaking after wiping the film, skip this step when processing subsequent rolls.

26. *As soon as it is dry, store the film* to keep it clean and scratch-free. Film generally takes 1 to 3 hours to dry, depending on the temperature and humidity of the environment. Check the bottom of the film; it dries last so if it feels dry then the entire roll should be dry. Remove the film from the clips, and place it on a clean counter or other surface for cutting (wipe and dry the surface before putting the negatives on it). If you have a large light box available, place the negatives on that. Carefully cut the negatives into strips, usually of five or six frames each, depending on the type of film and negative protectors you are using. Then gently slide the strips into the protector, one strip per slot. Take care not to scratch the negatives as you slide them in.

Washing Film

A thorough wash depends on fresh water.

You must wash film thoroughly to remove remaining chemical compounds which could cause future image deterioration. For a complete wash, you will need to use fixer remover and then wash for a specified period of time. Equally important, however, is an efficient washing method. To guarantee an efficient wash, use a washing method that ensures a constantly changing supply of fresh water.

Achieving a constantly changing water supply can be complicated. Many photographers use a **film washer**—usually an open plastic tank that attaches to a water faucet with a hose. As you turn on the faucet, water enters the bottom of the tank and pushes water out the top, providing a continuously fresh supply of water.

Summary: Film Processing

What follows is the sequence of steps to process film, along with recommended times and other instructions. Note that these are guidelines only; details may vary among types and brands of chemicals and due to conditions of use. Be sure to read all product labels for specifics.

Step	Time	Comments	Capacity*
Presoak Softens film emulsion to encourage even development.	1 min	Optional step: Pour water into tank. Temperature should be the same as temperature of succeeding solutions.	Not applicable.
Developer Makes the latent image visible.	Varies; refer to time-temperature chart.	Keep solutions in a range from 68–72°F (20–22°C), if possible, but 65–75°F (18–24°C) is acceptable.** Agitate by rotating and inverting tank continuously for first 30 sec, then 5 sec of every 30 sec thereafter.	Discard one-use developers immediately after use; replenished developers can be used for dozens of rolls.
Stop bath Ends development.	30 sec–1 min	Agitate by rotating and inverting tank for at least half of the time.	20 rolls of 36-exposure film per quart or liter of working solution.
Fixer Removes unexposed light-sensitive silver to make image permanent.	Standard fixers: 5–10 min Rapid fixers: 3–5 min	Agitate by rotating and inverting tank for at least half of the time.	15–20 rolls of 36-exposure film per quart or liter of working solution.
Rinse (first wash) Washes away most chemicals.	5 min	Use constantly changing water.	Not applicable.
Fixer remover Removes chemical byproducts from fixing.	2–5 min	Agitate by rotating and inverting tank for at least half of the time.	30 rolls of 36-exposure film per quart or liter of working solution.
Final wash Clears film of any remaining contaminating compounds.	5–10 min	Use constantly changing water. Periodically dump and fill tank to guarantee fresh wash water. Keep film on reel and reel in tank or film washer.	Not applicable.
Wetting agent Helps prevent spots and water marks from forming during drying.	30 sec–1 min	Keep film on reel while in wetting agent. Do not agitate.	60 rolls of 36-exposure film per quart or liter of working solution.

*A roll of 36-exposure 35mm film is approximately equal to 1½ rolls of 24-exposure 35mm film, one roll of size 120 (medium-format) film, and three sheets of 4" x 5" film.

**For best results, keep all processing solutions at the same temperature as the developer.

Washing Film

A good wash requires a constantly changing supply of fresh water. You can use a commercially made film washer (left) that circulates fresh water automatically. Or you can use running water in the processing tank (right), but be sure to dump the water from the tank and refill it every 30 seconds or so to circulate fresh water manually.

If you don't have a film washer, keep the reel(s) in the processing tank (with the top off) and put the tank under a faucet. Run water from the faucet into the tank for the required wash time, but dump the water out of the tank every 30 seconds or so to guarantee a changing supply of fresh water.

If you don't have running water, you can still wash film efficiently. Fill a bucket with 68–72°F (20–22°C) water. Pour water from the bucket into the processing tank. Let it sit for 20–30 seconds (agitate the tank if you like), then pour out the water and fill the tank again. Use six to eight exchanges of water for a first wash, and 12 to 15 exchanges for a final wash.

Whatever method of washing you use, it's important to keep the water temperature as consistent as possible. The temperature of running water, whether in a film washer or a processing tank, can vary widely; monitor it carefully during the entire wash. Stick your thermometer into the tank and check it constantly while the water is running.

Adjusting negative contrast

Time-temperature chart: page 136

Most of the time, when processing film you'll want to use the standard development time recommended for the film and developer you use. Standard developing time is sometimes referred to as **normal development** and appears on a time-temperature chart, usually provided with the film, the developer, or on the manufacturer's Web site.

If you've exposed your film correctly, processing it for normal development will provide a good negative almost every time. However, there are times when

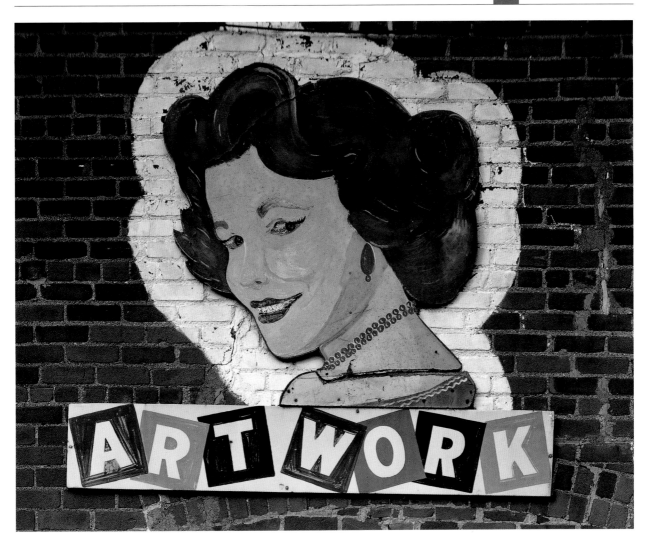

Jim Dow, *Woman's Face on Sign (On Brick Wall), "Art Work,"*
Mantako, MN, 1972

*Some photographers work like anthropologists, searching for pictures in the cultural land-
scape. Their job is not so much to construct or direct the subject as it is to find and take
compelling pictures. To this end, Dow travels extensively to record quirky details of
Americana: vintage signs, architectural oddities, and roadside attractions. © Jim Dow;
courtesy of Janet Borden Gallery, New York, NY.*

varying from normal development even slightly can noticeably improve your negatives. The following basic rule applies:

Film development time controls negative contrast.

In short, increasing film developing time produces negatives with greater contrast, and reducing developing time produces negatives with less contrast. Understanding this basic rule allows you to easily fine-tune the contrast of your negative. Let's say normal development time with your film and developer is 10 minutes. If you are photographing when the light is a little flat and dull, you can increase negative contrast slightly by developing your film for 12 minutes instead; if you are photographing on a somewhat bright, sunny day, you can decrease negative contrast slightly by developing your film for 9 minutes.

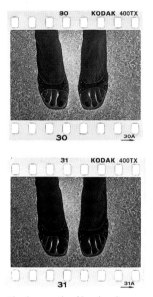

The longer the film development time, the greater the negative contrast. The top negative was developed for 10 minutes; the bottom negative was developed for 15 minutes. Both were exposed for the same amount of time.

One of the best uses for this technique occurs when you are photographing indoors under low light. Often your negatives in such situations will be a little light and print flat and gray. If you make a practice of developing film shot indoors just a little longer than normal (about 10–20 percent), your negatives will have more contrast and be easier to print.

Deciding how much to increase or decrease developing time can be tricky, as it varies from one lighting situation to another—and also according to the type of film and film developer you use. Here are some general guidelines you can use:

For more negative contrast, increase normal developing time by 10–25 percent or more.

For less negative contrast, decrease normal developing time by 10–15 percent or more.

In many cases, the subject lighting varies from one exposure to another on a roll of film. Because adjusting film development affects all the negatives on your roll, you may have to base your developing time on what you consider the most important pictures on the roll. If you have 15 shots taken in flat (low-contrast) light that you think will be your best images, you might want to increase the film developing time to make sure you have the optimal negatives for those pictures. If you do so, however, you may be sacrificing the quality of some of the other pictures on the roll.

Pushing Film. The term **pushing film** means increasing the film development time. Sometimes you'll want to do this to slightly punch up the negative contrast, as described above. But you might also want to push film when you are working in low-light conditions without a flash or other artificial lighting. In such situations, your film speed may not be high enough to capture the available light, even with your lens open to its maximum aperture and your shutter speed set as low as possible for you to handhold the camera. Or you may not be able to use a high enough shutter speed with the available light to freeze the action at a sporting event.

Exposure and Development

Although this chapter is about film development, don't underestimate the importance of film exposure in producing a good negative. Both exposure and development time are critical in determining the overall density of your negative. The density of the shadow areas of your negative is primarily determined by film exposure, and the density of the highlight areas is primarily determined by development. Thus, this commonly stated rule of thumb:

> **Expose for the shadows;**
> **develop for the highlights.**

Here's how it works. In your subject, the shadows are the darkest areas. This means they reflect the least amount of light back to the camera. If you give film too little exposure, the developed shadows will not render with enough density to register good textured detail. Changing development cannot create subject details where there are none on the film; it can only modify the contrast of existing detail. So, to produce a negative with good shadow density, you must give the film adequate exposure.

Film develops in proportion to exposure, which means that the development time does not have a significant impact on the shadow areas. Shadow areas are the areas that received the least exposure; they do not take much time to form on the negative.

For instance, if the normal developing time for a roll of film is 10 minutes, then the shadow density fully forms in about half that time—possibly 5 minutes. The remaining 5 minutes of development mostly affects the highlight areas.

The highlight areas are the lightest areas of your subject, which are the areas that reflect the most light back to the film. This means they have far more exposed silver particles needing development than shadow areas. Thus, the longer you develop your film, the greater the highlight density in the developed negative. If you develop your film for 15 minutes rather than 10, the highlights get significantly denser but the shadows do not. As the difference between the shadow and highlight density becomes greater, so does the negative contrast, meaning that increasing film development time increases negative contrast.

The opposite happens when you reduce the development time, from 10 minutes to, say, 8 minutes. The highlight areas render with less density and the shadow density stays about the same. This minimizes the difference between the shadows and highlights, resulting in less negative contrast. Thus, decreasing film development time decreases negative contrast.

Suppose the meter indicates that you don't have enough light to make a good exposure, even with your lens at its largest opening and your shutter speed at a slow setting, perhaps f/2 at 1/30. Try resetting your light meter for a higher film speed; for example, rate ISO 400 film at 800 or 1600. Setting the higher film speed signals the meter that the film is faster (more sensitive to light) than it really is, and therefore that it needs less light for adequate exposure. For instance, set at 1600 the meter may indicate that settings of f/2 at 1/30 will provide enough light; if so, take the picture, then "push" the film—develop it for longer than the normal amount of time suggested by the manufacturer.

Pushing is especially useful when you are photographing with a zoom lens because most zooms don't have a very large maximum aperture. For instance, a lens with a maximum aperture of f/4 probably won't allow enough light

Maximum lens aperture: page 52

through for photographing in low light without a flash or other accessory lighting. (That's why a normal fixed-focal-length lens that opens to a large f-stop, usually f/2 or so, works better than a zoom for photographing in low light.)

Also, consider using an extra-high-speed film in low light, rather than pushing development. ISO 1600 or 3200 film is fast enough to capture light in most dark scenes. However, under very dim light, you may need to push even extra-high-speed films.

Increasing film speed and pushing development can be very helpful in low-light conditions, but it is not a cure-all. The film doesn't suddenly become faster just because you are rating it at a higher speed. What you are doing is under-exposing the film—giving it less light than it really needs—and pushing development for increased contrast to compensate. This allows you to make a decent print in a difficult situation.

Photographing in low light: pages 95, 97

The amount of increased development you will need can vary widely, depending on the increase in film speed you want, the type of film, and the type of developer. These are general guidelines for pushing ISO 400 film:

Pushed speed rating . . .	means you are underexposing by . . .	therefore overdevelop by . . .
800	1 stop	35–50 percent
1600	2 stops	75–100 percent

Thus, if your meter indicates an exposure of f/2 at 1/15 with ISO 400 film, you can set your ISO at 800. Now the meter will recommend 1 stop less light—perhaps, f/2 at 1/30 (or the equivalent)—and you must increase development to compensate—for example, develop for 13½ to 15 minutes instead of the normal time, say, 10 minutes. Or, you can set your ISO at 1600 and use 2 stops less light—perhaps, f/2 at 1/60 or f/2.8 at 1/30—and develop for 17½ to 20 minutes instead of 10 minutes.

You can also use the same guidelines when pushing with a different-speed film, for example, rating ISO 1600 film at 3200 (a 1-stop push) and overdeveloping by 35–50 percent, or rating it at 6400 (a 2-stop push) and overdeveloping by 75–100 percent.

Note that there are extra-active high-speed film developers specifically made for pushing film. Normal developing times with these developers are like pushed times with other developers. Follow the instructions on the developer packaging for details rather than using the guidelines above for developing times.

Pushing film is a good solution when you are working in low-light conditions, but it does have some disadvantages.

Loss of shadow detail. Shadow details in the negative are determined by film exposure, and pushing means you have underexposed the film.

High contrast. The increase in development causes an increase in contrast. This is usually a good thing for photographing on a foggy day but may not be

Photographing in low light often requires pushing the film.

Pushing Film: Underexposing and Overdeveloping

Pushing film increases negative contrast, making it easier to make a good print of a subject in low-light conditions. Here, the picture on the left was made with ISO 400 film, processed for the normal development time. The resulting negative and print are flat—muddy and gray. The picture on the right was made by film pushed to a speed of 800 (underexposed by 1 stop) and processed for 35 percent more time, resulting in a negative and a print with less shadow detail but more overall contrast.

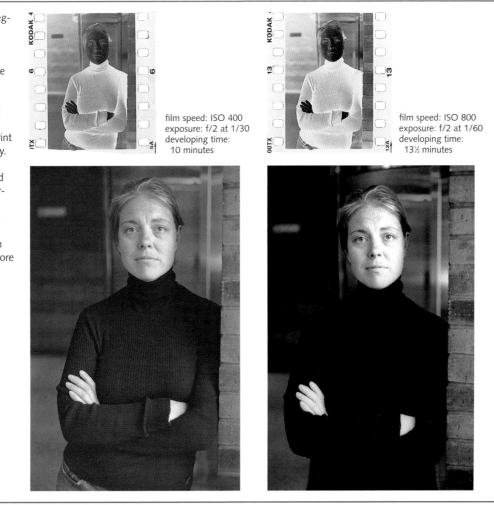

film speed: ISO 400
exposure: f/2 at 1/30
developing time:
10 minutes

film speed: ISO 800
exposure: f/2 at 1/60
developing time:
13½ minutes

good for photographing a stage performance when the light is low but already high in contrast (lots of dark and bright areas).

Increased graininess. You can expect increased development to produce negatives with coarser grain than normal development.

These disadvantages will apply to every picture on your roll of film, because the entire roll will be getting pushed development. Still, it's often worth it; pushing film may make the difference between getting the picture you want and having to pass it up.

Pushing film may result in lost shadow detail, high contrast, and increased graininess.

Pulling Film. The term **pulling film** means decreasing the film development time. Often you'll want to do this to slightly lower the negative contrast, as described above. But as with pushing film, the most dramatic results come when you change your film speed and decrease the developing time. Here's how it works.

Let's say the light is extremely bright and the meter suggests an exposure of f/11 at 1/500 with ISO 100 film. If you use these settings and develop the film normally (say, for 10 minutes), you'll get a negative that is very high in contrast. Sometimes high contrast looks great, but often it looks harsh and it usually means your negative will not have good shadow detail. This is because the shadow (dark) areas of your subject are especially dark on a bright day and therefore may not register enough density on the negative to show full textured detail.

One solution to this problem is to overexpose your film so the film's shadow areas get more light, leading to more density and textured detail in the developed negative. However, overexposing the film also will make the highlight areas denser—possibly too dense. If you then underdevelop the film, you will reduce the highlight density without appreciably affecting the shadow areas, which are controlled by exposure, not development. The net effect will be reduced negative contrast with sufficient shadow detail.

Adjusting film exposure: pages 90–91

There are several ways to overexpose film, but one easy way is to set the light meter for a lower film speed. This will signal the meter that you are using a slower (less sensitive) film than you are, in fact, using, so the meter will suggest f-stop and shutter speed settings that allow in more light than they otherwise would, which will overexpose the film.

The amount of increased development you will need can vary widely, depending on the decrease in film speed you want, the type of film, and the type of developer. These are general guidelines for pulling ISO 100 film:

Pulled speed rating . . .	means you are overexposing by . . .	therefore underdevelop by . . .
50	1 stop	10–20 percent
25	2 stops	25–30 percent

Thus, if your meter indicates an exposure of f/11 at 1/500 with ISO 100 film, you can set your ISO at 50 and use one stop more light—perhaps, f/8 at 1/500 (or the equivalent)—and develop for 8–9 minutes, instead of the normal time, say, 10 minutes. Or, you can set your ISO at 25 and use two stops more light—perhaps, f/5.6 at 1/500 (or the equivalent)—and develop for 7–7½ minutes.

You can also use the same guidelines when pulling with a different-speed film, for example, rating ISO 400 film at 200 (a 1-stop pull) and underdeveloping by 10–20 percent, or rating it at 100 (a 2-stop pull) and underdeveloping by 25–30 percent.

Pulling film by 1 stop usually provides enough of an increase in shadow detail and reduction of contrast in most situations. A two-stop pull is for more

Pulling Film: Overexposing and Underdeveloping

Pushing film decreases negative contrast, making it easier to produce a print with good shadow detail on a bright sunny day. Here, the picture on the left was made with ISO 100 film, processed for the normal development time. The resulting negative and print have too much contrast and not enough textured detail in the shadow areas. The picture on the right was made by film pulled to a speed of 50 (overexposed by 1 stop) and processed for about 15 percent less time, resulting in a negative and print with less contrast and better shadow detail.

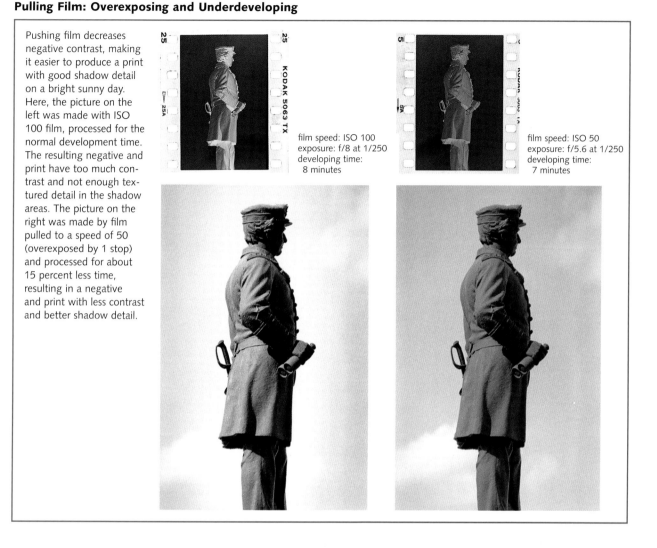

film speed: ISO 100
exposure: f/8 at 1/250
developing time:
 8 minutes

film speed: ISO 50
exposure: f/5.6 at 1/250
developing time:
 7 minutes

Never pull film more than 25 to 30 percent or so.

extreme situations. Whatever you do, don't reduce your developing time by more than 25 to 30 percent or your negatives may look muddy or murky rather than just low in contrast. Also, very short developing times may not allow shadow density and textured detail to fully form.

The main reasons to pull film are reduced image contrast and greater shadow detail. But as a bonus, you may also reduce image graininess due to the shorter development time. Again, keep in mind that the results will apply to every picture on your roll of film, so you may have to decide to develop optimally for the pictures you consider the most important on the roll and hope that the negatives on the rest of the roll will print well enough.

Troubleshooting: Film Development

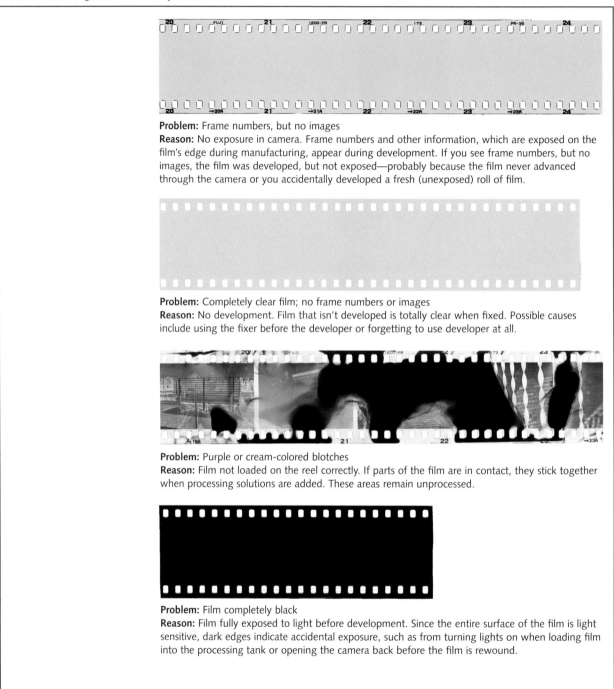

Problem: Frame numbers, but no images
Reason: No exposure in camera. Frame numbers and other information, which are exposed on the film's edge during manufacturing, appear during development. If you see frame numbers, but no images, the film was developed, but not exposed—probably because the film never advanced through the camera or you accidentally developed a fresh (unexposed) roll of film.

Problem: Completely clear film; no frame numbers or images
Reason: No development. Film that isn't developed is totally clear when fixed. Possible causes include using the fixer before the developer or forgetting to use developer at all.

Problem: Purple or cream-colored blotches
Reason: Film not loaded on the reel correctly. If parts of the film are in contact, they stick together when processing solutions are added. These areas remain unprocessed.

Problem: Film completely black
Reason: Film fully exposed to light before development. Since the entire surface of the film is light sensitive, dark edges indicate accidental exposure, such as from turning lights on when loading film into the processing tank or opening the camera back before the film is rewound.

Problem: Film unevenly darkened
Reason: Film partially fogged (unintentionally exposed) before or during development. In this example, the center post was left out of the plastic processing reels, allowing light to enter the tank. Other possible causes include loading film in a room that is not totally dark and the top of the tank coming off during development.

Problem: Film unevenly darkened
Reason: Incomplete fixing. Partially fixed film does not completely clear and may have a warmish tint. This sometimes occurs when the fixer is weak or depleted—or when fixing time is much too short.

Problem: Film fully developed only along one side
Reason: Insufficient developer in tank. If there isn't enough developer solution to cover the film completely, the fully immersed area will develop normally, while the uncovered area will not.

Problem: Overlapping images
Reason: Film did not fully advance through camera, either because of mechanical breakdown or user error.

Abelardo Morell, *Six Dictionaries,* 2000

Many of Morell's photographs depict ordinary things, such as this looming stack of dictionaries, in a way that makes them seem fresh. He also is painstaking about his craft, putting as much effort into making expressive and rich prints as he does into taking his pictures. © *Abelardo Morell; courtesy of Bonni Benrubi Gallery, New York, NY.*

Some photographers pay labs to make their prints. Many labs do an excellent job, but for ultimate control and satisfaction, nothing matches doing the work yourself. The darkroom experience is not for everyone; it takes work, patience, and attention to detail. However, many photographers will tell you that printing your own work is essential for getting the results you want. And it can be a lot of fun, as well.

Equipment

You can develop film on your own with a makeshift darkroom, but for printing you will need much more equipment and you should really have a dedicated space to work. It's generally less expensive and more convenient to use an existing darkroom than to build your own. Perhaps someone you know has a darkroom to share. You also may be able to rent space at a school darkroom or take a photography class just to use the school's facilities. Search online or ask at your local camera store about classes, community centers, or camera clubs in your area that offer darkroom use.

Here's a list of darkroom equipment you'll need whether you set up your own darkroom or use an existing one.

Enlarger. An **enlarger** is your primary tool for making photographic prints. Its purpose is to make **enlargements**—prints that are larger than the negatives they are made from. An enlargement may be as small as commercially made snapshots (3½" x 5" or 4" x 6") or much larger (16" x 20" or 20" x 24" or bigger). Most beginning photographers start out making 8" x 10" prints.

Enlargers are available for different-size negatives, and they are categorized according to the largest size they can handle. For example, a **35mm enlarger** will print only 35mm negatives (and obscure smaller sizes), while a **4" x 5" enlarger** handles negative sizes up to 4" x 5" (including 35mm and medium format).

The guts of an enlarger are an adjustable mechanism called a **head**, which projects the negative image onto a sheet of printing paper. The head moves up and down along a rail (or between two parallel rails) that attaches to a **baseboard,** a flat board that sits on a table or counter. As you move the head up and

Enlargers are used for making enlargements, prints that are larger than negatives.

Variable-contrast filters:
page 165

down on the rail, the projected image becomes larger or smaller. Once the image is the desired size, you turn another knob to focus, then lock the head in place by tightening a knob.

The top of the enlarger head contains a light source, usually a bulb that looks much like a common household bulb. Below the bulb is a **filter drawer,** to hold variable-contrast filters, or a built-in filtration unit used to control print contrast.

Under (or sometimes over) the filter drawer or built-in filters, there is either a condenser or a diffuser, both of which even out the light that comes from the bulb which is often brighter in its center than at its edges. A **condenser** is a thick glass lens, often consisting of two or more pieces of shaped glass. It gathers up light rays and focuses them as a strong beam, like a spotlight. **Condenser enlargers** produce prints with excellent contrast and a high degree of sharpness.

Most black-and-white enlargers use a condenser, but some models use a **diffuser,** which is usually a panel of frosted glass that softens light, like clouds

Parts of a Condenser Enlarger

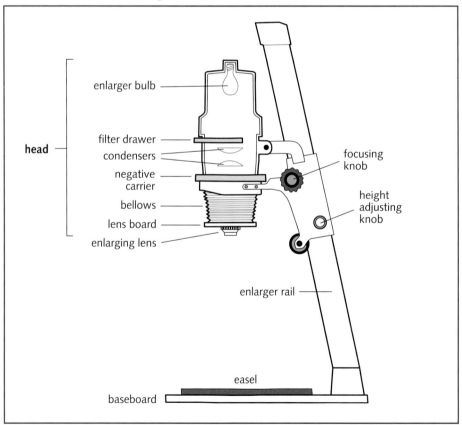

Condenser and Diffusion Enlargers

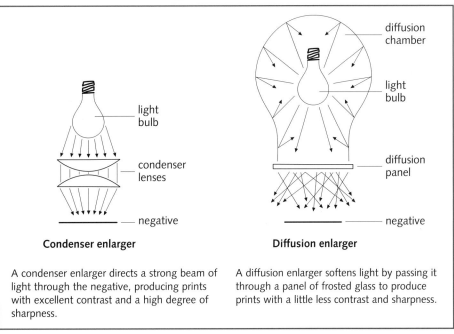

Condenser enlarger

A condenser enlarger directs a strong beam of light through the negative, producing prints with excellent contrast and a high degree of sharpness.

Diffusion enlarger

A diffusion enlarger softens light by passing it through a panel of frosted glass to produce prints with a little less contrast and sharpness.

diffusing sunlight on an overcast day. Prints made using a **diffusion enlarger** have a little less contrast and appear a bit softer (less sharp) than prints made using a condenser enlarger.

Below the condenser or diffuser there is a slot for the **negative carrier,** which holds the negative. Most enlargers have a bellows below the negative carrier. The lens is mounted at the bottom of the bellows, attached to a **lens board.** You focus the projected image by expanding or contracting the bellows, which changes the distance between the lens and the negative.

Enlarging lens. An **enlarging lens** serves basically the same function as a camera lens: to focus the image and control the amount of light passing through. In a camera, the adjustable lens opening controls the light reaching the film; in an enlarger, the adjustable lens opening controls the light reaching the printing paper.

Sometimes enlargers come packaged with a lens; other times the lens is sold separately. Price is a pretty good indicator of lens quality. Inexpensive enlarging lenses are available for under $50, while a top-quality model may sell for several hundred dollars. For most purposes, inexpensive and moderately priced lenses produce acceptable results. For more critical printing, especially when you are making large prints, high-quality lenses can make a significant difference in overall image sharpness and contrast.

An enlarging lens controls focus and the amount of light that reaches the printing paper.

Lens aperture: pages 35, 38–40

Like camera lenses, enlarging lenses are classified according to their maximum aperture. Thus an f/2.8 enlarging lens is faster than an f/4 lens, because it allows more light through when set at its maximum aperture. More light makes it easier to see and focus the projected image, and gives you the option of using a shorter print exposure time by using a larger f-stop.

Enlarging lenses, like camera lenses, are categorized by their focal length. When choosing a lens, you must consider the size of the negative you are printing. The minimum size focal length for an enlarging lens is roughly the same as the focal length of the normal lens on the camera that took the picture. Since 50mm is normal for a 35mm camera, you will need at least a 50mm enlarging lens to enlarge a 35mm negative.

The reasons for this are related to a lens's **covering power**—the circle of illumination the lens projects. The circle's size is related to its focal length; generally the longer the focal length of a lens, the broader its covering power.

This is why you can print using a longer-focal-length lens than recommended, but not a shorter one. For example, an 80mm lens projects a circle of illumination broad enough to cover a 2¼" x 2¼" negative, so it also will cover the smaller-size 35mm negative. However, the same 80mm lens does not project a broad enough circle to cover a 4" x 5" negative; for that amount of coverage you will need a longer lens (at least 135mm).

At a given height, the focal length of the enlarging lens determines the size of the projected negative. A longer-focal-length lens projects a smaller-size image than a shorter-focal-length lens, so an 80mm enlarging lens will project a smaller image than a 50mm lens. Thus, the longer the lens you use, the higher you must raise the enlarger head for enlargement. Furthermore, the higher you move the head, the weaker the light and the longer it takes to expose the printing paper, assuming you are using the same lens aperture. This means that choosing a focal length longer than required could result in longer print exposure times.

The following chart lists the minimum-recommended-focal-length enlarging lens for use with different-size negatives.

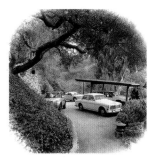

The lens you use must project a circle of light wide enough to evenly cover the entire negative. Here the corners of the print are too light, because the 50mm lens used was too short to fully cover the 2¼" x 2¼" negative.

Negative Size	Minimum Focal Length
35mm	50mm
2¼" x 1¾" (6 x 4.5 cm)	75mm
2¼" x 2¼" (6 x 6 cm)	75–80mm
2¼" x 2¾" (6 x 7 cm)	90mm
2¼" x 3¼" (6 x 9 cm)	100–105mm
4" x 5"	135–150mm

Negative carrier. A **negative carrier** is a device that holds a strip of negatives flat and in place in the enlarger. Each film format usually requires its own negative carrier. So if you use different film sizes, you will need a different carrier for each.

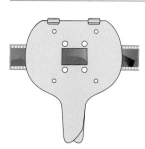

Negative carrier (35mm)

Variable-contrast (VC) filters

*Variable-contrast paper:
pages 171, 173*

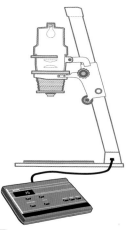

Timer

The carrier has a top and a bottom part, sometimes hinged together or sometimes as separate pieces. Both top and bottom have a rectangular or square opening the size of a single negative frame. When placed in the carrier, only the image to be printed shows; the rest of the negatives on the strip are masked out.

The opening of most negative carriers is uncovered. There also are **glass negative carriers,** which have a thin sheet (or two sheets) of glass covering the opening to help keep the film flat. You have to handle glass carriers with special care, as dust, smudges, and scratches on the glass may show up on the final print or otherwise degrade print quality.

Variable-contrast (VC) filters. Called **variable-contrast, polycontrast,** or **multicontrast filters,** these plastic filters fit in the enlarger, usually in a drawer located below the light bulb. They come in kits containing 10 or so separate filters numbered in half-step increments from #0–#5 (#0, ½, 1, 1½, 2, and so forth). The lower-numbered filters are pale yellow and decrease print contrast, while the higher-numbered filters are magenta, or sometimes reddish-orange, and increase contrast.

Variable-contrast filters are effective only with variable-contrast printing papers, the most commonly used black-and-white photographic papers. These papers produce a range of print contrasts depending on which filter you use to expose your paper.

You can buy variable-contrast filter sets in different sizes, such as 3" x 3" or 6" x 6". Make sure your filters fit into your enlarger's filter drawer; trim them to size if they are too big.

Different brands of variable-contrast filters are generally compatible with all variable-contrast papers; for instance, you can use filters from Kodak with Agfa papers and vice versa. However, filters might produce slightly different results from one paper type to another. For best results, paper manufacturers generally recommend using their own brand of filters.

Timer. An enlarging **timer** regulates print exposure times accurately and conveniently. There are analog and digital models available. Digital timers allow incremental exposures in fractions of seconds and are generally more precise.

The enlarger's power cord fits into an outlet on the timer. There is a focusing switch on the timer that allows you to turn on the enlarger light so you can set up and focus the image. When you are ready to expose the printing paper, you turn the switch to its timer position, set an exposure time, and then press a button on the timer. The timer turns on the enlarger light for the set time and shuts it off. On most models, the timer then resets to the specified time, ready for the next exposure.

Focusing magnifier

Tray

Tongs

Safelight

Focusing magnifier. A **focusing magnifier** enlarges a portion of the projected image, allowing you to see and focus it more critically. **Grain focusers** provide the most magnification, allowing you to see the individual grains of silver that make up the image. When the grain appears sharp, the image will be in sharpest focus.

Trays. Processing trays, made of chemically resistant plastic (or sometimes stainless steel), hold chemical solutions used for print processing. You will need at least four trays. Standard sizes include 5" x 7", 8" x 10", 11" x 14", 16" x 20", and 20" x 24". Make sure your trays are large enough to accommodate the largest sheets of paper you will be working with in a particular printing session.

Apron. A plastic, rubber, or cloth apron dedicated to darkroom use helps keep chemicals from staining your clothes.

Towels. Have clean cloth towels or paper towels on hand to keep your hands dry when printing. You will have to rinse your hands regularly to minimize chemical contact with skin and to keep paper, equipment, and chemical solutions from becoming contaminated. Towels also are helpful when mopping up spills of chemical solutions.

Tongs. Instead of your fingers, you should use tongs made of stainless steel, plastic, or wood to handle wet printing paper and carry it from tray to tray. You will need at least three pairs of tongs—one each for the developer, stop bath, and fixer—to avoid chemical contamination, which can lead to print staining or other deterioration.

Safelight. Printing papers are sensitive to light, but with black-and-white papers you can safely use a dim amber-colored light to illuminate the darkroom when printing. There are several types, but simple **safelights** are 15- to 25-watt bulbs in a housing covered with a colored filter. A single safelight should be sufficient to illuminate a small darkroom, while large darkrooms may need two or more.
 Safelights are not totally safe. They can still **fog** (inadvertently expose) printing paper under certain circumstances. Make sure the safelight is at least 3 or 4 feet away from the paper, and don't leave unexposed paper out of its box or envelope for more than a few minutes.

Easel. A metal **easel** holds printing paper under the enlarger. It generally consists of two parts: a base to position the paper on and a hinged top to hold the paper flat with the help of two or more adjustable blades. You set the desired image size by adjusting the blades along a ruled molding on the edges of the hinged top.

Arno Rafael Minkkinen, *Self-Portrait, Mountain Lakes, NJ, 1977*

Minkkinen's surreal self-portraits give the sense that his body is a collection of quirky parts, rather than a whole. Here, by anticipating how the scene would look in black-and-white, he was able to set up the picture so his light fingers would stand out from the dark background. © Arno Minkkinen; courtesy of Barry Friedman Ltd., New York, NY.

Easel (four blades)

Easels are available in many sizes, based on the largest size printing paper they will accommodate. An 8" x 10" easel, for example, holds 8" x 10" or smaller paper. Usually an 8" x 10" or 11" x 14" easel is adequate, but easels also are made for larger paper sizes, such as 16" x 20" and 20" x 24". Most easels can be adjusted for different-size papers, while some are made to hold one or more fixed sizes. With most easels, you can use smaller paper than the maximum allowed, such as making 8" x 10" prints with a 16" x 20" easel.

Easels usually produce a white border on prints, since the areas of the paper under the top blades receive no exposure. Professional models have four adjustable blades, which allow the widest variety of border and centering possibilities; you can make small prints with a wide border, center the image on the paper for an even border all around, or leave a wider border on the bottom of the image than on the top.

Negative cleaner. Dust and other residue on the negative are among the most frustrating problems when printing. If they are not removed they will show up, usually as light areas on a print. There are several accessories available to keep negatives clean, such as cans of compressed air, rubber squeeze blowers, and soft, wide brushes. Especially dirty negatives may require a film-cleaning solution and a soft wipe or cotton swab.

Compressed air

Print washer. For a simple washing setup, you can use a processing tray and water, either running from a **tray siphon** made for this purpose or directly into the tray from a faucet or hose. An even better solution is a proper print washer with a place for running water to enter and a separate drain. There are many washer models available. Some are round in shape and circulate prints to provide agitation during the wash; other models, often called **archival washers**, are vertical and hold prints in individual slots.

Archival washer

Drying prints: pages 201–2

Archival: page 205

Print dryer. You can dry prints with heat or air dry them. Heated units are most efficient, as they dry prints quickly. But good heated dryers are expensive and can require a lot of maintenance. Air drying takes longer, but is simpler, less expensive, and generally best for **archival** results (long-term print permanence). You can place prints on plastic screens to air dry or you can just hang them from a wire or string with a plastic spring-type clothespin.

Paper safe. A paper safe is a lighttight box that holds and allows easy access to unexposed printing paper. While not a necessity, it makes paper handling more convenient, since it is easier to open than the box that printing papers come in.

Cutting paper: page 238

Paper trimmer. Sometimes you will need to cut printing paper to a smaller size. A paper trimmer makes the job easy, but be sure it is in good condition or your cuts may not be square or accurate. You also can cut paper with scissors or a ruler and cutting tool, such as a utility knife or X-acto knife.

Print squeegee. A squeegee is a flat rubber blade or roller for squeezing excess water from a washed print for faster drying. You also can use a soft sponge for this purpose. Be sure that either the squeegee or sponge is clean, or you may contaminate prints as you wipe them.

Contact prints: pages 203–5

Glass (for contact printing)

Glass. You will need at least two pieces of heavy glass—one for making contact prints and one for supporting wet prints for squeegeeing to dry them. Each piece must be larger than the largest-size printing paper you use. For example, use 11" x 14" glass for 8" x 10" contact prints and another at least that size for squeegeeing. You can use Plexiglas, rather than glass, for squeegeeing, but not for contact printing; it is not heavy enough to hold negatives flat against the paper.

A commercially made **contact-printing frame** resembles a picture frame; you place the paper and negatives in the frame, close it, and make your contact print. Other contact printers consist of glass hinged to a base; you place the paper and negatives on the base, and then press the glass on top of them to make contact.

Graduates, funnels, beakers. As with film developing, you will need a variety of glass or chemical-resistant plastic containers for measuring, holding, and storing chemical solutions. Graduates and beakers should have a measuring scale on the side, preferably one that gives you solution volumes in both ounces and milliliters. You will need both large (32–64 ounce or 1000–2000 milliliter) and small (about 4–8 ounce or 125–250 milliliter) models. Several of each will make your job easier.

Storage container (collapsible)

Storage containers. You will need several containers to accommodate all the solutions—and to separate used and fresh solutions. Collapsible containers keep excess air out, thus prolonging the freshness of stored solutions.

Printing Papers

Fogged paper example: page 206

Like film, printing paper is coated with a light-sensitive emulsion, but film has a plastic base while printing paper has a paper base.

quantity paper information: base, weight, tone, surface, contrast

Resin-coated papers are more widely used than fiber-based papers, but many advanced photographers prefer the quality of fiber.

Toning: pages 229–32

Spotting: pages 232–34, 236

Hand coloring: pages 222, 225

Photographic **printing paper** consists of a light-sensitive **emulsion** coated onto a **base** (support) material. The emulsion is made of light-sensitive silver halide crystals suspended in gelatin, while the base material is white paper stock. Note that in many respects the makeup of photographic paper resembles film, whose emulsion is coated onto a clear plastic base.

Printing paper almost always comes in sheets. Standard sizes include 5" x 7", 8" x 10", 11" x 14", 16" x 20", and larger. Paper comes in a light-tight wrapper inside an envelope or box. A package may contain 10, 25, 50, 100, 250, or even 500 or more sheets of one size and type. Most beginning photographers work with a 25- or 100-sheet package; the greater the package quantity, the lower the per-sheet cost.

Make sure you always keep your paper in its package except when you are working in a darkroom with a safelight. Even the slightest amount of exposure to any other type of light will fog paper, ruining it for use.

Choosing a printing paper can be confusing because there are so many types. Each produces a somewhat different look; sometimes the difference will be dramatic and sometimes it will be subtle. At your camera store, ask for samples of prints made on various types of paper to help you choose. Experiment until you find the type that best complements your work.

Following are the major considerations in choosing a paper: base, weight, tone, surface, and contrast.

Base. All black-and-white printing papers use paper as a base for the light-sensitive emulsion. **Resin-coated (RC)** papers also have a plastic coating on both sides of the base for easier handling and other conveniences, while **fiber-based** papers are not coated. Each type has important differences in both handling and appearance.

RC papers are in widest use. They cost less than fiber-based papers; process, wash, and dry faster; and are generally more convenient. For example, RC papers usually require less exposure time, use less chemistry, and dry flatter than fiber-based papers. All this makes RC papers ideal for many uses, including making contact sheets and teaching beginners how to make prints.

Fiber-based papers require extra care. They generally take more time to expose and process than RC papers, cost more, and are less convenient in certain ways. However, they are often preferred by advanced photographers because they usually are more long lasting (archival), have a richer overall look than RC papers, and are easier to tone, spot, and hand color. Many beginners learn using RC papers and switch to fiber-based papers later.

Weight. Printing papers are classified according to their base thickness. RC papers are usually **medium weight.** Fiber-based papers are generally **double weight,** although a very few are **single weight.**

The weight does not affect the appearance of the printed image. Heavier papers curl less when dry and are less susceptible to physical damage, such as creasing, wrinkling, pinching, and even tearing. Double-weight fiber-based papers also dry flatter and curl less than single-weight papers, but they cost more.

Tone. Tone refers to the color bias of the printing paper. Some papers produce **warm-tone** images (brown to green-brown), while others produce **cold-tone** images (neutral to blue-black). Often this difference is subtle, though some papers produce strongly warm tones—in shades of brownish-black, rather than blacks and grays.

The difference in paper tone comes from a variety of factors, such as the chemical composition of the emulsion and the base of the printing paper. Warm-tone printing papers often have a creamier white base than cold-tone papers.

Surface. Most paper types are available in at least two or three different surfaces, such as glossy, semimatte, and matte. The terminology may vary with different manufacturers; for example, semimatte is sometimes called lustre or pearl. Also, one brand's glossy may be more or less glossy than another brand's. And RC papers produce a higher-gloss image than glossy fiber-based papers.

Your choice of paper surface is individual, driven by the look you want for a particular image or for your style of work. However, the glossier the paper, the sharper the image and the greater the contrast. Matte papers make an image look softer (less sharp) and flatter (less contrast).

Contrast. Printing papers also are characterized by the way they allow you to control **print contrast** (the difference between lights and darks). There are two choices: variable contrast (also called **polycontrast** or **multigrade**) or **graded papers.** Both types rate contrast numerically, on a scale that could range from #0 to #5. Lower numbers (#0, #1) produce lower-contrast prints, while higher numbers (#4, #5) produce higher contrast.

Variable-contrast papers are most convenient because they allow you to achieve a range of print contrasts using one package of paper only. Contrast is controlled using filters in the enlarger to modify the color of the light because each sheet of paper has both low- and high-contrast emulsions built in. The two emulsions activate to different degrees when exposed to different color light. Low-numbered yellow filters expose mostly the low-contrast emulsion and high-numbered magenta (or reddish-orange) filters expose mostly the high-contrast emulsion.

Variable-contrast papers also allow you to adjust the contrast in half-step increments (#½, #1½, #2½, and so forth), because variable-contrast filters come in half-step increments. Enlargers with built-in filters allow adjustments in even smaller fractional increments.

Generally, the glossier the print surface, the sharper and greater the contrast of the print.

Variable-contrast papers are more convenient to use and allow finer contrast control, but some graded papers produce more image richness.

Variable-contrast filters: page 165

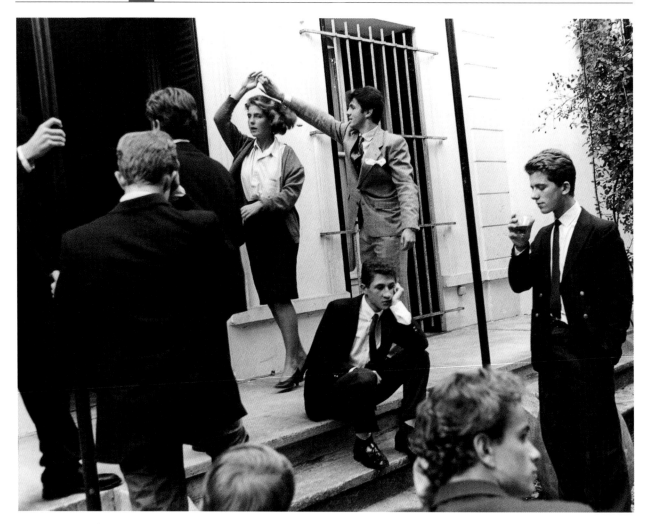

Lauren Greenfield, *Dance Lessons, "Rallye Costa de Beauregard,"*
Paris, France, 1987

*The challenge for a photographer working candidly is to identify important moments
and subtle gestures, then make quick decisions on where to stand, where to point the
camera, and when to shoot. Greenfield's composition makes good use of the entire frame
to convey a sense of alienation at this social club for teenagers of the French aristocracy.*
© *Lauren Greenfield; courtesy of Pace/McGill Gallery, New York, NY.*

Graded papers do not work with filters. Instead, each sheet of paper produces a single grade of contrast; if you want to change contrast, you have to switch to a different package of paper. For example, if you want higher contrast, use a #3 paper. For lower contrast, use a #1 paper. This method is less convenient than using variable-contrast paper because you have to buy a separate package of paper for each desired contrast grade; it also doesn't allow you to fine-tune the contrast quite as much since graded papers don't allow fractional grade changes the way variable-contrast papers do.

The range of available contrast with graded papers is more limited than with variable-contrast papers, as many companies offer only grades #2, #3, or #4. You will be able to make a good print with a well-exposed and well-developed negative using graded papers, but with poor negatives you may need the wider range of contrasts that variable-contrast papers offer.

Many advanced photographers prefer graded papers for their quality, despite their limitations and their relatively high cost. For instance, many graded papers are premium quality, offering exceptionally rich tonality—a very broad range of grays and unusually deep blacks.

The Printing Process

Contact prints: pages 203–5

Chemicals for processing film: pages 134, 136–39

Keep all solution trays in a sink or in a wet area of the darkroom.

Making a print requires a variety of judgments and interpretations, much more so than developing film. Following are basic printing steps and discussions of the key judgment areas. Note that you may want to make contact prints the same size as your negatives before deciding which images to print.

Part I: Setting Up the Chemicals

Set up four trays for the printing process: one each for developer, stop bath, fixer—all similar to the chemicals you use for processing film—and a **holding bath**, plain water used to hold prints until they are ready for washing.

It's best to put all the trays in a sink; this way if you spill the solutions you can clean them up more easily. They also will be less likely to leave stains. If you don't have a large enough sink, designate a counter, or a section of a counter, as a wet area and keep all solutions there and away from your negatives, the enlarger, and other equipment.

Position the trays in a line, and always work in the same direction, so you won't mix up the chemicals when you're working. Most photographers work toward the faucet, so the last tray (the holding bath) has running water available. (If your darkroom does not have running water, work left to right—from developer to holding bath.)

You will need a different type of developer for prints than for film. Though film and print developers both develop the image and share some of the same ingredients, they are formulated differently.

Setting Up the Trays

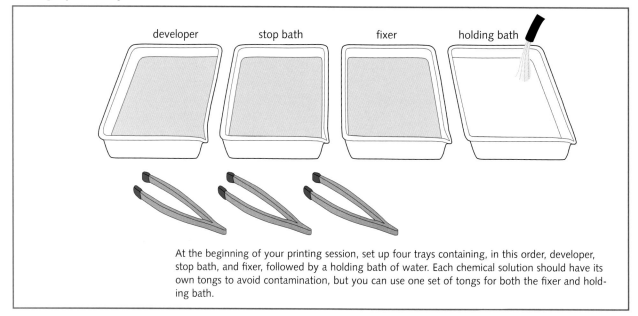

developer stop bath fixer holding bath

At the beginning of your printing session, set up four trays containing, in this order, developer, stop bath, and fixer, followed by a holding bath of water. Each chemical solution should have its own tongs to avoid contamination, but you can use one set of tongs for both the fixer and holding bath.

What you will need

paper developer
stop bath
fixer
fixer remover (with fiber-
 based papers)

Most chemicals for film and paper are similar, but there are important differences.

Hardener: page 138

Print washing:
pages 199–200

Toning: pages 229–32

Stop bath is generally mixed the same way for paper as for film, but some fixers are mixed at different dilutions, depending on the brand. Check the instructions that come with the fixer for specifics, but chances are you will need a less concentrated fixer for prints than for film, especially if you use a rapid fixer.

You don't always need a hardener in the fixer when processing prints. Using a hardener may help a little to protect the paper emulsion, especially if you are going to heat dry your prints. But with air-dried prints it increases the likelihood of curling—and it also may reduce the effectiveness of print washing and toning.

As part of the final wash, you will need a fixer remover only if you make fiber-based prints. RC prints don't need fixer remover because they wash more easily and quickly, due to the paper's plastic coating which keeps fixer from soaking deep into the paper fibers.

You should fill processing trays to at least half capacity. An 8" x 10" tray needs about 32 ounces of solution; an 11" x 14" tray needs about 64 ounces; and a 16" x 20" tray needs about 1 gallon. If you're making only a few prints, you can use less solution to save money; if you're making a lot of prints, use more so you won't have to keep changing solutions as the chemicals get used up.

It's difficult to control the temperature of solutions in trays. They eventually reach room temperature, because they sit there for hours at a time. Fortunately, you can process prints successfully within a wide range of solution tempera-

tures. Try to stay around 68–72°F, however. If necessary, turn up the heat or air conditioning to change the room temperature. Cooler temperatures may result in slow and possibly incomplete processing, and warmer temperatures may result in processing times that are too short; hot solution temperatures could physically damage a print, especially the plastic coating of RC papers.

Prints are rarely washed individually. Instead, you keep several prints in the holding bath until you are ready to wash them all at once. If the holding bath doesn't have running water, change the water in the tray every 15–30 minutes or so to prevent too much fixer from accumulating and causing prints to be overfixed. Overfixing could cause image bleaching and make the print difficult to wash thoroughly.

Part II: Setting Up the Image

You first need to place the negative in the enlarger and prepare it for printing. Follow these steps:

Steps 1 and 2

1. *Place a strip of negatives in the negative carrier,* emulsion side down, with the negative frame to be printed centered in the opening of the negative carrier. The emulsion is the dull surface of the film. When held with the emulsion side down, text and numbers on the edge of the film will read correctly and the image will appear in the same orientation as it did when you shot it; if the negative is positioned emulsion side up, the resulting print will be laterally flipped (reversed left to right). Handle negatives only by the edges, as they smudge and scratch easily.
2. *Clean dust or other loose grit off the negative,* using canned air or another type of blower or a brush. Be careful that you don't accidentally scratch or otherwise damage the negative when cleaning it.
3. *Close the negative carrier and fit it tightly in place* in the enlarger head.
4. *Set the easel to the desired image size.* For most prints, you will want a white border, so the actual image size will be smaller than the size of the paper. If you want to print the full frame of a 35mm negative on an 8" x 10" sheet of paper, for example, you can set the image size on the easel for 6" x 9" or another size that matches the 35mm dimensions (about 1" x 1½").

negative carrier

Step 3

 Easels are constructed differently, but almost all have size scales, usually on the top, bottom, and/or sides. Using the scales, you position the blades of the easel to set the image dimensions. A very few easels are nonadjustable for a single, standard image size.
5. *Place the easel on the base of the enlarger,* centered below the lens.
6. *Turn on the safelight,* if you haven't done so. Some models take a few minutes to warm up.

Cleaning Your Negatives

Rubber blower

Compressed air

A negative's surface must be free of dust, dirt, grit, and other debris to guarantee the best possible prints. Dust or other small particles on the negative block light from passing through, creating white marks on the print.

There are several good cleaning methods to avoid dirty negatives. Dry film in a clean, dust-free environment (sometimes difficult to find in school and other gang darkrooms); place film in negative protectors as soon as it's dry (don't leave it for days in the school or other darkroom); and keep the protectors in a safe place (a binder or a box that closes completely and keeps dust out).

You almost always have to clean your negatives, no matter how careful you've been. Use a soft, wide brush to wipe loose dust off the surface. Keep the brush clean and use it with care, however, or it may mark or scratch the negative. Storing the brush in a plastic sandwich bag between uses is a good way to keep it clean.

Squirting air from a simple rubber bulb squeeze blower is another way to remove loose dust. Compressed air is a more expensive but usually more effective tool. Be careful not to shake the can before use and hold it upright; otherwise it may emit liquid propellant that you will have to clean off the negative. Several short bursts will more effectively dislodge dust than a single long blast.

Seriously dirty negatives may require more than air to get them clean, especially if the dirt or grit is stuck in the emulsion. Before taking extreme measures, first make a print to see if any marks show; some marks that are visible on the film may not appear in the print. If they do appear, you can use a film cleaning solution and a soft cloth, such as a chamois cloth or lens tissue. Make sure the cloth is clean (again, store it in a plastic sandwich bag between uses) and follow the packaged instructions. Most important of all, wipe the film very gently. You must be very careful when rewashing or using film cleaner; wet film is soft and very easily scratched or damaged.

You can always rewash and dry the negative, too. Lay the film in a small tray or place it in a processing tank and wash it gently with running water. Then dunk the film in a diluted solution of wetting agent for 1 minute and hang it to dry.

Step 9

7. *Turn off the room lights.*
8. *Turn on the enlarger.* Usually you do this using a focus switch on the enlarging timer. You should see a projected image on the easel, but it may be out of focus and/or dim.
9. *Open the aperture* of the enlarging lens to its largest f-stop to project a bright enough light to see the image clearly.
10. *Set the image size* by moving the enlarger head up or down on its rail, as needed. The projected image becomes larger as you move the head up the rail and smaller as you move it down. You also will need to adjust the

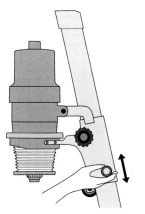

Step 10

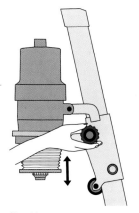

Step 11

position of the easel on the enlarger base until the projected image is closely framed by the easel blades. When you've achieved the desired image size, lock the head in place, usually by tightening the knob that attaches the enlarger head to the rail. Note that the image will probably be out of focus at this point; focusing comes next.

11. *Focus the negative* by turning the focusing knob to expand or contract the bellows. You can assess the sharpness of the projected image by eye, but you're almost always better off with a focusing magnifier, either a standard model that just magnifies the image or a grain focuser that allows you to focus on the film grain for even more accuracy.

Focusing affects image size to a degree, so you may have to lift the head up or bring it down to compensate. Work back and forth between setting image size and focus, fine-tuning the projected image until it is both the correct size and in focus.

For best focusing, you should position an extra sheet of printing paper (preferably the same type as the paper you're using for printing) in the easel and focus the projected image onto that paper—with the magnifier positioned on the paper. This way you will be focusing on the exact same plane as the printed image; otherwise you're focusing on the easel surface, which is very slightly lower than the paper surface. The white paper also may make it easier to see and focus the projected image. You can use the same sheet of paper for focusing whenever you set up to print.

Using a Grain Focuser

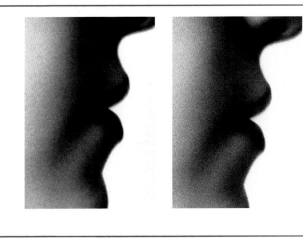

To get the sharpest possible print, use a grain focuser to magnify the image grain. As you turn the enlarger's focusing knob, you will see the blurry crystals (left) come slowly into focus (right). When the grain is sharp, the print is as focused as it can be. A grain focuser can be difficult to use. Be sure to place it in a dense area in the center of the projected image so you will have enough grain to focus on.

Cropping

The best way to get the composition you want is to carefully frame the subject when you take the picture. However, when printing, you can modify the composition by cropping. Here the framing was tightened by raising the enlarger head to show less of the picture, thus simplifying the composition.

You don't have to print the full negative image each time. Instead, you can choose to exclude part of the sides, top, and/or bottom of the image. This technique is called **cropping**; it allows you to print a portion of the negative instead of the **full frame** (the entire negative image). For example, if the full image is a portrait of a person from head to waist, you can print just the head and shoulders by raising the enlarger head on the rail until just these parts fall within the rectangular or square area defined by the blades of the easel.

Many photographers don't like to crop their work. Some even have a philosophical aversion to it, believing they should see and capture the photograph in camera and not rely on cropping in the darkroom to make the print. But there are some practical considerations, as well. Cropping produces a print with less sharpness and more graininess, because it involves a greater degree of enlargement.

On the other hand, judicious and minimal cropping can vastly improve the composition of some photographs without seriously compromising them technically. And some photographs may even be more interesting if they are a little fuzzy and grainy.

Setting the Image Size

When setting up the negative for printing, you must set the easel for the size of your image. This size is almost always smaller than the size of the printing paper, because easel blades cover the edges of the paper; the edges receive no light when the paper is exposed, thus producing a white border when the paper is developed. The size of the image and the width of the border depend on how you set up your easel.

Keep in mind that printing papers come in set sizes—8" x 10", 11" x 14", and so forth—but these sizes rarely match the proportions of your negatives. For instance, the proportions of 8" x 10" paper are more square than the proportions of the rectangular (about 1" x 1½") 35mm negative. Other negative sizes are not rectangular at all, such as the square 2¼" x 2¼".

If you want to print your 35mm negative on 8" x 10" paper with a half-inch border on all sides, you would set your easel to 7" x 9". However, this will require cropping the sides of the image, since 7" x 9" is more square than the dimensions of a full 35mm negative. If you want to print full frame, without cropping, set your easel to 6" x 9". Following are some suggested image sizes for different sizes of paper, when printing 35mm negatives.

Paper Size	Image Size, Full Sheet (cropped, ½" border)	Image Size, Full Frame (uncropped)
8" x 10"	7" x 9"	6" x 9"
11" x 14"	10" x 13"	8" x 12"
16" x 20"	15" x 19"	12" x 18"
20" x 24"	19" x 23"	15" x 22½"

Part III: Making a Test Strip

A **test strip** is a section of printing paper that shows a range of different exposures from a single negative. It's used to help determine the correct print exposure. While a test strip isn't foolproof, it is a good starting point from which you can fine-tune print exposure (and contrast).

Here are basic instructions for making a test strip, once you've already set the image size and focused.

Step 1

1. *Close down the lens aperture from its wide-open setting.* You can use any f-stop for printing, but the midrange stops, such as f/8 and f/11, are usually best to start with. In most cases, a larger lens aperture will provide more light than needed to make the exposure, while a smaller aperture may require an excessively long exposure.

 In the dark, you may have trouble seeing f-stop settings on the enlarging lens. Some enlarging lenses have illuminated settings, while others click at each full- or half-stop increment, allowing you to identify the settings. Simply turn the lens aperture ring (where the f-stops are set) until you hear

Test Strip

Make a test strip to determine your print exposure. The strip on the left shows a progression of exposures from 4 to 20 seconds. The 4-second exposure is too light and the 20-second exposure is too dark. The correct exposure is somewhere in between—here, 12 seconds, as seen in the print on the right.

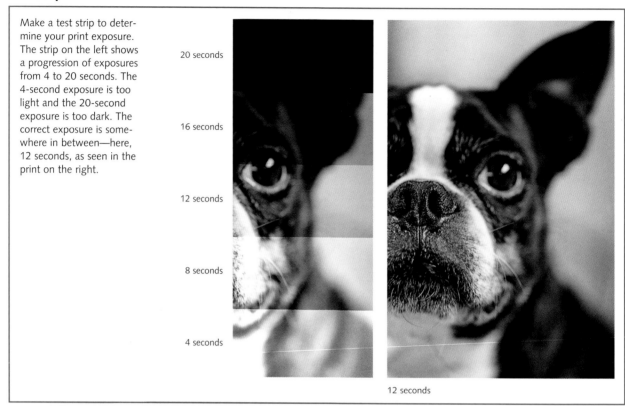

20 seconds

16 seconds

12 seconds

8 seconds

4 seconds

12 seconds

Fogged paper example: page 206

or feel it click to your desired opening. If the maximum f-stop of a lens is f/4, three full clicks bring you to f/11: first to f/5.6, second to f/8, and third to f/11. (With lenses that click every half stop, you'll need to click twice for a full-stop adjustment.)

2. *Remove a sheet of paper from its package.* Use the same size and type of paper as you will be using to make the final print, as different types of paper will provide different test results. When opening a package of paper, be sure that no light other than safelight strikes the paper. Even slight exposure to stray light will cause the paper to fog (darken) upon development. Before closing the package, rewrap the paper in the protective bag that came with it. Or place a quantity of paper in a paper safe, which is easier to access than having to open the package and repack the paper every time you need a sheet. Also, never leave unexposed paper out any longer than you need to, even under a safelight.

3. *Cut the sheet of paper into three or four strips.* You will need just one strip for the test, so put the others safely away in the paper box (or paper safe) for the future. You can use a full sheet of paper for the test but this is more costly and not really necessary (although a full sheet of paper will yield more information than a small strip).

4. *Lay the strip of paper under the easel blades, emulsion side up.* Identifying the emulsion can be difficult, depending on the paper type, but in general the emulsion side appears to be a little shinier than the base, and the paper tends to curl toward it.

 With experience you will learn where to place the strip of paper in the easel to provide the best test result. Look at the projected image and position the strip in an area with good distribution of light and dark areas. Avoid areas that are totally light or totally dark, since tests made in these areas aren't useful when trying to judge the correct exposure for the entire image.

5. *Cover about four-fifths of the strip with an opaque mask*—one that blocks light entirely, such as a piece of cardboard, a book, or (closed) printing paper package. Don't use a sheet of paper since it's not fully opaque; it will let some light through.

6. *Set the enlarging timer for 4 seconds.* This is a starting point only; the time you will actually need can vary widely, depending on many factors, including the density of the negative, brightness of the enlarging bulb, size of image enlargement, speed of the printing paper, and variable-contrast filter (if you are using one).

7. *Expose the section of the paper that's not covered by the mask.* You usually do this by pushing a button on your enlarging timer. This will make a 4-second exposure on one-fifth of the paper strip, while leaving the rest of the strip unexposed.

8. *Move the mask so it exposes another one-fifth of the strip.* Do this by lifting the mask off the paper and gently laying it back down in the desired spot, taking care not to move the strip in the process. To ensure that the test strip doesn't move, you should put the ends of the strip under the easel blades.

9. *Expose for another 4 seconds.* This will produce a total exposure of 8 seconds in the section first exposed (4 plus 4) and 4 seconds in the second section.

10. *Move the mask and expose the strip two more times,* as directed in steps 8 and 9. This will produce total exposures of 16, 12, 8, and 4 seconds in the various sections.

11. *Remove the mask altogether and expose the entire strip for a final 4 seconds.* Now the strip has five sections with a range of five different exposures:

Step 5

20, 16, 12, 8, and 4 seconds. When developed, this range should span from too light to too dark. Such a range will provide a good guide to the required print exposure for that particular negative.

There are many variations on how to make a good test strip. Some photographers prefer to use more or fewer exposures—maybe three exposures of 5 seconds each or eight exposures of 3 seconds each; keep in mind that if you have a bigger strip or a full sheet of paper more exposures are easier to read. With experience you will learn the best method for your own needs and for the equipment you use.

*Judging good print
exposure: pages 186–87*

Part IV: Processing Printing Paper

Follow these steps to process test strips or final prints. Processing times are suggestions only, as they will vary somewhat depending on the types of paper and chemicals you use. Refer to package instructions for specifics. Note that processing temperatures are not as critical for prints as they are for film. A range of 65–75°F is acceptable but 68–72°F is preferred.

Handle paper with care by its edges; don't touch the image area. Use tongs to gently grab the corners of paper in the solutions and when transferring paper from one tray to another.

1. *Slip the exposed paper into the tray of developer.* Emulsion side down is best to quickly soak the entire emulsion in the critical early stages of development; otherwise you run a risk of streaky results. After 15–20 seconds or so you may want to flip the paper over to watch the image form.

Step 1

2. *Agitate the solution* by rocking the tray to ensure that fresh solution constantly flows over the paper surface. Agitation should be gentle, but constant. Develop 1–1½ minutes with RC papers and 2–3 minutes with fiber-based papers.

 Be sure to keep the paper in the developer for the entire recommended time, even if the image looks too light or too dark. You can't accurately judge print density under safelight illumination. In fact, the image sometimes appears almost fully developed in a relatively short time (maybe 30–45 seconds), but it continues to develop more subtly after that. Another reason to develop for the full time is consistency; to be able to predictably repeat print results you must keep both exposure time and developing time constant.

Step 2

3. *Lift the paper out of the developer* solution by one corner, using tongs, about 5 seconds before the developing time is up. Hold the paper—don't shake it—over the developer tray for a few seconds so the excess solution drains off the bottom corner. The image may continue to form as long as the paper

During processing, use tongs to hold and transfer paper from tray to tray.

Step 5

Agitate constantly and gently by rocking the tray.

Keep fixed prints in the holding bath until you are ready for a wash at the end of the printing session, or until you have filled the holding-bath tray with prints.

Washing prints: pages 199–200

is soaked with developer, which is why you want to take it out of the developer a few seconds early.

Use different tongs for each solution. Do not allow the tongs from the developer to dip into the stop bath solution when transferring the print, or you may contaminate the tongs and the solutions. Contamination can cause print staining and reduced solution capacity.

4. *Put the paper in the stop bath.* Soak it for 15–30 seconds (for RC papers) or 30 seconds to 1 minute (for fiber-based papers). The mild acid solution stops development with no visible change in the image. Agitate in the stop bath for the entire time by gently rocking the tray.

5. *Remove the paper from the stop bath* a few seconds before the time is up.

6. *Put the paper in the fixer.* To avoid contamination, do not dip the tongs from the stop bath into the fixer solution. Fixing time depends on the type of fixer you use, its freshness, and the type of paper you use. Standard fixers generally need 3–5 minutes with RC papers and 5–10 minutes with fiber-based papers; rapid fixers take about half that time. The shorter times are for solutions that are newly mixed and the longer times are for solutions that are almost used up.

Agitate for the entire time the paper is in the fixer by gently rocking the tray. The fixer clears away the paper's unexposed and undeveloped silver, allowing you to view the strip in the light. (Without adequate fixing, the paper will darken when the lights go on.) You can actually turn on the lights after a short time in the fixer (after 30 seconds to 1 minute) if you're anxious to view the results. Before turning on the room lights, be sure you've stored all unexposed printing paper safely away. And make sure to put the paper back in the fixer for the full recommended time if you plan to save the print.

If you're working with others in a gang darkroom, you won't be able to turn on the lights whenever you want to see your print. Instead, rinse the partially or fully fixed print, place it in a clean, dry tray to keep solution from dripping on the floor, and carry it out of the darkroom to view and evaluate it.

7. *Remove the paper from the fixer,* once it's fully fixed, a few seconds before the time is up. Again, use tongs and let the excess solution drain off.

8. *Put the paper in the holding bath* until it's ready for a final wash or until you have filled the holding-bath tray with prints. (It's okay to use the same tongs for the fixer and holding bath.) Use a siphon in the holding-bath tray to recycle the water, or change the water in the holding bath every 15–30 minutes or so. This will prevent fixer from building up in the bath, which could cause the prints to be overfixed. You could wash each print individually as you make it, but doing so would be a waste of valuable time and water.

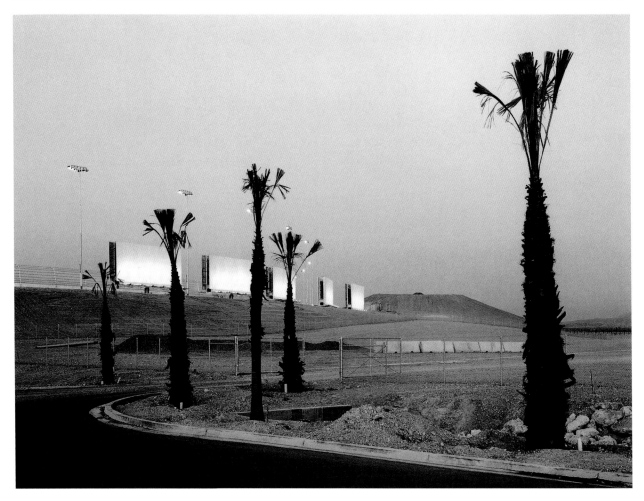

Steve Smith, *Las Vegas, Nevada,* 1997

At one time, landscape photography emphasized the majesty of pristine wilderness.
Instead many contemporary photographers like Smith comment on the human presence
as an important part of nature. His long-term project on development in the American
West demonstrates the precarious balance between human and natural environments.
© Steve Smith; courtesy of the artist.

Usually, you process black-and-white prints in trays of developer, stop bath, and fixer solutions. But there also are **automatic processors** available to do the job. The most common type, called roller-transport, contains trays of solution. You place the exposed paper into a slot on one end of the processor. Rollers pick up the paper and automatically carry it through a series of chemical solutions until it comes out the other end, fully developed and (on some models) washed and dried. While these processors are convenient, they typically require a lot of maintenance. Also, they can only process RC printing papers; they can't process fiber-based papers.

Part V: Determining Print Exposure

Once you've processed the test strip, examine it carefully to determine the best exposure for the final print. You will find that some tests are more useful than others, depending in large part on where you've positioned the test strip. The section of the image that shows on the test should be an important part of the overall picture, such as skin tone in a portrait subject. It also should contain a good range of light and dark areas.

The light by which you view the test also is important. It shouldn't be too bright or too dark, and it should be positioned at a slight angle to the print; if directed straight at the print, the light may be too bright for an accurate evaluation or cause glare that makes it hard to see subtle tonal values.

The finished test strip should have a range of five exposures (or however many exposures you gave it). The best tests are too dark on one end and too light on the other, with the sections in the middle showing a range of print densities. However, its is not uncommon to get a test strip that is too dark or too light overall. Test strips that are too dark need less time and/or a smaller lens aperture. Try a new test with 2-second intervals instead, or close down the lens one or two stops and test again at 4-second intervals. Test strips that are too light need more time and/or a larger lens aperture. Try a new test with 8-second intervals, or open the lens one or two stops and test again at 4-second intervals.

Good test strip example: page 180

When evaluating the test, concentrate on important and clearly identifiable areas of the subject. Skin tones, for example, should have good detail and texture. Blue jeans should be dark, but not pitch black, and snow should be white, but not washed out.

Sometimes the correct exposure is somewhere between sections of the test strip. If the 8-second exposure looks a little light and the 12-second exposure is slightly dark, about 10 seconds is probably right. If this is the case, there is no need to make a new test strip.

About Print Exposure

Latent image: page 25

Print density is the overall brightness or darkness of the print.

Before you make a test strip, there are some fundamental points about print exposure that you should know.

When you expose printing paper to light through a negative, an invisible latent image is formed on the paper—just as film holds latent images when exposed in camera. Soaking the paper in processing chemicals develops that image. The greater the amount of light striking the paper, the darker the developed image. Like film, dark areas of the print are made up of metallic silver.

Exposing printing paper through a negative reverses the tones of the negative in the print. More light passes through the shadow (thin or nearly clear) areas of a negative than through its highlight (dense) areas. Thus, more light reaches the paper in what will become the dark areas of the print than in the highlights, thereby matching the original subject.

Print density refers to the overall brightness or darkness of the print. It's determined by exposure—the amount of light that reaches the printing paper. Too much exposure produces a print that is too dense (dark); too little exposure produces a print that is not dense enough (light). A **dense** print is dark all over—in both the highlight and shadow areas; a **light** print lacks density in both highlights and shadows.

There are several factors that determine how much exposure is needed to make a good print. These include the density of the negative (dense negatives need more exposure than thin negatives), the brightness of the enlarger light (some bulbs are brighter than others), the type of paper used (like film, some are more

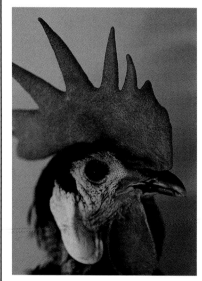 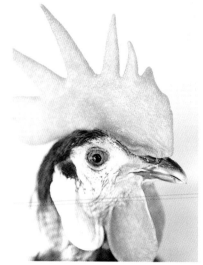 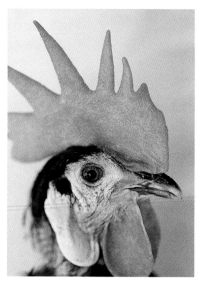

Too dense (dark)
24 seconds at f/11

Too light
8 seconds at f/11

Just right
16 seconds at f/11

About Print Exposure (continued)

Adjusting exposure time and lens aperture are the main ways to control print density.

light-sensitive than others), and the variable-contrast filter used, (high-contrast filters generally need the most exposure).

These factors are sometimes controllable: You can put a brighter or dimmer light in your enlarger or use a faster- or slower-speed paper. But the two primary ways to control print density are by varying the exposure time and/or the aperture of the enlarging lens to change the amount of light that strikes the paper. Exposing paper for more time produces a denser print; exposing it for less time makes a lighter print. Opening up the lens aperture produces a denser print; closing it down produces a lighter print.

Note that these variables correspond to the primary camera controls of film exposure: shutter speed and lens aperture. The same reciprocal relationship exists; if you increase one, you must equally decrease the other to keep exposures constant. So a print exposure of f/11 at 12 seconds produces the same results as an exposure of f/8 at 6 seconds. As you open the lens aperture (from f/11 to f/8), you double the amount of light traveling through and must halve the amount of exposure time (12 to 6 seconds) to compensate.

There's no need to save your test strip: Use it for reference until you've made your final print, and then discard it. If you reprint the negative at a later time, you will need to make a new test strip anyway, since equipment, materials, and other conditions may change.

A simple printing system: page 197

Once you've determined an exposure time, place a fresh, full sheet of paper in the easel emulsion side up, reset the timer for 10 seconds (or whatever time you've chosen), and expose the paper. Don't change anything but the exposure time—not the f-stop setting, easel location, image size, or focus (unless you need to refocus because the test image is not sharp).

Develop, stop, and fix the exposed paper. Then examine the print again in room light. The main factors to consider when evaluating the print are overall density and contrast—and whether specific image areas need to be darker or lighter than the whole. Pay particular attention to the print highlights and see that they look right.

Overall density is controlled by print exposure. If your print is dense (too dark), you will need to make a new print using less time and/or a smaller lens aperture. If your print lacks density (too light), make a new print using more time and/or a larger lens aperture. Making small changes to the exposure time is generally the best way to make subtle adjustments.

Generally, correct print density means a good range of tones from light to dark, with detail in most highlight and shadow areas. But, ultimately, correct

Black Border

You can produce a black border around your image by using a negative carrier with an opening that is slightly larger than the negative.

Some photographers like the look of a black border around their image to help frame the picture. You can make a black border by using a negative carrier with an opening slightly larger than the image area of your negative. The larger opening allows you to position the negative in the carrier so the film's clear plastic edges show on all sides. Clear plastic doesn't block any light so the border is fully exposed and renders black in the developed print.

Most negative carriers don't have an opening large enough to produce a black border. If yours doesn't, use a flat file to enlarge the opening. Don't make the opening too large, or the carrier might not hold your negatives flat. Blacken the filed-out metal with a waterproof marker so the metal doesn't reflect stray light.

To make a black border, position the negative in the carrier so the clear plastic edges show up in the opening. Set the print size on the easel and focus the image as you normally would. Then enlarge the blade size on the easel to leave a little extra room around the focused image. Most photographers print a very clean, thin line of 1/8 " or so, but you also can make the border larger or even jagged if the opening is not smoothly filed out; just make sure the border size doesn't overwhelm the picture.

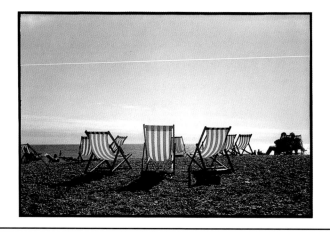

density is somewhat subjective. There's a range of acceptability, as some photographers like their prints a little dark and others like them on the light side.

Still another consideration in determining correct print exposure is print size. The more you enlarge a particular negative, the greater the required exposure. For example, a negative printed at 8 " x 10 " may take 10 seconds at f/11 to achieve good overall density, whereas the same negative printed at 11 " x 14 " may need 20 seconds or even longer at the same lens aperture. You will have to make a new test strip any time you adjust the image size.

Print size affects overall density; the larger the print of a particular negative, the longer the required exposure, all other things being equal.

Prints generally dry a little darker than they look when wet. This occurrence, called **dry down**, is most noticeable with fiber-based papers. The result is sometimes subtle, but is important, and should be considered when evaluating your prints.

Part VI: Controlling Contrast

Variable-contrast filters: page 165

The primary control of **print contrast,** the difference between shadow and highlight areas in your print, lies in the contrast grade of paper you use—a choice of either variable-contrast papers (controlled by filters or a variable-contrast enlarging head) or graded papers. Variable-contrast filters are easy to use, readily available, and inexpensive. However, the individual filters also are easy to lose and scratch (or otherwise damage).

A variable-contrast enlarging head allows you to dial in filters for convenient and precise contrast control.

Variable-contrast enlarging heads are available for some enlarger models; these are more expensive than variable-contrast filters, but provide a more efficient, convenient, and precise method of adjusting contrast when you use variable-contrast papers. Such heads have built-in filters, allowing you to simply dial in the desired contrast grade. Also, they allow even finer incremental changes in contrast than the half steps allowed by individual filters.

Both variable-contrast and graded papers use the same contrast rating system—the higher the number, the greater the contrast. Most variable-contrast papers offer a contrast range from #0 to #5, with #0 representing the lowest possible contrast and #5 the highest—with half-step increments in between (#0, #½, #1, #1½, #2, and so forth). Graded papers offer a narrower range of contrasts—usually in whole steps from #1 to #4. In virtually all paper types, a #2 (or so) represents average contrast; this also is the approximate contrast level of most variable-contrast papers when used without a filter.

Follow these instructions to adjust print contrast:

1. *Make an initial print with good overall density,* following the instructions on the previous pages. It's easiest to evaluate print contrast with a well-exposed print. If you are using variable-contrast paper, put a #2 filter in the enlarger's filter drawer before you expose your paper.
2. *Examine the print for contrast.* Look closely at the range of tones. Prints with normal contrast have both dark and light areas with lots of grays in between. High-contrast prints have mostly dark shadows and light highlights, while low-contrast prints are mostly gray—lacking deep blacks and/or bright whites.

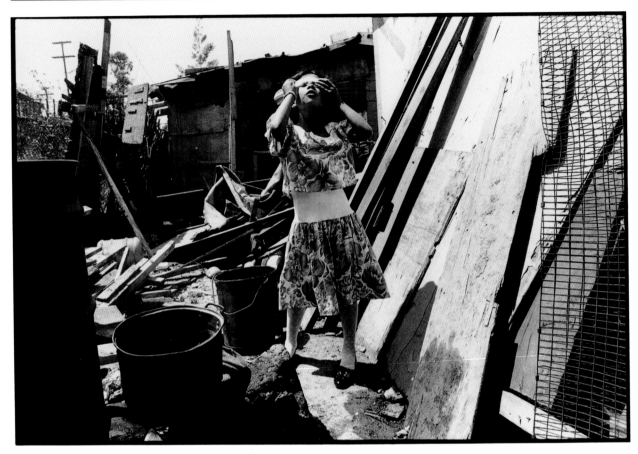

Jack Lueders-Booth, from *Inherit the Land,* Tijuana, Mexico, 1995

Documentary photographers like Lueders-Booth rely on photography's power of description to portray their subjects' lives. This image is from Lueders-Booth's project on Mexican families who live in garbage dumps. To convey as much information as possible, he carefully controlled print contrast to maintain good detail in both the dark shadows and bright highlights. © Jack Lueders-Booth; courtesy Scrabble Hill Gallery, Deer Isle, ME.

Step 3

Using different filters or different grades of paper often requires changing the exposure time.

Print contrast is somewhat subjective; some photographers prefer high contrast while others prefer low contrast.

3. *If your print has too much contrast, remove the #2 filter and place a lower-contrast filter,* perhaps a #1, in the enlarger's filter drawer; if it has too little contrast, use a high-contrast filter, such as a #3. Or, dial in the desired contrast if you are using a variable-contrast enlarging head. With graded papers, the lowest contrast is usually a #1 or #2 and the highest is #3 or #4.

4. *Make a new print,* using the same exposure. Sometimes you can tell from the test strip whether you like the contrast of the new print. If the contrast seems too low or too high, don't bother to make a new print; simply choose a higher- or lower-numbered contrast and make a new test strip.

5. *Examine the new print for both density and contrast.* In general, shadow areas on most prints should be dark, but still retain some detail or texture; they should not become solid black. Most light areas should be bright, but still show detail; they should not become solid white.

6. *Adjust the exposure time if the print is still too dark or too light, and/or replace the variable-contrast filter or graded paper if the print is still too low or too high in contrast.* It is very common to have to go back and forth a few times, adjusting exposure and contrast, until you get the results you want.

 Some variable-contrast filters hold light back to varying degrees, so you may need to adjust exposure after changing filters. How much depends on the filter you use; magenta or reddish-orange (high-contrast) filters require more exposure than yellow (low-contrast) filters. If you use graded papers, you also may have to make exposure changes as you change contrast grades.

Like good print density, good print contrast is somewhat subjective. Some photographers like their prints with a hard (high-contrast) edge; others like a soft (low-contrast) look. Also, different kinds of pictures might benefit from different treatment—for example, you may like your landscapes high in contrast and your portraits softer.

Here are some other things to keep in mind about print contrast:

- Print contrast is in large part determined before you even begin printing—when you take the picture and develop the film. Such factors as subject lighting, choice of film, film exposure, and film development all contribute to the negative contrast, which goes a long way toward determining print contrast.
- The effect produced by variable-contrast filters and graded papers is relative. Using a #5 filter with variable-contrast papers does not necessarily produce a high-contrast print. It only produces a higher-contrast print from the same negative than a #4, #1, or any other filter with a lower number than #5 would. If your negative lacks contrast, you will need a high-contrast filter or paper grade to produce a print of normal contrast. If your negative has inherently high contrast, you will need a low-contrast filter or paper grade for a normal-contrast print.

Print size affects contrast; the larger the print made from a particular negative, the lower the print contrast.

- Print contrast also is affected by the print size. Enlarging an image reduces print contrast. So if you make a good 8" x 10" print with a #2 filter, you may need a #2½ or #3 filter (or so) if you make a 16" x 20" print from the same negative.
- You will get somewhat different results depending on the brand and type of filters and papers you use. A print made with a Kodak #4 filter and Agfa variable-contrast paper may have more or less contrast than a print made from the same negative, using paper and filters from the same manufacturer. The brand of filter also may make a difference. And a #3-graded Kodak paper won't necessarily produce the exact same level of contrast as a #3-graded Agfa paper.
- Other factors, such as changes in the type of print developer or its dilution, temperature, or development time, also affect print contrast—although such differences are usually fairly subtle. For instance, some types of developers are formulated to produce prints with more or less contrast than others.

Part VII: Burning-in and Dodging

A print may have good overall density and contrast, but still have areas that are either too bright or too dark. **Burning-in** is a technique used to darken a specific area of a print by selectively adding exposure. **Dodging** is a technique to lighten a specific area of a print by selectively holding back exposure. Most prints require some burning-in and/or dodging for best results.

Burning-in is to selectively darken a specific area of a print by adding extra light after the initial exposure.

 Burning-in and dodging are critical fine-tuning steps—often making the difference between an adequate print and an excellent one. With some prints, you only have to burn-in or dodge one area to produce a satisfactory print. But be patient: it's not uncommon to have to burn-in and dodge multiple areas.

Burning-in. To understand burning-in, imagine a well-exposed print made at f/11 at 10 seconds with a #3 filter. Once developed, the print may show good overall density and contrast, yet have an upper left corner that is too light. You can make that corner darker without affecting the overall brightness of the rest of the print by making another print with the same settings, then adding extra exposure only to the area that needs darkening.

 Follow these instructions to burn-in an area of a print:

1. *Place a fresh sheet of printing paper in the easel, and expose it for the time needed to produce a good print*—in the above example, f/11 at 10 seconds (with a #3 filter).
2. *After the paper has been exposed, hold a piece of cardboard or other opaque mask just under the lens.* Examples of other masks include a book, a notebook, your hand, or a commercially made burning-in tool; do not use a piece

Print Contrast

Variable-contrast papers give you a lot of control over print contrast—the difference between the highlight and shadow areas. If a print made with a #2 filter is too gray (upper left), increase contrast by making a new print with a #3 filter (upper right). On the other hand, if a print made with a #2 filter has too much contrast (lower left), decrease contrast by making a new print with a #1 filter (lower right).

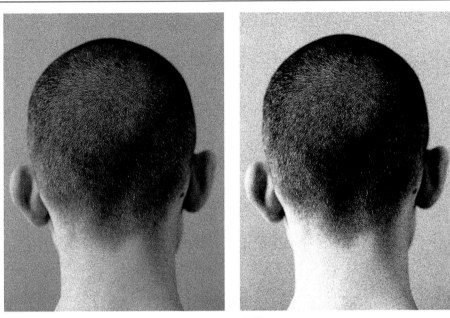

#2 filter

#3 filter

#2 filter

#1 filter

Summary: Print Processing

These are times and capacities for standard print processing. They are intended as guidelines only and vary according to the brands used, dilution, and other conditions of use. Times and capacities also vary depending on whether you use RC or fiber-based (FB) papers.

Step	Time	Comments	Capacity*
Developer	1–1½ min (RC papers) 2–3 min (FB papers)	Agitate constantly; dilute according to manufacturer's instructions; develop for at least the minimum recommended time.	50–100 8"x10" prints (or equivalent) per quart of working solution.
Stop bath	15–30 sec (RC papers) 30 sec–1 min (FB papers)	Agitate constantly; dilute according to manufacturer's instructions.	50–75 8"x10" prints (or equivalent) per quart of working solution.
Fixer	3–5 min (RC papers) 5–10 min (FB papers) About half these times with a rapid fixer.	Agitate constantly; do not overfix.	40–60 8"x10" prints (or equivalent) per quart of working solution.
Water rinse	5 min (FB papers)	Not needed with RC papers.	Not applicable.
Fixer remover	2–3 min (FB papers)	Not needed with RC papers.	50–75 8"x10" prints (or equivalent) per quart of working solution.
Holding bath	For the length of the printing session, or until the bath is filled with prints.	Keep fixed prints in bath until ready to proceed to final wash.	Change water every 15–30 min or so.
Final wash	5–10 min (RC papers) 20–30 min or longer (FB papers treated in fixer remover)	Agitate; make sure wash water is constantly changing; don't wash more than 15–20 prints at a time; time varies with the effectiveness of the wash.	Not applicable.

*The following are approximately equal to 50–100 8" x 10" prints: 100–200 5" x 7" prints; 25–50 11" x 14" prints; and 12–25 16" x 20" prints.

of paper, as paper will let some light through. Take care that you don't accidentally bump the enlarger or move the easel while positioning the mask.

3. *Turn on the enlarger and burn-in by moving the mask so the projected light falls only on the area of the paper that needs darkening*—in this example, the upper left corner. Burn-in exposure times vary widely; you might start by using the same amount as the initial exposure—here, 10 seconds.

 Move the mask back and forth slightly but keep it in constant motion to blend the additional exposure into the rest of the image; otherwise the burn will leave a noticeable line. In practice, parts of the image adjacent to the burned-in areas often receive additional exposure, but if blended correctly, this should not appreciably affect the overall look of the print.

4. *Process the print.* The results should show the same overall density and contrast as the initial print, but with a darker upper left corner. If the corner still looks too light, make another print and burn in for a longer time; if it's too dark, burn in for less time.

Keep the mask in motion as you burn-in or dodge.

Bad burning-in example: page 207

The amount of burning-in can be moderate or considerable. To darken an area moderately, try a burn of 30–50 percent of the initial exposure (3–5 seconds more exposure for an initial exposure of 10 seconds). If the area needs more significant darkening, burn-in for at least 100 percent of the initial exposure time (a 10-second burn for a 10-second initial exposure). And don't be surprised if very bright areas, such as overcast skies, require burning-in for three or four times the initial exposure (30–40 seconds more for a 10-second initial exposure)—or even longer.

If the area to be burned-in is along the edge of the image, you can use just an opaque mask to do the job. If the area is in the middle of the image, however, you will need an opaque mask with a hole cut in the center. Let light project through the hole to the areas of the print that need darkening. You can use a commercially made burning-in tool, or you can make your own with a piece of cardboard, and punch out the hole yourself. Make several such tools, each with a hole of a different size and shape.

You can vary the size of the projected beam of light either by stocking several masks, each with different-size holes, or by varying the position of the mask under the enlarger. Lifting the mask up toward the lens makes the circle of projected light broader, while bringing it down toward the easel makes it narrower. If you position the mask close to the easel, be sure it is large enough so that light doesn't spill over and accidentally expose the edges and corners of the paper.

Burning-in

After establishing the correct overall print density and contrast, you may have to selectively darken one or more specific areas of the image, a technique called burning-in. Here the print on the left, exposed for 10 seconds, looks good except for an area along the top that is too light. A second print was made, again at 10 seconds, but an additional 10 seconds was added only to the top area to darken it.

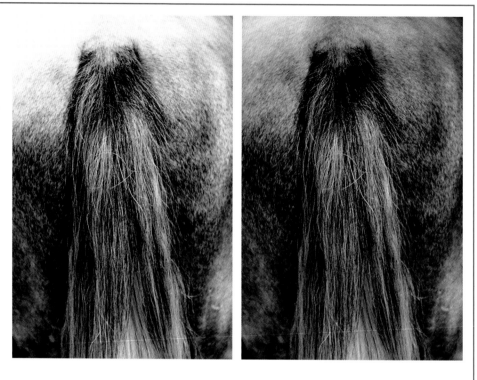

To burn-in an area in the middle of your image, use an opaque piece of cardboard with a hole punched out to let in additional light to expose the paper in selected areas.

A Simple Printing System

Here's a simple system for evaluating and controlling print exposure and contrast. Examine highlight areas and shadow areas separately. Let the exposure time determine your highlight density and the filter or paper-grade choice determine your shadows.

Here's how it works: Make a test strip and an initial print to establish an exposure time that produces good highlight density—where the light areas look right—regardless of how light or dark the shadows look. Once you have a print with good highlights, examine the shadow areas; if they look too light, make another print with increased contrast, and if they look too dark, make another print with less contrast. When you change contrast to control the shadow areas, you may well have to change exposure time to maintain the same highlight density—depending on your materials and how much of a contrast change you make.

In examining highlights and shadows, pick important areas that are not overly bright or dark. Such bright or dark areas often need to be dealt with by burning-in or dodging, after making your exposure and contrast decisions. For example, if an area remains too bright even when every other area in the print looks good, you will probably need to burn it in. Conversely, if an area is too dark when the overall print looks good, you will probably have to dodge it.

Dodging. Dodging is the opposite of burning-in. It allows you to selectively lighten a specific area of a print by holding back light from that area during the initial exposure. If you dodge correctly, the rest of the print will not be affected. Suppose you have a print that looks good overall using an exposure of f/11 at 10 seconds with a #3 filter, but the upper right corner is too dark. Following are basic instructions for dodging.

Dodging is to selectively lighten a specific area of a print by blocking light during the initial exposure.

1. *Place a fresh sheet of printing paper in the easel, and expose it for good overall exposure and contrast*—here, f/11 at 10 seconds with a #3 filter.
2. *During that exposure, place a piece of cardboard or other opaque mask under the lens to dodge (block) light from reaching the area that is too dark (upper right corner).* Dodging times vary widely, but try 10–20 percent of the initial exposure—here, 1–2 seconds.

 During the exposure, the image will be projected on the mask, which can help you to guide its position for dodging. Move the mask back and forth in constant motion to blend the dodged area into the rest of the image; otherwise the dodge will leave a noticeable line. In practice, parts of the image adjacent to the dodged areas may receive a little less exposure, but if blended correctly this should not appreciably affect the overall look of the print.

Dodging

After establishing the correct overall print density and contrast, you may have to selectively lighten one or more sections of the image, a technique called dodging. Here the print on the left, exposed for 10 seconds, looks good except for an area on the right that is too dark. A second print was made, again exposed for 10 seconds, but during exposure light was held back from the right side for 2 seconds to lighten it.

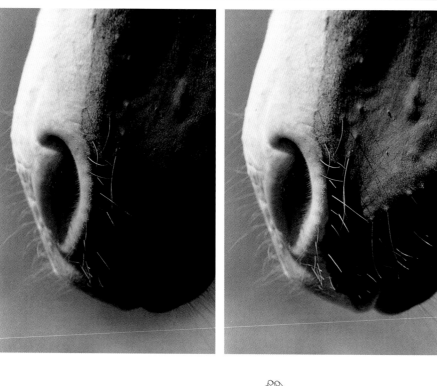

To dodge an area in the middle of your image, use an opaque piece of cardboard on a wire handle to hold back light during an exposure.

3. *Process the print.* The results should show the same overall density and contrast as the initial print—with a lighter upper right corner. If the corner still looks too dark, make another print and dodge for more time; if it's too light, dodge for less time.

Bad dodging example: page 206

To lighten an area moderately, try a dodge of 10–20 percent of the initial exposure, as described in step 2. If the area needs more significant lightening, dodge for about 30 percent of the initial exposure (a 3-second dodge for a 10-second initial exposure). More than 30 percent usually makes the dodged area of the print look too light, uneven, and/or muddy.

You can dodge an area in the center of a print using a commercially made dodging tool, or you can make your own by taping a small piece of cardboard onto the end of a stiff wire handle (such as a straightened paper clip or a wire clothes hanger). Make several such tools with different pieces of cardboard of various sizes and shapes.

During the exposure, position the dodging tool so that its cardboard end blocks light from reaching the area that needs lightening. And again, keep the entire tool in motion while dodging for even blending with the adjacent image areas.

Dodging times tend to be shorter than burning-in times.

Avoid short overall exposure times when dodging. Say that you have an initial exposure of f/8 at 7 seconds, and you need only about a 10 percent dodge (.7 seconds) in one area. It's virtually impossible to accurately time so short a dodge. So extend the exposure by closing down the lens aperture. Closing it to f/11 would make an equivalent exposure time of 14 seconds (the smaller opening allows half as much light through the lens, so requires twice the exposure time), and closing it to f/16 would make an equivalent exposure time of 28 seconds. A 28-second exposure would permit a more controllable 10 percent dodge: 2–3 seconds, rather than less than 1 second.

Part VIII: Washing Prints

Once a print is fixed, it sits in the holding bath of water until you are ready to wash several prints at a time. The main purpose of the wash is to eliminate all traces of the fixer; inadequately washed prints will stain, discolor, and/or fade over time.

Fiber-based prints require a more thorough washing than RC prints.

RC prints don't require a long wash, because their plastic coating prevents fixer from sinking deep into the paper fibers. A short running-water wash of 5–10 minutes should do the job. However, fiber-based papers absorb much more fixer, so they require a far more thorough wash. A plain water wash is not really adequate; first wash prints for 5 minutes, treat them in fixer remover for at least 2–3 minutes, and then put them in a final running-water wash for at least 20–30 minutes.

Manually agitate prints in the fixer remover by shuffling the print at the bottom of the pile to the top. Keep shuffling until the recommended time in the fixer remover is up. Wear rubber gloves when handling the prints in solution, and be very careful not to physically damage the prints as you agitate.

The exact time needed to wash prints varies with several factors, including the brand of fixer remover and (especially) the effectiveness of the wash. For an effective wash, you will need a print washer that provides a constant supply of fresh water. Soaking a print in water isn't enough; to eliminate the fixer, you need the wash water to recycle on a constant basis.

A simple wash using a tray and siphon, with holes punched on the side at the bottom.

You can make a serviceable print washer using a plain processing tray (larger and deeper than your other processing trays, if possible) and a **siphon,** an inexpensive plastic device that clips onto the side of a tray. The siphon connects to a water faucet with a rubber hose, allowing water from the faucet to enter the tray at the top of the siphon, while it sucks out tray water from the bottom. You can make the draining action, and thus the water exchange, more effective by punching small holes in the sides of the wash tray, toward the tray's bottom.

To guarantee that they don't stick together and inhibit the wash, manually agitate the prints much as you do in the fixer remover—shuffling the print at the bottom of the pile to the top. To guarantee a completely fresh supply of water, stop every minute or so and drain all the water from the tray and start again.

This method will get the job done, but it is time consuming, and you will have to be very careful not to physically damage the prints with the running water and agitation. It's best to use a proper print washer. There are several types available, including **archival washers** with a tank made of thick plastic and with several slots to hold prints—one print per slot. Separating prints from each other in this way (with dividers) guarantees that each print gets a full and complete wash.

An archival washer is an efficient way to wash prints because it holds prints in slots, one print per slot.

Archival washers do their work automatically. Just fill the tank, and a hose at the bottom of the washer takes fresh water in and drains fixer-laden water over the top of the tank. Some models take water in from the sides and top, and then drain it out the bottom.

The number of prints you can wash at one time depends on the type of washer you use. If you are using an archival washer, fill it to capacity, one print per slot; if you are using a more manual washing method, don't wash more than 15–20 8" x 10" prints at the same time—and fewer, if you are making larger prints. If you have made more than 15–20 prints, wash them in separate batches.

Once a wash has started, do not add another print from the holding bath. If you do, it will contaminate the wash with residual fixer. If that does happen, start the timing of the entire wash over from the moment you put in the last print.

Part IX: Drying Prints

For quicker and more even drying, squeegee washed prints to remove excess water. Place each print, one at a time, face down on a large sheet of glass. Plexiglas or the back of a smooth-bottomed processing tray or any flat, clean, waterproof surface also may do. Make sure the surface is extremely clean; traces of fixer or other chemicals may cause a print to stain right away or as the print ages.

To remove excess water, squeegee prints carefully before drying, but be very careful not to scratch the image.

Air drying prints is the simplest and in many ways the best method.

Run a clean rubber squeegee or sponge dedicated to this purpose over the back of the print. Do not squeegee too hard or the print may crease or scratch. Turn the print over, squeegee the glass or tray surface to remove excess water, and then gently squeegee the front, taking extra care not to scratch the image.

Once squeegeed, prints are ready to be dried. You can either air dry them or use a heated drier. Air drying is the simplest, cheapest, and in many ways the best choice. There are two basic methods: hanging prints up or placing them flat on a screen. Whichever you choose, expect a drying time of about 30 minutes for RC prints and 4–8 hours for fiber-based prints—and possibly even longer, depending on room temperature and humidity.

To hang prints up, stretch a piece of string or light wire in or near your darkroom, much like a clothesline. Then use a single plastic spring-type clothespin (wooden pins can leave a stain) to hang each print by one corner. Or you can clip two prints together, back to back on the line, clipping each pair of corners (four clothespins total), to help reduce the tendency of prints to curl.

Another method of air drying is to place squeegeed prints on plastic screens, much like window screens; don't use metal screening, which will rust and stain prints. You can get commercially made drying screens from a few suppliers, or you can use new standard window screens, as long as the screening is plastic. You also can construct your own drying screens by building a frame and attaching plastic screening material (available at any hardware store) with staples. Use four pieces of inexpensive 1" x 2" (or other size) wood stock for the frame, and then screw the wood together, using metal corner braces to keep it square.

You can make drying screens of any size to fit your space and storage requirements. It's okay to stack several screens on top of each other to save space, as long as the frames keep the prints separated; but the more space you leave between the screens, the faster the drying time—especially with fiber-based prints. Make sure you wash drying screens regularly with a mild soap or fixer remover solution, followed by a thorough rinse, to keep them clean and uncontaminated.

For air drying on a screen, place squeegeed RC prints emulsion side up; otherwise the screen might produce pattern marks in the plastic print coating. You can safely place fiber-based prints emulsion side down or up on screens. Placing them down helps keep prints flat, as fiber-based papers are more likely to curl when drying.

Drying Prints

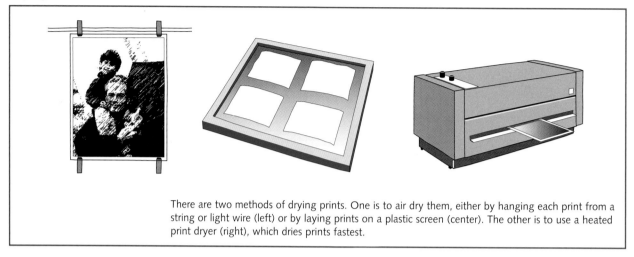

There are two methods of drying prints. One is to air dry them, either by hanging each print from a string or light wire (left) or by laying prints on a plastic screen (center). The other is to use a heated print dryer (right), which dries prints fastest.

There are many types of heated print dryers available for RC and fiber-based prints; some are set up to handle only RC prints, while others can handle both types. In a pinch, you can use a hairdryer set on medium to quickly dry squeegeed RC prints. For even drying, make sure you keep the unit in motion as you dry—and don't let the paper get too hot.

Simple print dryers have a smooth metal heating plate with a cloth (or other) cover. You place squeegeed prints one at a time between the cloth and the plate, and the heat dries them. Other types are essentially heated boxes with rollers; you place your squeegeed print in one end, and the rollers pick it up and carry it through the heated unit and out the other end, fully dried. There also are larger and more elaborate models. With one type, you place squeegeed prints on a cloth sheet, which rolls into a rotating heated drum. The drum pulls the cloth and prints around at one end and deposits the dried prints at the other.

If you use a heated dryer, keep it clean to avoid contaminating prints as you dry them.

Flattening prints: page 239

Heated drying is faster than air drying, and usually leaves prints flatter. However, dryers must be maintained so they will keep working well. They also must be cleaned regularly, because they can pick up residual chemicals from poorly processed and washed prints, especially in a gang darkroom where some individuals will be more careless than others. This means that heated dryers, unless they are kept very clean, can potentially contaminate prints. Air drying takes longer and often leaves prints slightly curled, but it is simpler, less expensive, and relatively contamination-proof (assuming that, if you use drying screens, you wash the screens regularly); curled fiber-based prints can be flattened after they have dried.

Making Contact Sheets

Contact prints are the same size as the negative; contact sheets are usually made from an entire roll of film.

Contact sheets allow you to see what you have on the film and easily file and organize your negatives.

For every roll of film you shoot, you should make a **contact print,** a print that is the same size as your negatives (as opposed to enlargements, which magnify negatives). A contact print from a 35mm negative measures just under 1" x 1½" (24 x 36 mm); a contact print from a 6 x 7 cm negative measures 2¼" x 2¾" (6 x 7 cm); and so forth.

Because the images are not enlarged, contact prints show maximum sharpness and no visible grain. Contact prints from large-format negatives, are sometimes used as final prints because of their sharpness and sufficient size. A 4" x 5" negative, for example, makes a 4" x 5" contact print, a size large enough to view easily—and an 8" x 10" contact print from an 8" x 10" negative is generally even more satisfying to look at.

A **contact sheet** is a print, usually on 8" x 10" or 8½" x 11" paper, that represents an entire roll of film. Contacts are best used for proofing—to see what you have in the exposed film—before you spend the time and money to make enlargements of individual negatives.

Contact sheets also provide a useful way to file and keep track of your work, especially when you begin to accumulate a lot of negatives. Assign the same file number to each roll of negatives and the corresponding contact sheet. For example, designate your first-ever roll of negatives as #1; use a waterproof pen to mark #1 on the plastic protector containing the negatives and also on the back of the contact sheet. Or you might include the year you took the pictures in your filing system by using a prefix of "05" for 2005, "06" for 2006, and so forth, designating your first roll in 2005 as "05-1" and your second roll as "05-2." You also can use the back of the contact print to note additional information, such as the subject's name and where, when, and how the pictures were taken.

Following are instructions for making a contact sheet.

1. *Lift the enlarger head so it sits near the top of its rail,* in order to project a wide circle of light when the enlarger is turned on. The circle must be larger than the sheet you are printing on.
2. *Set the lens aperture at f/8* to begin with. For a brighter light (and shorter exposure time), open the lens aperture to f/5.6 or f/4 or so; for a dimmer light (and longer exposure time), close down the aperture to f/11 or f/16.
3. *Place a fresh sheet of 8" x 10" printing paper, emulsion side up, on the base of the enlarger.* Do not use an easel.
4. *Position a plastic negative protector containing strips of negatives down on the paper* with the negatives emulsion (dull) side down. If you are not using a protector, position individual strips of negatives carefully in rows on the paper, again emulsion side down. The negative protectors are the preferred method, because they are clear plastic and permit light to pass through. They also are safer, allowing you to make the contact prints without handling

Step 1

Contact Sheet

You make a contact sheet by placing your negatives, preferably in plastic protectors, on a sheet of photographic paper under glass to hold them flat. You can fit an entire roll of film on one sheet of paper this way. Contact sheets are useful for keeping a record of your work, and help you decide which images to print. Make sure your negatives are oriented the same way and in numerical order for easy reference.

Step 5

Test strips: pages 179–82

See bw-photography.net
for more about archival issues.

the negatives directly. Such handling can scratch or otherwise physically damage negatives.

5. *Gently lower a clean sheet of glass (heavyweight is best) over both the negatives and the paper* to hold them flat and in contact. A plain sheet of glass works fine, but there also are commercially made contact printing frames available.

6. *Use your enlarger's timer to expose the paper for a predetermined time*—say 10 seconds. The required exposure time varies widely depending on the density of your negatives, the brightness of the enlarger light, the type of paper and developer, and other factors. You can make a test strip first to determine exposure time. But with experience, you should get a feel for how long this exposure should be, especially if you use the same enlarger repeatedly.

7. *Process the exposed contact sheet like any other print.* If it comes out too dark, try another sheet using less exposure; if it comes out too light, do another sheet with more exposure.

Don't expect a perfectly exposed contact print every time. As often as not, your film exposures will vary somewhat; a single contact sheet may show some frames with good density as well as others that are too light or dark. This is not usually a problem, as long as you can see the image well enough to evaluate it; almost all contact sheets are for reference only— not final prints.

A sheet of 8" x 10" paper is often a little small to show an entire roll of 35mm film. To counter this problem, you may have to crop part of the roll when making your contact sheet. A better solution is to print one or two strips of negatives on a separate sheet; or you can use a larger-size printing paper, such as 8½" x 11", to better accommodate an entire roll.

Archival

Over time, images are subject to various kinds of deterioration, such as fading and staining, as well as simple physical damage. The term **archival** is used broadly to describe the stability of a photographic image over time; with black-and-white photography, this usually means either a negative or a print. Some materials are inherently more long lasting than others; for instance, fiber-based black-and-white papers are considered more stable than RC papers. For maximum stability, consider these other factors:

Processing. For maximum image stability, it is best to use fresh, uncontaminated solutions when developing film and making prints. In particular, make sure you fix and wash negatives and prints for at least the recommended amount of time; use fixer remover for negatives and fiber-based prints before the final wash; and be sure your washing methods are efficient.

Heat and humidity. Both high temperatures and high humidity can cause deterioration of a photographic image. If possible, keep negatives and prints at temperatures no warmer than 75°F and at average humidity. In particular, keep them away from cars (in hot weather), attics, basements, and other places that typically get hot and humid.

Presentation and storage materials. Keep negatives and prints away from direct sunlight. And when they are not in use, store them or mat them using safe materials such as plastic negative protectors and rag mat board.

Troubleshooting: Making a Print

Problem: Print gray or dark and muddy, either overall or unevenly (in streaks)
Reason: Paper fogged—exposed to light, usually before exposure or development, but possibly during development before fixing.

Problem: Right side of the print too light and muddy in relation to the rest of the image
Reason: Right side dodged for too long. Expose a new sheet of paper, limiting your dodging time to no more than 30 percent of the initial print exposure time.

Problem: Edges of image not sharp or cleanly delineated
Reason: Easel blades not fully covering the edges of the image. Make another print, taking care to position the easel blades so they completely cover the edges of the projected image.

Problem: Rectangular image tilted, not square on the printing paper
Reason: Paper not centered in the easel correctly. Make another print, taking care to squarely position the paper before closing the easel and exposing the paper.

Problem: Top right corner of the print is darker than the rest of the image, showing a straight line across
Reason: Corner burned-in for too long with a stationery mask used when burning-in. Expose a new sheet of paper using a shorter burning-in time and keep the mask in motion when burning-in—or when dodging.

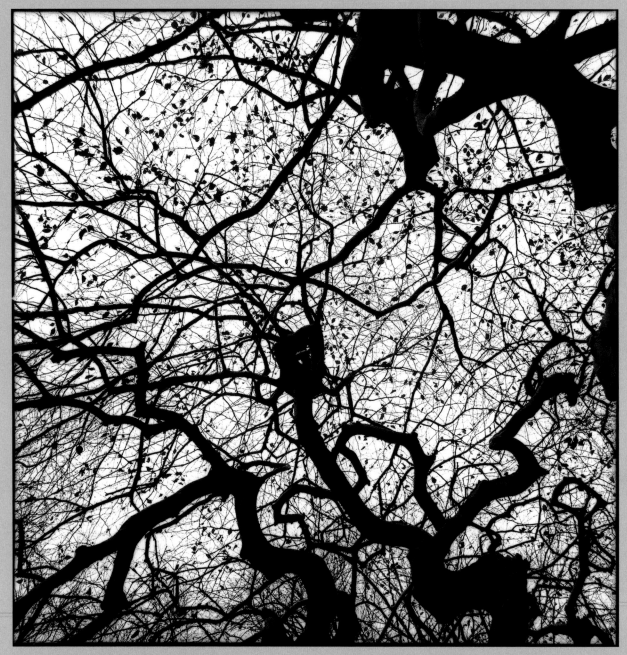

David Akiba, *Arnold Arboretum, 1991*

High contrast emphasizes a picture's graphic qualities, reducing a subject to its essential form. Akiba pointed his camera upward to record the stark silhouette of this tree against a bright sky. There are several ways to create this dramatic effect in the darkroom, but it helps when the subject is intrinsically high in contrast. © David Akiba; courtesy of the artist.

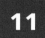

11 Alternative Approaches

See **bw-photography.net** for more alternative approaches.

Although the preceding chapters cover the most common black-and-white techniques, processes, and materials, there are still numerous, less widely used approaches. Most are for those times when the photographer wants to achieve an uncommon look by trying something different. This chapter describes several of these alternative approaches.

Infrared Film

Infrared film was originally developed for industrial and scientific applications, but it is now used mostly by creative photographers who like its unusual visual qualities, variously described as surreal, dreamlike, ethereal, and otherworldly. Although sensitive to visible light much as traditional films are, this film also is exposed by infrared—radiation that is not visible to the human eye. The resulting images show the subject fairly realistically, but with distinct differences. For instance, vegetation and organic materials have a lot of infrared, so are rendered with more density on infrared negatives, making these areas light on subsequent prints. The effect can vary widely depending on the subject's infrared content, the type of infrared film you use, and the filter you have on the lens when taking the picture.

The infrared results are strongest when you use a filter. An opaque gray #87 filter is especially effective because it blocks most of the visible light. However, if you are using this filter on an SLR camera, you have to remove it so you can see well enough to compose and focus the subject, and then replace it to take the picture.

Infrared films are used primarily for their unique look.

Filters: pages 101–8

Many photographers use a #25 red filter instead. Although this filter is dark, it is not opaque and usually does not have to be removed to compose and focus your image. Other filters that work less dramatically with infrared film include the #58 green and #12 yellow.

Perhaps the most difficult thing about using infrared film is establishing the correct exposure. Light meters read visible light, not infrared, so the reading they provide is an estimate at best. Furthermore, different brands of infrared films have different sensitivities to light and infrared, and your choice of filter also will affect exposure. With Kodak infrared film, for example, you can try

setting your meter at ISO 100 and exposing the film as you would any other. Or just use these exposure settings with a #25 filter on your lens:

Hazy sun	f/11 at 1/125
Normal direct sun	f/11 at 1/250
Very bright sun	f/11 at 1/500

Bracketing: page 89

Check the instruction sheet that comes with the film for more specific exposure recommendations, but, if possible, bracket to guarantee at least one well-exposed negative; for example, make an initial exposure at f/11 at 1/125, then make bracketed exposures at f/8 at 1/125 and f/16 at 1/125 (or the equivalent).

Focusing with infrared film presents still another challenge. Since infrared is invisible, the lens doesn't focus the same way it does when focusing subjects for traditional photographs. One solution is to turn the lens slightly after focusing, so it is set to focus a little closer than it otherwise would. Or you can use a small

Depth of field: pages 49–53

lens aperture (f/5.6 or smaller) or a wide-angle lens to increase the image's depth of field to compensate for focusing discrepancies.

Infrared film is processed and printed in much the same way as any other film. Check the instructions packaged with your developer for film developing times. However, you will have to handle infrared film with extra care. The film is heat- and light sensitive, so you should store it in a refrigerator before and after it is used. Take it out of the refrigerator about two hours before use, and return it to its original container after use and refrigerate it. To prevent condensation from forming and possibly ruining the film, always leave refrigerated

Infrared film requires extra care because it is heat- and light-sensitive and vulnerable to physical damage.

film in its original packaging until it reaches room temperature before using it.

Infrared can penetrate the felt strips of the film cassette that houses 35mm film (or the paper backing of medium-format roll film), so load and unload the camera in darkness. Infrared film also is especially vulnerable to physical damage, such as scratching, so handle both processed and unprocessed film by its edges and with great care.

High Contrast

High-contrast prints are those with black shadow areas and white highlights, with few or no gray tones. High contrast is used for visual effect, rather than to accurately describe or document a subject. The results are generally stark and graphic—and often dramatic. The primary factors influencing print contrast are the subject's inherent contrast and subject lighting, as well as how you process your film and print your negative.

Subject contrast. Some subjects have inherently more contrast than others, such as a black dog against a white wall or a white dog on a dark couch. The first and simplest tactic to achieve high contrast is to photograph this type of subject.

Russell Hart, *Untitled,* 1983

Some photographers work with special films that have distinctive visual characteristics. Hart used infrared film for this beach scene to record visible light as well as infrared, which is imperceptible to the human eye. Because the chairs and people radiate more infrared than other parts of the scene, they take on an eerie glow. © Russell Hart; courtesy of the artist.

If the conditions are not right, create them by positioning your dark subject against a light background or your light subject against a dark one.

Subject lighting. The light conditions are often more important than inherent subject contrast. Pay close attention to the type, direction, and quality of light around your subject. Lighting contrast is not always predictable. A bright, sunny day generally produces high contrast, for example, but if you photograph in the shade of a tree on a bright day, you may get somewhat low-contrast results. On the other hand, if you photograph on a cloudy day by a window indoors, there may be a lot of contrast between what's inside and outside or even between shadows and highlights within the room.

Beyond subject contrast and lighting, there are several methods of achieving high-contrast results in the darkroom, either by making a high-contrast negative or using a high-contrast printing technique.

Negatives. Possibly the best way to reduce an image to just blacks and whites, with no grays, is to make a copy negative on high-contrast film—then print that negative. Such films are called **litho films,** because they were originally made for the offset printing (lithography) industry. The procedure is somewhat involved, but not really difficult, and you can use this technique for a number of other darkroom manipulations described later in this chapter.

Basically, you use litho film in sheet form and treat it like photographic paper. Put your negative in the enlarger and expose it onto a sheet of 4" x 5" or larger litho film. You can use safelights to handle litho films; you don't need total darkness. Develop the film in trays, using special litho (high-contrast) developer or regular paper developer. The result will be a **film positive**—a sheet of film with a positive image. A positive is useful for making negative prints, prints with a reversed image, but usually you'll need to contact print your positive onto a fresh sheet of litho film to make a negative. Note that each time you copy the image you will get increased contrast.

You also can achieve relatively high contrast in your negatives by manipulating film exposure and development. Underexpose the film slightly, and then overdevelop it. This technique is not likely to yield a totally black-and-white result, but it does produce a higher-contrast negative than you could hope to achieve with standard exposure and development—especially if your subject is high in contrast to start with.

Printing. You also can use basic printing techniques to increase image contrast. The simplest and most effective is to use a high-contrast filter with variable-contrast paper—preferably #5. (If you use graded papers, use the highest grade available). On its own, this will probably not eliminate all the gray tones in a

Lighting: chapter 8

You can produce high-contrast prints either in camera by photographing suitable subjects in contrasty light or by one of several methods of darkroom manipulation.

See **bw-photography.net** for more on copy negatives.

Negative print: pages 218–20

Underexposure and overdevelopment: pages 152–55

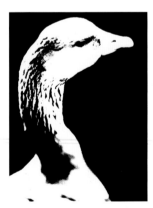

High contrast produced by printing with a #5 filter.

print. But it will increase the contrast significantly—and if your original negative is high in contrast, you may just end up with a totally black-and-white image, or close to it.

Your choice of print developer also can affect final print contrast somewhat, particularly when you are using fiber-based printing papers. Some brands of print developer produce greater contrast than others. The dilution of the developer also can affect contrast slightly. The greater the concentration of developer, the greater the print contrast. So if you normally mix stock developer with water in a 1:9 ratio (1 part stock developer to 9 parts water), increase the strength—perhaps to a 1:4 ratio.

Extended development also may increase print contrast a bit, most likely with fiber-based papers. If you normally develop prints for 2 minutes, use 3 or 4 minutes instead.

Your choice of developer, as well as its concentration and processing time, can affect print contrast in a subtle way.

Solarization

Solarization involves reexposing printing paper or film to plain, white light during development, then completing development to produce a partial image reversal, an effect that causes the positive print to look somewhat like a negative. A successful solarization has an eerie, silvery appearance, often characterized by distinct white or light edges separating light and dark areas. These lines are called **Mackie lines.** You won't get strong Mackie lines with every solarization, but they can have a striking effect when they do occur.

The basic procedure is to expose the paper or film and begin to develop it normally. Before the image is fully developed, briefly reexpose the paper or film to light, and then continue the development—followed by stop bath, fixer, and a wash. The effects of solarization are mostly seen in lightly exposed areas (print highlights and film shadows), since these are areas that have a lot of unexposed silver available for reexposure. Denser areas (print shadows and film highlights) have been heavily exposed already, so the additional exposure won't affect them as much.

The following is a basic step-by-step process for solarizing prints. As always, experiment for best results.

Solarization occurs when you re-expose partially developed paper or film to light, and then complete the development.

See bw-photography.net for more on film solarization.

1. *Expose your paper,* just as you would to make a normal print. Put a negative in the enlarger, make a test strip to determine exposure, and expose a full sheet of paper according to the time indicated by the test. For best results, use a slightly shorter exposure time (by 10–20 percent or so) than you would if you were not planning to solarize. For example, if the test strip suggests 10 seconds as the correct exposure, use 8 or 9 seconds instead. Varying this initial exposure time can produce dramatically different effects.

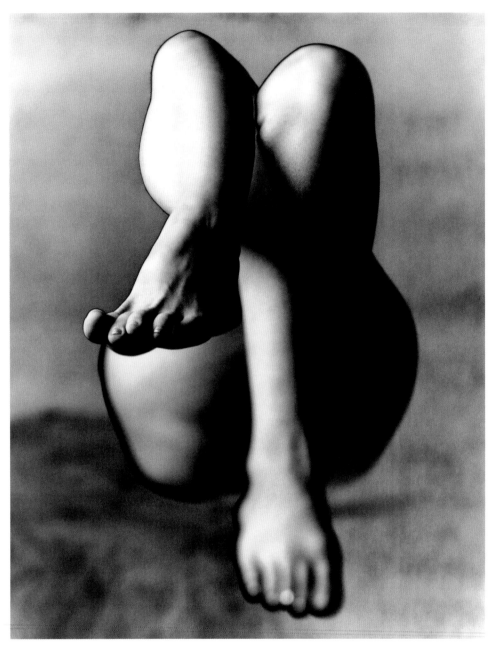

Claudio Vazquez, *LULU 53,* 1999

Vazquez used a technique called solarization to make a different kind of picture of a widely photographed subject, the human figure. Solarization occurs when the image is reexposed during development, creating a partial reversal of tones and often distinctive edges called Mackie lines. © *Claudio Vazquez; courtesy of Kathleen Ewing Gallery, Washington, DC.*

Use either a household bulb or an enlarger for solarization, but make sure the spread of light is broad enough for even exposure on the entire sheet of paper.

Step 3

Step 7

Step 8

2. *Prepare an area for the reexposure.* You can use a plain, low-wattage household bulb (15 watts or so), positioned 3–4 feet above a countertop where the paper sits. A more common technique is to use light from an enlarger. After exposing the paper, remove the negative carrier from the enlarger and lift the head to its maximum height, so there will be a broad spread of light to guarantee even exposure to the entire sheet of paper. Close down the lens aperture to a small f-stop to dim the light for reexposure. (There is no need to do this if the lens is already set to a small f-stop.) Then put a dry towel on the countertop or enlarger base to protect the surface from dripping paper or wet trays.

3. *Place the exposed paper in the tray of developer,* as you normally would, and agitate.

4. *Once the image starts to become visible,* remove the paper from the developer. The timing here is important; you will get different results depending on whether you let the paper develop for more or less time. As a general rule, try pulling the print from the developer about one-fourth of the way through full development. If your full developing time is 1 minute, for example, pull the print at 15 seconds; if your developing time is 2 minutes, pull at 30 seconds. Experiment with different times to get the result you like best.

5. *Place the paper on the back of a flat tray or sheet of glass and squeegee off* the excess water. (Otherwise, water drops and streaks may be recorded when the paper is re-exposed.)

6. *Take the paper, still on the tray or glass, to your enlarger or other light source for reexposure.* Position it emulsion side up (with the partially developed image facing the light).

7. *Briefly expose the paper to light.* The reexposure time is critical and depends on several factors, such as the sensitivity of the paper you are using (for instance, fiber-based papers are generally less sensitive to light than RC papers, so require longer reexposure times) and the intensity of the light (how far it is from the paper, how bright it is, the f-stop you use). Also, reexposure varies from image to image. Experiment with different times, but most of the time re-expose very briefly—for 1–2 seconds or even a fraction of a second.

8. *Put the paper back in the developer* for the remaining development time. Agitate normally.

9. *Stop, fix, and wash,* as you would when processing any print.

Photograms

A **photogram** is a photograph made without a camera, usually by positioning objects directly between a light source and photographic paper or film. It's a simple technique that's been around for a long time; in fact, some of the first

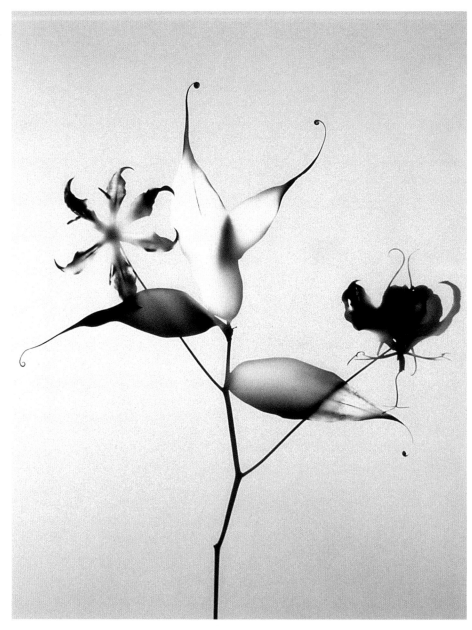

Lana Z. Caplan, *Gloriosa Lilies,* 2001

Some of the earliest photographs were photograms—images made without a camera. This deceptively simple technique often yields surprisingly sophisticated results in the hands of artists like Caplan, who makes her delicate and evocative photograms on film rather than paper, then prints the resulting negatives. © Lana Z. Caplan; courtesy of Gallery NAGA, Boston.

Photogram

To make a photogram, you don't use a camera. Instead, you place objects between a light source and photographic paper or film and make your exposure. For maximum control, use light from an enlarger with a timer (left). In this paper photogram (right), areas that received a lot of exposure darkened; areas where the leaf partially or fully blocked light rendered light.

Photogram made by placing objects on paper.

Photograms are photographic images made without a camera.

photographs ever made were photograms. The results are an often-surprising blend of shapes, forms, and tones that vary widely depending on the types of objects, how they are used, and their relative transparency.

If you use an opaque object to make a photogram, it blocks all light from reaching the paper or film, and thus is rendered as a silhouette. Translucent objects usually work better, because they allow various degrees of light through and render as one or more gray tones. Also, try laying the object against the paper or film so it doesn't lay totally flat; this can produce gradations in tones that have a somewhat three-dimensional quality.

Correct exposure may be difficult to judge; you can expose photograms in many different ways and still be happy with the results. A long exposure, for instance, will allow more light to travel through translucent objects, and produce a different look (darker grays, less white silhouettes) than would a shorter exposure.

You can use a wide variety of objects and techniques to make a photogram. Patterned fabrics and objects from nature, such as leaves, vegetables, feathers, and so forth, work particularly well. Painting shapes and forms on a piece of glass offers still another option. Place the painted glass over the paper (or even place it in the enlarger instead of a negative carrier), and treat it like a negative to make a print.

Although the most common way to make photograms is with printing paper, you also can use sheet film.

Sheet film: pages 27, 29

Most photograms are made directly on paper, which means they are often one-of-a-kind images, difficult to reproduce with precision. But you also can make photograms on sheet film, and film photograms let you make as many identical prints from the negative as you choose. Be sure to use very-slow-speed films, because normal-speed films are too sensitive to light to use under an enlarger. Slow litho films are especially good, because they can be used with a safelight; most nonlitho films have to be handled in total darkness.

Follow these steps to create photograms:

1. *Lift the enlarger head high enough* to evenly expose the entire sheet of paper or film.
2. *Close down the lens* to a small opening, say f/11 or f/16.
3. *Position a sheet of paper or film on the base of the enlarger,* emulsion side up and directly under the enlarging lens. You can put the paper or film in an easel to hold it flat, but flatness isn't always necessary for a good photogram.
4. *Place one or more objects either on or just above the paper or film.*
5. *Turn on the enlarger and expose the paper or film.* Actual exposure time varies widely depending on many factors, including the intensity of the light source (brightness of bulb, f-stop, distance between light source and film or paper) and the density/translucency of the objects. Also, film generally requires much less exposure time than paper, and fiber-based papers require more exposure than RC paper. Try starting with an initial exposure of 20–25 seconds for paper and 1–2 seconds for film and adjust the time when you see the results. If the results are too light, make a longer exposure next time; if the results are too dark, make a shorter exposure.
6. *Process the exposed paper or film* as you normally would, in trays.
7. *Examine the results* and decide whether to make a new photogram, changing the exposure, using new objects, or adjusting their position.

An enlarger provides a convenient and controlled light source, but you also can use a low-watt (15–25 watt) light bulb suspended 3–4 feet above the film or paper for your exposure.

The background of the photogram receives the most exposure, because it is not covered by any opaque objects. If paper is used, the background is rendered dark; if film is used to make the photogram, the background is rendered dark on the negative and light on the print.

Negative Prints

You are used to working with a film negative to make prints, but you can also make a **negative print**, a negative image on printing paper. Dark parts of the subject render as light, while light parts are dark. Reversing the tones in this way often creates a surreal, otherworldly look.

There are many ways to make a negative print. The simplest method is to contact print a normal, positive print onto a fresh sheet of printing paper, using your enlarger as a light source. Light passes through the top paper just as it would through a film negative, though you need more exposure because paper holds back considerably more light than film would. Since you are starting with a positive image, the result will be tonally reversed: a negative on paper. Follow these directions:

1. *Lift the enlarger head high enough* to evenly expose the entire sheet of paper.
2. *Open the enlarging lens* to its widest aperture. You can use any lens aperture, but the stronger light from a large aperture helps keep exposures from becoming too long.
3. *Position a fresh, unexposed sheet of paper under the enlarger,* emulsion side up, as you would when making contact prints. Make sure the paper you are using had no brand identification or any other type of writing on the back, as such markings will show visibly when the negative print is processed.
4. *Position the positive print face down on the unexposed paper* so that the emulsion of the print is flat against the emulsion of the blank paper.

Negative printing

To make a negative print, contact print a positive picture (left) onto a fresh sheet of paper. If you place the print and sheet of paper emulsion-to-emulsion, you will get the sharpest results, but the image will be flipped laterally (right).

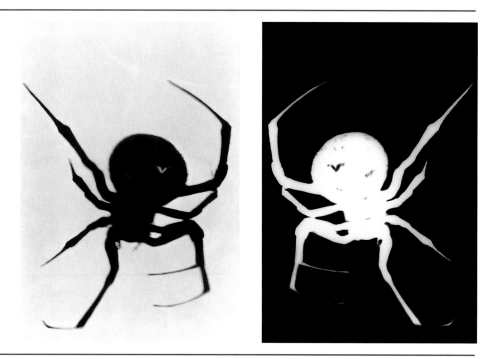

Test strips: pages 179–82

Making a negative print has a lot in common with making a contact print from a negative.

Variable contrast: pages 189–92

5. *Place a piece of glass on top of the positive print* to press it firmly against the unexposed paper. Make sure the glass is clean, scratch-free, and heavy enough to hold the paper flat.
6. *Turn on the enlarger and expose the paper.* It's best to make a test strip first to determine the correct exposure and adjust when you see the results. Often exposure will range between 10 and 20 seconds, but the actual time will vary widely depending on many factors, including the intensity of the light (brightness of bulb, f-stop of lens, distance between light source and paper) and the density of the positive print (dark prints require longer exposure times). Also, fiber-based papers require more exposure than RC papers.
7. *Process the exposed paper normally.* The resulting print will show a negative image. If it is too light, make another print with a longer exposure time; if it's too dark, make another print with a shorter exposure time.

These instructions are basically the same as those for making contact prints from film negatives, so you don't really need an enlarger for your light source. A simple low-watt (15–25 watt) lightbulb pointing down at a countertop will do the trick. If you do use an enlarger, you can use variable-contrast filters or built-in filters with variable-contrast papers or graded papers to change image contrast.

Placing the two pieces of paper emulsion-to-emulsion yields sharp results, but also flips the image laterally; for instance, words print backwards and what is on the left side of the positive print ends up on the right side of the negative print. For some images, this reversal does not matter. If it does matter, however, you can expose the fresh paper by placing the positive print facing up, rather than down. This will correct the flipped orientation, but may result in decreased image sharpness.

Sandwiching Negatives

It's a simple matter to print two or more negatives together, one on top of the other, as you would a single negative. This technique, called **sandwiching negatives,** can lead to some odd, surreal results. Follow these steps:

1. *Place the two negatives together,* both emulsion side down, in the negative carrier. In theory, you can use as many negatives as you like, but using more than two will make exposures considerably longer.
2. *Turn on the enlarger, adjust the combined image to the desired size, and focus.* Then proceed as you would when printing a single negative: Make a test strip to determine the needed exposure, then process and wash the print normally.

Two negatives sandwiched together block more light than a single negative, so you will need longer exposure times. Burning-in and dodging, which you are

Sandwiching Negatives

For sandwiching negatives, place one negative on top of another. Then place them in an enlarger and print them as you would print a single negative. Here, one negative printed normally produces this print of a pier and beach (top left), while another negative produces this print of the top of a woman's face (top right). Sandwiched together, the negatives produce the bottom image.

likely to need, also take longer with overlapping images. In addition, because one negative is on top of the other, you should use a smaller lens aperture (try f/11) to guarantee that both negatives print with equal sharpness. Keep in mind that small lens apertures also will lead to longer print exposures.

Combining two negatives sometimes produces less print contrast than each negative would produce separately. Use a high-grade filter with variable-contrast papers (or a higher-contrast graded paper).

Technically, you can put any two or more negatives together and make a successful print. However, it is the rare combination that makes a satisfying image visually. Use negatives that complement each other. For example, if your negatives contain too much detail, the final result may be a muddy or confusing image. Try instead to combine a complex subject with a simple scene, one with large areas of texture or pattern, such as clouds or the surface of water.

Hand Coloring

Hand coloring allows the photographer a lot of control over the look of the final image.

Hand coloring example: page 225

You can apply color to the surface of a photographic print with many types of tools, such as a brush or cotton wipes or swabs. There are products made specifically for hand coloring, but you also can use oils, dyes, markers, watercolors, or any color medium that will adhere to the print.

You can choose to emphasize the photographic quality of a print or play it down.

Practical color photography methods were not widely available until the 1930s. Before then, the best way to make a color photograph was to apply the color by hand, a technique called **hand coloring**. There were many techniques, but the most common was simply to add color dyes or paints directly to the surface of a photograph with a brush or some other applicator.

Hand coloring gives photographers more control over how the color looks than today's standardized color films and papers provide. Various hand coloring methods can produce results ranging from soft and impressionistic to hyperrealistic. You can apply color selectively or even use colors that were not in the original subject. In short, hand coloring allows you to achieve a more personal and crafted look than traditional color materials.

There are products specially made for hand coloring photographic prints. You also can use almost any type of coloring material, such as dyes, oil paints, watercolor, markers, pencils, or even food coloring, as long as the color adheres to the surface of the print. Some materials produce different color characteristics, while others create more or less surface texture. Experiment to find a look that works for you.

There are a number of ways to approach hand coloring. Apply color broadly to the surface of the print using a brush, paper or cloth wipes, or a cotton ball. Or for fine, detailed work use a thin brush or a cotton swab.

Some hand colored images look like actual color photographs, while others downplay their photographic quality. This depends on the coloring material you use and how you mix and apply it. In general, transparent, diluted washes of color allow the image to show through, causing the print to retain a photographic feeling; they also may produce a more subtle or pastel look. More opaque coloring materials or denser applications are more likely to obscure the original photograph and produce stronger and more brilliant color.

Whatever material or method you use, it's best to have extra prints of the image available so you can experiment. Practice your technique to gauge the color and surface, as well as the stroke and control of the applicator.

Usually a print gains a bit of density and loses some contrast when hand colored, so you may want to make your original prints slightly lighter and with a bit more contrast than you normally would. Note that the color is usually more noticeable in light areas than in dark areas.

Paper surface also is very important. Hand coloring blends best into matte and semimatte fiber-based papers. While you can hand color glossy and RC papers, the color is more likely to sit on the surface of such papers and is more likely to show brushstrokes, producing a look you may or may not want.

Liquid Emulsion

Liquid emulsion allows you to make your own printing paper.

Liquid emulsion example: page 226

You can make your own printing papers by hand coating **liquid emulsion** onto the paper of your choice. The results won't be as finished as with mass-produced photographic papers, which are made with much more consistency than an individual could hope to match. However, the rough, handworked quality of liquid emulsion may be just right if you're trying to achieve a particular look.

You can use any type of paper with liquid emulsion, though watercolor and printmaking papers are most suitable. A variety of paper surfaces, tonal colors (warm or cold), and sizes are available at any good art supplier—and such characteristics will have an important effect on the final results. Note that you also can apply liquid emulsion to nonpaper surfaces, such as fabric, wood, ceramics, glass, and metals; however, you may have to take extra steps, such as sanding the surface or coating it with polyurethane, to ensure that the emulsion adheres to some of these materials as well as it does to paper.

Coating paper with liquid emulsion is easy in theory, but challenging in practice. The basic technique is to brush one or more thin coats onto the paper surface, let the emulsion dry, and make your print as you would make any photographic print. But it takes some practice and skill to coat the paper evenly and well; otherwise the image will show imperfections, streaks, and brushstrokes—characteristics that some liquid emulsion users actually strive for.

Here are some basic steps for processing paper coated with liquid emulsion. Read the emulsion manufacturer's instructions, as some products are different than others, and experiment:

1. *Cover your work surface* with paper towels, newsprint, or similar protection to soak up any spilled emulsion or water.
2. *Place the uncoated paper flat on the covered surface.*
3. *Turn off the room lights and turn on a safelight.* Liquid emulsion may be safely handled in safelight illumination, just like standard photographic paper.
4. *Place the liquid emulsion, in its bottle, in a beaker of hot (120°F) water.* At room temperature, liquid emulsion is a thick gel, and this step will liquefy it, making it easier to apply. The bottle should remain still in the beaker, as any agitation can cause air bubbles that may create image defects.
5. *Wet a clean, soft brush with emulsion from the bottle and spread a thin layer* over the paper as evenly as you can manage. Or try pouring a small amount (about the size of a quarter for an 8" x 10" sheet) in the center of the paper and use the brush to spread it out. Often you will need only one coat, but very porous papers and other materials might need two coats or more. Don't overcompensate by applying the emulsion too heavily.

Make your brushstrokes all in one direction. However, if you apply more than one coat, apply the second coat perpendicular to the first one. Allow the previous coat to become slightly tacky before recoating the paper. You can coat a number of sheets at a time and store them in darkness for use later, but you should try to use them within a day or two.

6. *Dry the coated paper.* You can leave the paper flat or hang it up on a line, using clothespins. Drying can take 30 minutes to several hours, depending on the heat and humidity in the room. Turn off all lights while liquid emulsion dries to prevent fogging (unwanted exposure).

7. *Set up your negative in the enlarger,* much as you would when working with any photographic paper.

8. *Expose a sheet of dry, coated paper.* It's best to start with a test strip. Expect longer exposure times than with standard photographic papers since paper coated with liquid emulsion is less sensitive to light. And take extra care not to scratch or otherwise physically damage the surface of the paper, as liquid emulsion is relatively fragile, even when dry.

9. *Process the exposed paper.* You can use a standard print developer, but rinse the paper with water after the developer instead of stop bath; the stop bath can harm the emulsion. Finally, use a standard fixer (with hardener) to fix the image. These times are recommended:

Hardener: page 138

Developer	2–3 min
Water rinse	½–1 min
Fixer	15 min

10. *Wash the print in running water for about 5 minutes* after the fixer. Then use a fixer remover for about 3–5 minutes, followed by a final wash for at least 30 minutes in cool running water.

11. *Air dry the washed prints* on drying screens or by hanging them up.

Processing nonpaper surfaces and three-dimensional objects coated with liquid emulsion requires similar steps, though specific techniques may need modification. Use a brush or sponge to apply the processing chemicals, and wash the surfaces in the same manner as paper, working gently, but continuously. Alternatively, you can immerse coated objects in buckets of processing solutions.

Note that you can tone or hand color liquid-emulsion prints if you choose. But do so with care to avoid physical damage. A thin coat of polyurethane, available at hardware stores, painted or sprayed over the paper surface may help make the image more permanent.

Jill Enfield, *Glebe House Bed, 1992/2003*

Because color photography was not yet invented, early photographers hand colored their prints, but some contemporary artists make this technique a creative option. Enfield combines thin layers of color with an eye for alluring subjects. For this simple interior, her delicate touch is just enough to enhance the mood of the original black-and-white print without overwhelming it. © Jill Enfield; courtesy of the artist.

David Prifti, *Trace,* 2003

A photograph does not need to be a flat rectangular or square picture. Prifti uses liquid emulsion to print photographs on old building materials and scrap metal. Part sculpture and part photography, this approach enables him to interweave themes of family, home, and memory with unconventional shapes, surfaces, and textures. © David Prifti; courtesy of Gallery NAGA, Boston, MA.

Henry Horenstein,
Longnose Skate,
Raja Rhina, 2000

A photograph's impact comes not only from what it depicts, but also from the choice of techniques and materials used to make the print. For this picture of a one-week-old sea creature, Horenstein used black-and-white film, but printed on paper intended for color photography. This combination enabled him to finely tune his monochromatic choices. © Henry Horenstein; courtesy Sarah Morthland Gallery, New York, NY.

Elaine O'Neil, *British Museum, London, England, 1978*

"Black-and-white" photographs don't have to be just black and white. They also can be colored, most often using a final processing step called toning. For her amusing take on natural history museums, O'Neil sepia tones her print to give a warm brown look and an antiquated feel. © Elaine O'Neil; courtesy of the artist.

There are several ways in which you can change and improve the appearance of a print after it has been washed and dried. Some of the options include changing its overall color (toning); filling in dust, scratches, and other markings (spotting); and displaying and protecting it with board (mounting and matting).

Toning

Toners change the color of black-and-white prints and often increase print permanence.

A **toner** is a chemical solution that changes the color of a black-and-white print. Several types are available. A **two-bath toner** bleaches the image in one bath, then redevelops it so it turns a different color in a second bath. A **direct toner** changes the image color in a single bath.

Most toners turn a print's blacks and grays to shades of brown, but others produce shades of purple, blue, red, or other colors. Depending on how you use toners, the results can vary from subtle to dramatic. And many toners also increase print contrast and make prints more permanent—better able to resist fading, staining, and other forms of physical deterioration over time.

Though you must handle each type of toner a little differently, there are a few things to keep in mind regardless of the type you use. You should always start with a wet, fully washed print. Either tone your prints right after they have been washed, or soak dry prints in a tray of water for a few minutes before toning them. You don't have to tone prints right away; you can tone them anytime after they are made, even years later.

You will need extra trays to hold the toning baths—one or more, depending on the type of toner you use. If possible, use these trays for toning only, as contamination with other chemicals may cause toned prints to stain. With a waterproof marker, write the type of toner you use on the side of each toner tray, and be sure to wash the trays thoroughly after each toning session.

See bw-photography.net for more on darkroom health issues.

Take every precaution to minimize your exposure to toning chemicals. Most are at least somewhat toxic and many emit harmful and foul-smelling gases, so set up in a well-ventilated darkroom, tone near an open window, or even work outdoors. Wear an apron and rubber gloves when mixing toners, and use gloves or tongs to handle prints when toning.

Some toners come packaged as liquids and some as powders. The liquids are more convenient and safer to use. Kodak Sepia Toner, a classic two-bath toner, comes in two packets (Parts A and B) of powder.

With most toners you will get different results with different applications. Start with the instructions on the toner package and experiment from there for best results. In general, the longer the toning time, the more dramatic the results. Keep in mind that your choice of printing paper also has a significant effect on the final results.

Sepia Toner

Sepia toner is used to produce a print with a moderate or strong warm-brown color, depending on how you use it. It's often packaged as a two-bath toner; the first bath bleaches out most of the image and the second bath tones it—redeveloping the silver particles as warm brown. Just before you're ready to use a two-bath sepia toner, make two separate solutions by mixing the two powders with water according to the package instructions; Part A is the bleach and Part B is the toner. Here are some general instructions:

1. *Set up several trays of solution,* one each for plain water presoak, bleach, first water rinse, toner, and second water rinse.
2. *Soak the print face down in the presoak* for at least 1 minute, rocking the tray gently. A wet print is more receptive to the bleach solution, and helps make the toning more even. Use tongs to transfer the print from the presoak to the bleach.
3. *Place the print face down in the bleach* (Part A) solution. Rock the tray briefly and turn the print over so you can see it bleach (fade) out and turn a slight yellow-brown. You can vary the bleaching time from 1 to 8 minutes (or more). The amount of time the print stays in the bleach controls the final results; the longer the print soaks in the bleach, the more sepia the results.
4. *Rinse the bleached print* for 2 minutes or so, until the rinse water is no longer yellow. Any traces of the bleach can contaminate the next solution.
5. *Soak the print in the toner* (Part B), and watch it reappear and change color. In 2 minutes or so, it will stop redeveloping, having reached its maximum color change. Keep the print in the toner for the full 2 minutes. Don't try to vary toning time to control your results; vary the bleach time instead.
6. *Rinse your print* for 2 to 3 minutes to remove any traces of the toner.
7. *Wash the print* for 20–30 minutes. You don't need a fixer remover.
8. *Dry the print* as you would normally.

The amount of time you leave the print in the bleach controls the color; the longer the bleach time, the more sepia the results.

Toner

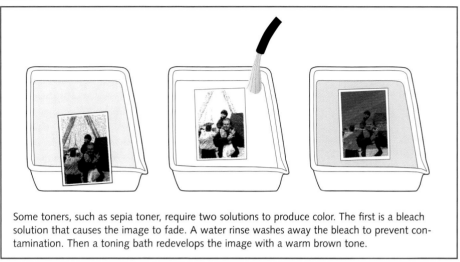

Some toners, such as sepia toner, require two solutions to produce color. The first is a bleach solution that causes the image to fade. A water rinse washes away the bleach to prevent contamination. Then a toning bath redevelops the image with a warm brown tone.

Selenium Toner

Selenium toner is a one-bath solution that produces subtle color changes and helps increase print permanence.

Archival: page 205

Selenium toner is a liquid, one-bath toner that generally produces a mildly cool, purplish color, with rich shadow tones, depending on how you use it. It is generally packaged as a liquid, **one-bath toner**. When placed in the toning bath, the print changes color. With selenium toner, the eventual color depends on how much you dilute the solution and how long you soak the print. Many photographers use a more diluted selenium toner to promote increased print longevity, with only slight or indistinguishable color change—subtle darkening of the shadows and increased contrast.

As a starting dilution, mix 2 oz of concentrated selenium toner with 32 oz (or 1 liter) of a working solution of fresh fixer remover. Be sure to use fresh fixer remover or contaminants from previous fixing may react with the toner and cause staining. With experience and experimentation, you may find other dilutions that work for you. More concentrated solutions should produce stronger colors than more dilute solutions.

There are many ways to use selenium toner. Following is a suggested method:

1. *Set up three trays,* one each of fresh fixer remover, selenium toner diluted in fresh fixer remover, and water.
2. *Place an untoned duplicate print from the same negative in the water tray* for comparison purposes. This step is optional, but it can be especially helpful when judging the color effects of subtle toners, such as selenium.

3. *Presoak the print to be toned in the first tray* of fixer remover for 2–3 minutes to help prevent print staining. Print staining is a common problem with selenium and many other types of toner.

4. *Remove the print from the fixer remover* and place it face down in the toner/fixer remover solution. Rock the tray briefly and turn the print over so you can see color changes. Compare results with the duplicate print soaking in the water tray. You can vary the toning time from as little as 2 minutes to 30 minutes or longer, depending on the degree of color change you desire.

5. *Remove the print from the toner/fixer* remover tray.

6. *Wash and dry* it as you would an untoned print.

To tone several prints at once, place prints one at a time in each solution, and shuffle them constantly from the bottom to the top of the pile. It will be easier to shuffle if you first place pairs of prints back to back to each other after all the prints are wet.

Spotting

To keep spotty prints to a minimum, do your best to keep your negatives free of grit, dust, and other imperfections.

Negative protectors: page 133

Drying and cleaning negatives: pages 148, 176

What you will need

spotting brush
spotting dye
cotton gloves
blotting material
white match paper
white saucer or dish

Dirty negatives cause some of the most annoying and time-consuming darkroom problems. Some amount of grit, dust, scratches, or fingerprints on processed film is not unusual, particularly when you are working in gang darkrooms. Sometimes you won't notice these defects, but more often you will; during exposure, they block light from reaching the printing paper, so they usually show up as light or white (and occasionally dark) spots or marks on the resulting print.

The best defense against dirty negatives is to keep them from getting dirty to begin with. Dry your wet negatives in a dust-free environment and store them safely away in negative protectors immediately. Keep your darkroom clean by vacuuming regularly and wiping down counters and other surfaces with a damp cloth. Before printing each negative, brush or blow off surface dust and dirt with compressed air or a soft brush. If none of this works, use a film-cleaning solution with a soft cloth.

Few negative are totally dust-free, despite all these precautions. Spotting is a technique for covering up print spots (and other defects), usually by using a fine-tipped brush to apply a dye solution to blend the spots with the areas around them.

Spotting can be tedious and frustrating. You will need a steady hand and much patience. However, a print covered with small spots and scratches is a sloppy print, so consider the time used for spotting well spent. You'll need these materials:

Spotting

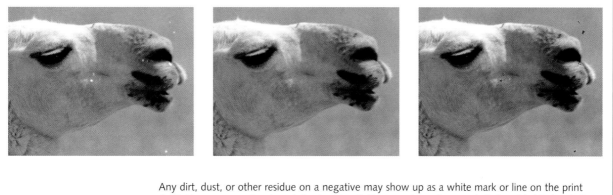

Any dirt, dust, or other residue on a negative may show up as a white mark or line on the print (left). You can use a brush and dye to retouch these marks so they are indistinguishable (center), a technique called spotting. Carefully match the tone of the spotting dye to the area surrounding the light mark before applying; if you apply too much dye, you may create a visible dark mark on the print (right).

Spotting brush. Use a high-quality, fine-tipped brush. A brush's size is rated numerically: the lower the number, the smaller its tip. Thus a #1 brush can make a smaller spot than a #3 brush because it has a smaller tip. An extra-small brush, such as a #000, #0000, or #00000, is ideal for print spotting. Camera stores generally carry spotting brushes, but you'll find a wider selection of fine-tipped brushes at an art supply store.

Spotting dye. Spotting dyes (and pigments) are available in both liquid and dry form. There also are sets of spotting pens that come in packs offering a range of grays. You will need to mix both liquid and dry dyes with water for use. When diluted, both types produce a shade of gray that can be used to match those areas that need spotting.

Cotton gloves. Handle prints with care when spotting, as fingerprints or skin oils can cause smudging. Simple, white cotton, lintless gloves are available at camera stores for this purpose.

Blotting material. It's best to spot with a nearly dry brush—one that is not too wet with solution. Use almost any type of blotting material, such as a paper towel, sponge, or blotter paper, to absorb excess dye from your brush and get it to match the tone of the area surrounding the spot.

White match paper. Before you apply spotting dye to your print, you will need a method to match its density to the areas that need spotting. Use a piece of the

white border of a duplicate or discarded print (preferably made with the same type of paper as the print to be spotted) to help make the match.

White saucer or dish. Use a small white saucer and/or dish to hold a dab of spotting dye and water, and to provide a bright background for diluting the dye.

Spotting techniques vary but all require diluting, applying, and reapplying spotting solution to match various tones in a print. Following is a suggested method:

1. *Place your white match paper on top of the print.* Position it next to an area with dust, dirt, or scratch marks that need spotting.
2. *Soak the tip of your brush with spotting dye.* Use water or wetting agent to liquefy dry spotting dye.
3. *Blot the tip of your wet brush gently on blotting material.* A somewhat dry brush works better than a wet brush.
4. *Touch the tip of the brush lightly to the test paper.* Do not make a brushstroke—just make a small dot.
5. *Compare the mark on the test paper to the tone around the area that needs spotting.* If the mark is darker than the area, dilute the solution further with water or wetting agent. Dip the brush in the newly diluted solution, blot it, and make another test mark on the match paper. You don't always have to dilute the solution; often, just blotting the brush will do the job.
6. *Keep testing and lightening the dye on the brush, until the mark you make looks a little lighter* than the tone around the area that needs spotting. It's best to start with dye that's a little light and gradually build up the density in the area with repeated applications; you can always darken spots that are too light, but spots that are too dark are trickier to fix.
7. *Apply the dye immediately to fill in the spot on your print* when you are satisfied with your test. Hold the brush straight up and down; touch the tip of the brush lightly on the paper; and make repeated tiny spots in the area until it is filled in. Never try to fill in an entire area by painting it in.
8. *Examine the print for areas that need a similar gray tone, and spot them* right away. Repeat this procedure, matching all areas that need spotting. Large spots take a lot of work, since you must fill them in slowly—spot by spot. As your brush dries, you must add more dye and, again, dilute the solution or blot the brush until the tone matches the areas that need spotting.

By far the most common spotting problem is making marks that are either too dark or too large. That's why you should make sure the tested dye looks a little lighter than seems needed. If the results are too light, they can always be

Step 4

Keep your dye light, and build up the density as needed with repeated applications.

Step 7

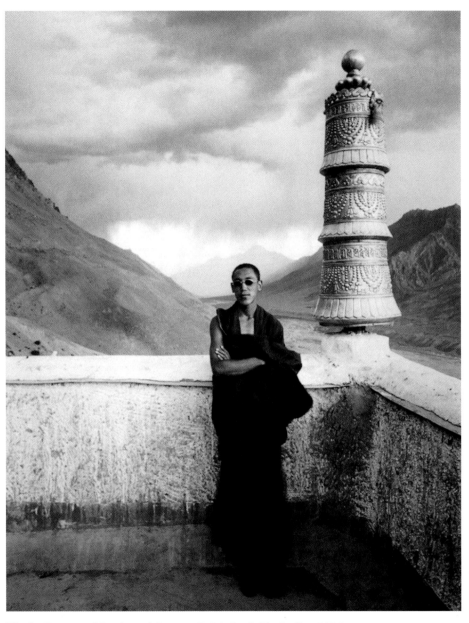

Linda Connor, *Monk and Storm, Spiti, Ladakh, India, 2002*

Connor's meticulous attention to craft enhances her stunning photographs of spiritual people and places. A beautifully produced photograph deserves careful presentation. Connor brings the same energy to finishing her work that she brings to photographing her subjects and making her prints. © Linda Connor; courtesy of the artist and Haines Gallery, San Francisco, CA.

darkened. Don't try to hurry up the process with a few broad brushstrokes. A sloppily spotted print usually looks worse than an unspotted print.

Since most dyes are water soluble, you can fix sloppy spotting by soaking your print for a few minutes in a tray of water. Then dry the print and try again.

Prints made on RC papers are generally harder to spot than prints made on fiber-based paper. You also will find matte-surface papers easier to spot than glossy papers.

Some popular spotting solutions are packaged in kits with different dyes for warm- and cold-toned printing papers—and for hand-colored or toned prints. You can mix these dyes as directed to best match your print, but often you won't have to. With careful spotting using a neutral black spotting dye, you should be able to spot most black-and-white prints successfully—and even some hand-colored, or sepia- and brown-and-white-toned prints.

Mounting and Matting

You can either mount prints on a single, stiff board or mat them between two boards for display and protection. The boards help the print remain flat, and they provide a clean, neutral environment for viewing the print. They also help protect the print from nicks, creases, and other physical damage.

Dry Mounting

One common way to display prints is to dry mount them—attach them directly to board with glue. You can choose to either cold mount or heat mount. Cold mounting generally uses a spray adhesive or a double-sided sticky tissue; heat mounting uses adhesive tissue that turns into an adhesive when heated. For heat mounting, you will need a certain amount of equipment, generally available in gang darkrooms or framing shops. Here's what you will need:

Dry-mount press. A **dry-mount press** is used for mounting prints to mat board (and also for flattening fiber-based prints). It has two parts: a flat, smooth metallic top that heats up, much like a clothes iron, attached to a base at the bottom that supports the print, mat board, and dry-mount tissue.

Mat board. Mat board is a heavy paperboard used for displaying or backing prints. It is available in many sizes and types.

Dry-mount tissue. Dry-mount tissue is a thin tissue-like sheet that turns into an adhesive when heated. It's available in a variety of sheet sizes from a few different manufacturers. Make sure you have a size at least as large as your largest print; you can always cut down large sheets to dry mount smaller prints.

What you will need

dry-mount press
mat board
dry-mount tissue
tacking iron
protective cover sheet
board or paper trimmer
cotton gloves
kneaded eraser, sand-
 paper, burnishing tool

Flatten prints: page 239

Mat Board

You can purchase mat board for mounting and matting prints at most photo supply stores. However, art supply stores and mail-order suppliers generally offer a better or broader selection. Boards have these different characteristics.

Color. Boards are available in black, gray, and other colors, but most photographers prefer white. Many shades of white are available, from cool and bluish to warm and cream-colored. While there are no fixed rules, in general, the board color should be fairly neutral and complementary and shouldn't compete with the photograph for attention.

Weight. Board is rated according to its thickness, designated as "ply." For example, 2-ply board is lightweight, flexible, and economical; 4-ply board is medium- to heavyweight, sturdier, and more expensive. A few photographers use super-heavyweight 8-ply board for even more strength and protection.

Surface. Board comes in a variety of surfaces, from glossy to rough, and in different textures. You will usually want a surface somewhere in between—flat and matte, but not too rough or textured—to provide a neutral and attractive border for your prints.

Quality. High-quality boards look good and age well, while cheaper boards may discolor and deteriorate with time—or even cause mounted and matted prints to stain over time. **Rag board** (made from 100 percent cotton fibers) or acid-free boards are considered best for long-term display and storage.

Size. Boards come in various sizes and may have to be cut down (by the store or by you) for use. Pick a board size that is compatible with the size of the print you are mounting. Uncut 32" x 40" (or so) sheets are some of the most economical; you'll pay more for board precut to standard sizes, such as 8" x 10" or 11" x 14".

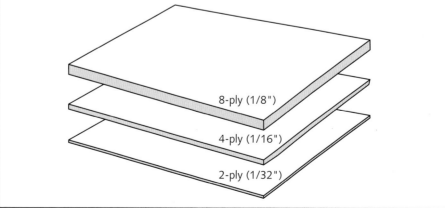

8-ply (1/8")

4-ply (1/16")

2-ply (1/32")

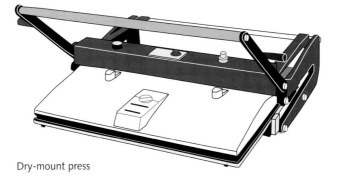

Dry mounting involves attaching a print directly to a piece of mat board, using a thin tissue-like sheet that turns into an adhesive when heated.

Dry-mount press

Tacking iron

Tacking iron. A **tacking iron** is basically a small iron on a handle. The edges of the iron are curved and covered with a nonstick surface, so the iron can be used to tack dry-mount tissue to the back of a print and mat board in preparation for dry mounting.

Protective cover sheet. You must protect your print and mat board from direct contact with the heated top surface of the dry-mount press. Use a smooth piece of mat board (1- or 2-ply) or other clean, smooth paper. Make sure the cover sheet has no texture, dirt, or grit to mark the print once it is pressed.

Board or paper trimmer. You will need a method of trimming the borders off prints and cutting mat board to size. There are commercially made board and paper trimmers available, but be sure the blades are sharp and the trimmer is properly aligned or you will get crooked (not square) cuts; board and paper trimmers are similar except models for cutting board are heavier duty than models for cutting paper. You also can use a sturdy ruler and cutting tool, such as a utility knife or an X-acto knife, for trimming borders off prints or a heavier ruler (preferably made of metal) and a stronger utility knife for cutting mat board.

Cotton gloves. Lintless gloves are generally useful for careful handling of negatives and prints. Use when dry mounting to help keep prints and mat board clean. Most camera stores and mail-order suppliers sell cotton gloves.

Kneaded eraser, sandpaper, burnishing tool. If your mat board gets dirty, use a kneaded eraser to clean it up; don't use the pink eraser on the end of your pencil as it may leave marks on the board. Use a very fine sandpaper or burnishing tool, such as a burnishing bone or emery board, to smooth rough edges of cut mat board.

Flattening Fiber-Based Prints

Fiber-based prints rarely dry perfectly flat. Usually they dry wavy or curled, sometimes extremely so. The easiest way to flatten them is to heat them in a hot dry-mount press, and then let them cool under a flat, weighted object. You'll have to cover the print with a smooth protective sheet before placing it under a weight.

Preheat the press to 180–225°F. Then place one print at a time face down in the press, with one clean sheet protecting the front and one protecting the back of the print. Keep the print in the press for 1–2 minutes. Then take it out and immediately put it under a flat, heavy object, such as a large book or piece of heavy glass, so the print remains flat as it cools. In a few minutes, when the print has cooled, you can remove the weight, but you may have better results if you leave the weight on the print for several hours. It's okay to stack several of them under the weight while they cool off and flatten.

Follow these basic instructions for dry mounting prints:

Step 1

1. *Determine the size of the mat* by first measuring the image size. For instance, if your image size is 6" x 9", you may want a 12" x 15" mat for a 3" border all around. Buy a piece of mat board precut to that size—or cut the board yourself. Use 2- or 4-ply board.
2. *Preheat the dry-mount press* by turning it on and setting the thermostat. For RC prints, set the press to 180–200°F; for fiber-based prints, set it for 200–225°F. Note that some brands of dry-mount tissue call for different temperature settings, so follow the package instructions.
3. *Preheat the tacking iron* by plugging it in and setting the thermostat to a midrange temperature.
4. *Prepare a counter or table* for dry mounting by clearing, cleaning, and drying it thoroughly. Then place a nontextured covering surface, such as a large piece of smooth mat board or Kraft paper, on the counter or table.
5. *Place the print to be dry mounted face down on the covering surface.*
6. *Position a sheet of dry-mount tissue on the back of the print.* The tissue should be the same size as the print—or larger. Check to make sure the tacking iron is heated up.
7. *Attach the dry-mount tissue to the back of the print* by gently touching the tip of the tacking iron to the middle of the tissue and dragging it for 2–3". Heat turns the tissue into an adhesive, so it will attach to the back of the print.

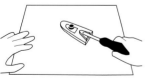

Step 7

8. *Turn the print (and attached tissue) over, and trim the excess white border from the image* of the print for a cleaner look; a print usually looks better when it doesn't have the white border next to the different color of the

Borders

A print can be positioned on mat board in various ways, depending on its orientation, format, and size. Print borders are usually at least 3″ on the top and sides and weighted to be slightly larger on the bottom.

When mounting or matting your prints, you can cut your board to the exact size you want or you can buy board that is precut to standard sizes. Cutting the board yourself allows the most flexibility in choosing the size of your borders, but it requires more work on your part. The first thing to do is determine the mat size. Measure your image and add at least 3″ to all dimensions. Many photographers leave a slightly larger border at the bottom to weight it visually to better balance the presentation. So if your image size is 6″ x 9″, add 3″ to the top and sides and 3½″ to the bottom for an overall mat size of 12″ x 15½″.

While this size works very well, using precut boards is more convenient and also allows you to use off-the-shelf frames, rather than custom-made frames. Some standard sizes include:

8″ x 10″
11″ x 14″
14″ x 17″
16″ x 20″
20″ x 24″

The strategy for determining border sizes with recut boards is slightly different than when cutting the board yourself, because you have to fit the image inside a fixed size. To estimate the closest standard size that provides a comfortable border, add about 3″ to all four sides of your image, or about 6″ to each of the dimensions. For example, if you have chosen an 11″ x 14″ board for your 6″ x 9″ image, the borders will be 2½″ on all sides; choosing a 14″ x 17″ board gives you a 4″ border on all sides. It's up to you to choose which standard size best suits your image and your budget. As with custom boards, it's best to visually weight the bottom a little.

Note that you can position your print on the board in different ways. Generally vertical prints are positioned on a vertical board and horizontal prints are positioned on a horizontal board, but you also can position horizontal prints on a larger vertical board. Square prints can be positioned on a square board with roughly equal borders all around, but they also can be positioned on a vertical board.

Step 8

Step 9

Step 10

Step 11

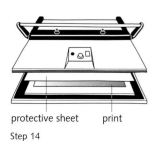

protective sheet print

Step 14

mat board. Cut a little into the image to ensure that no trace of the white border is left. Make your cuts with great care, using a paper trimmer or a ruler and cutting tool. If you use a trimmer, lay the edges of the print flat against the guide strip and then make the cut; if you use a ruler and cutting tool, cut on a surface such as cardboard to protect the counter or tabletop. Hold the ruler down firmly and cut straight down along the ruler's edge. Make sure the cut is square and accurate. Now the print and the dry-mount tissue are the same size.

9. *Position the print with attached tissue on a piece of mat board* to prepare for mounting. Measure the borders. Usually you will want the print to be a little higher than centered on the mat board, with a slightly larger margin on the bottom than on the top and with side margins of equal size.

10. *Put a weight on the print* once it is positioned accurately on the mat board. You can use almost anything that will keep the print in place—such as a small (dry) drinking glass or a wallet. First cover the print surface with a clean piece of paper, so the weight doesn't damage or dirty the image.

11. *Lift up one corner of the print, letting the dry-mount tissue remain against the board.* Lightly apply the tip of the tacking iron to the dry-mount tissue directly underneath to attach that corner of the tissue to the mat board.

12. *Carefully place the corner of the print down and remeasure the borders.* At this point the print is attached to the tissue in the center, and the tissue is attached to the mat board by one corner. The attachment to the board may be weak so you must remeasure to make sure the position of the print has not shifted. If it has shifted, gently detach the corner tissue from the mat board, without tearing it from the rest of the sheet or damaging the mat board, and repeat steps 9–12.

13. *Attach the opposite corner of the dry-mount tissue to the board,* as in step 11. Again, measure the borders of the print on the mat board to make sure the position of the print has not shifted.

14. *Insert the print, tissue, and board in the dry-mount press.* The print should be facing up with the protective cover sheet on top to keep the heated top of the press from touching the surface of the print.

15. *Shut the press* to fully attach the print to the board. This will take about 1–2 minutes depending on several factors, including the type of photographic paper you used, the temperature of the press, and the thickness of the protective cover sheet.

16. *Open the press* and remove the mounted print. Be careful; the mat board will be hot. Immediately put it under a flat, weighted object, such as a large book or sheet of heavy glass, so it will remain flat while it cools off. You should protect the surface of the print from the weight with a clean

sheet of paper or mat board (this may not be necessary if a clean sheet of glass is used as the weight).

17. *Take the mounted print out from under the weight* after 15–30 minutes (or longer). Gently bend the mat board back and forth with two hands to make sure that the print doesn't come unglued. If it does, repeat steps 13–15, this time leaving the board in the press for a few minutes longer.

If you are having trouble getting good adhesion, preheat the print and board by placing them separately in the press for 1–2 minutes, protected from the heated top of the press by a clean, smooth cover sheet. This should remove residual moisture from the print and the board, and should allow for better adhesion. Then follow steps 5–16 above.

Most dry-mounted photographs have a border, but some are **flush mounted**— mounted on backing board with no border. The procedure is the same as when dry mounting with a border, except that you don't have to be as careful when positioning the print on the board since the borders will be trimmed off. Simply attach the dry-mount tissue to the print, as in steps 6 and 7 above, and lay the print and tissue anywhere on the mat board. Tack the two opposite corners down, as in steps 11 and 13 (don't worry about measuring and remeasuring). Then attach the print and board by placing them in the dry-mount press and then removing them (steps 14–17). When the board is cool, cut off the borders of the print with a ruler and utility knife or board trimmer. As in step 8, make sure you cut the board so the corners of the image are square.

Overmatting

Another common way to display prints is to **overmat** them—mount them between two pieces of mat board. The board on top (the overmat, also called window mat) has an opening to show the print. The board on the bottom provides support. The print is loosely attached to the supporting board, on all four corners, usually with mounting corners.

Overmatting improves print presentation, and it also offers good protection. It is widely used by museums and galleries, because it is considered the best technique for displaying prints and also for long-term preservation. This is because the surface of the print sits just below the overmat, shielding it somewhat from physical damage. Also, if the overmat becomes dirty, you can easily replace it without damaging the print. Furthermore, because the print is not attached permanently to either mat board or dry-mount tissue, there is less chance of contamination from tainted board or tissue.

Because overmatting requires two pieces of mat board, it's a bit more expensive than dry mounting. However, it does not require dry-mount tissue or access to a costly dry-mount press. You'll need these items:

Overmatting is preferred by many photographers because it enhances the look of the image and provides protection for the print.

What you will need

mat board
board or paper trimmer
cotton gloves
kneaded eraser, sandpaper, brandishing tool
mat cutter
pencil
mat scribe
ruler and/or T-square
mounting corners
linen tape

Mat cutter

Mounting corners

See bw-photography.net for more on mail order suppliers.

Mat board. The mat board for overmatting is the same as the mat board for dry mounting. You can use most any weight, but typically 4-ply board is used for the overmat and either 4-ply or 2-ply for the support.

Board or paper trimmer. As described on page 238.

Cotton gloves. As described on page 238.

Kneaded eraser, sandpaper, burnishing tool. As described on page 238.

Mat cutter. A **mat cutter** makes a beveled (angled) cut in the mat surface. Models range from simple handheld units that you hold against a ruler to make the cut to integrated (and more expensive) systems to hold the board and also to guide the blade.

Pencil. You will need a sharp pencil to mark the back of the overmat board when measuring the window for cutting.

Mat scribe. A mat scribe is an optional but useful measuring and marking instrument. On one end it holds a pencil and on the other it attaches to the edge of the mat board. Once you've established the dimensions of the border, you attach the scribe to an edge of the board. As you glide the scribe along the board, the pencil marks one side of the window opening.

Ruler and/or T-square. You will need a ruler to mark the dimensions of the window; a thin metallic ruler with a cork backing works particularly well. When measuring the window, a T-square will help you make even and square markings on the back of the overmat.

Mounting corners. When overmatting, the best way to attach your prints to the supporting board is to use **mounting corners**. Some people make their own corners, but it's easier to buy premade corners. Plastic corners are very easy to use; they are self-adhesive, so you simply press them down on the supporting board and slide in the corners of the print. You can buy plastic corners in many camera, art supply, and stationery stores, as well as from mail-order suppliers.

Linen tape. Safe, nonstaining, and acid-free linen tape is best for hinging the support mat board to the overmat. Some types are self-adhesive, while others must first be moistened with water to activate the adhesive. Linen tape is available from art supply stores and mail-order suppliers.

Follow these basic instructions for overmatting prints:

Step 1

1. *Determine the size of the mat* by first measuring the print's image size, then subtracting the size of your image from the size of the mat board. For instance, if your image is a vertical 6" x 9", you may want a 12" x 16" mat to provide a comfortable 3" border all around.

2. *Get two pieces of mat board cut to that size*—or cut the board yourself. You can use almost any weight board, but you generally need at least a 4-ply board to make a good-looking bevel cut so try using 4-ply for the overmat and 2- or 4-ply for the support board.

3. *Prepare a counter or table for overmatting* by clearing and cleaning it thoroughly. Then place a covering surface, such as a large piece of mat board or Kraft paper, on the counter or table.

4. *Place the overmat board face down* on the covering surface.

Step 5

5. *Use a pencil to draw the desired window size and location* on the back of the board to prepare the board for cutting; never mark the front of the board. With some types of board you can use either side as the front or back, while other types are one-sided.

 Make sure your markings are even and straight and your corners are square. There are different ways to accomplish this. One way is to do the simple math. If your board is 12" x 16" and your print is 6" x 9", you can have 3" borders on the top and both sides and a 4" border on the bottom. Using a ruler (or T-square) and pencil, measure and rule up these dimensions; remeasure all sides to ensure accuracy.

 Alternatively, you can use a mat scribe to mark the required dimensions. Set the scribe for the border measurement, such as 3" or 3¼", and mark the window in pencil accordingly.

 Regardless of your method of marking the window, you will want to play it safe by making the window larger or smaller than the image size by about 1/8". If you want to float the image inside the window (leave a thin white border between the image edge and the window edge), increase the opening by ⅛", to 6⅛" x 9⅛". If you don't want the white border of the print to show, reduce the opening to 5⅞" x 8⅞" so that it overlaps the edge of the image slightly.

Step 6

6. *Cut one side of the window.* Again, cut on a surface such as cardboard to protect the counter or tabletop. Place your ruler along one marked side of the window, holding it down tightly so it won't slip. Make your cut with a mat cutter, which allows you to make a beveled cut. A bevel provides a smooth transition between the mat board and the image.

 Before you use a mat cutter, set the depth and angle of the blade. Then place the edge of the cutter along the edge of the ruler. Start close to your-

linen tape

Step 10

Step 12

mounting corner

Step 13

Step 14

self and push the cutter away from you to make the cut. Begin cutting just inside the corner of the window to ensure that the cut does not extend past the corner.

Work slowly, but steadily—and with a firm hand. Cutting an overmat takes patience. Practice on scraps of board before making your final cut. You will want to make sure the blade is set deep enough to cut through your mat board, but not too deep—or it may wiggle when cutting and produce an uneven window. Beyond that, keep the ruler and blade from slipping, and don't cut beyond the marked corners.

7. *Cut the other three sides of the window,* repeating the instructions in step 6.

8. *Poke out the cut portion of the board,* taking care not to tear it. The board will have a window opening the size of the print image.

9. *Smooth out rough cuts and slight tears* in the corners where two cuts meet. Work lightly with very fine sandpaper or a burnishing tool, such as a burnishing bone or emery board. Then erase all pencil marks on the back of the window mat to keep such marks from touching the surface of the print.

10. *Hinge the overmat to the support mat board* using linen tape. Butt the two boards together along the top side of each. The hinge goes on the inside of the overmat, so be sure the front of the overmat faces down when you are butting the two boards. Connect the boards with a piece of linen tape.

11. *Position the print in the overmat window* by placing it loosely on the support board and closing the overmat. Adjust the position of the print so it fits in the window.

12. *Place a weight, such as a short, dry drinking glass, on top of the print,* so it will not shift position. Make sure the print is covered first, perhaps with a clean piece of paper so the weight won't damage the print surface.

13. *Raise the overmat and fasten the print to the support board* with four mounting corners. There are other methods of securing the print to the support board, but mounting corners work well because they keep the print in place without causing a permanent bond; if you want to remove the print at any time, you can do so without damaging it.

14. *Close the overmat.* You can leave the overmat and support board attached on one side only; there is no need to tape the boards closed on the other side.

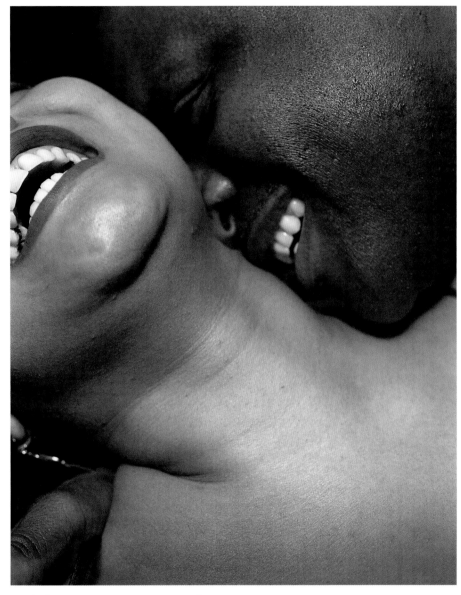

Nicholas Nixon, *E.A., J.A., Dorchester, 2002*

Over the years, Nixon's work has examined a wide variety of topics, including schools, AIDS, and family. His richly crafted black-and-white prints are actually contact prints made from 8" x 10" negatives. Here, he moves in very close to his subjects, a view that gives a tender moment even greater intimacy. © Nicholas Nixon; courtesy of the artist.

Index

Page numbers in *italics* refer to illustrated material.

accent lights, 119
acetic acid, 137
action mode, 85
active autofocus, 37
Adobe Photoshop, 21
air belles, 145
Akiba, David, *Arnold Arboretum, 208*
alternative approaches, 9
 hand coloring, 222
 high contrast, 210–13
 infrared film, 209–10
 liquid emulsion, 223–24
 photograms, 215–18
 sandwiching negatives, 220–21
 solarization, 213–15
angle of view, 41–48
 and distortion, 44–46
 and focal length, *43*
 See also focal length
antihalation layer, 23
aperture
 combining with shutter speed, 71–72
 defined, 6, 38
 and depth of field, 49–53, 72
 for electronic flash, 122, 123–24
 of enlarging lenses, 164
 and film exposure, 35–41, 69
 for low-light scenes, 40, 47, 55, 97
 maximum, 39, 40, 41, 47, 52, 55
 for printing, 179–80, 187
 setting f-stops, 38–40, 71–72
 See also f-stop
aperture-priority autoexposure mode
 (A, Av), 83–84
aperture ring, 38
archival quality, 168
 overmatting for, 242
 stability factors for, 170, 205
 toners for, 229, 231
archival washers, 168, 200
artificial lighting. *See* electronic flash;
 studio light
autoexposure modes
 adjusting, 74, 90–91
 aperture-priority mode, 83–84

autobracketing, 89
autoexposure compensation setting, 90–91
autoexposure lock (AE lock), 86, 94
backlight option, 95
program mode, 83
shutter-priority mode, 84
subject-program mode, 84–85
See also film exposure; light meters
autofocus (AF), 7–8, *33, 35*
 cameras, 17, 21
 problems with, 36–37
automated cameras
 and battery usage, 4
 problems with, 3
automatic processors, 185

B (bulb) setting, 60
background lighting, 119
backlighting, 86, 94–95, 114, *115,* 118
Baden, Karl, *Charlotte, 112*
base
 film, 23
 paper, 170
baseboard, 161
batteries, 4
bellows, 15
Bishop, Jennifer, *Route 10, California, 128*
black-and-white film. *See* film
black borders, 188
blue skies, filters for, 103, *104,* 105
blurring
 deliberate, 49, 62, 63
 and shutter speed, 63–65, 66, 72
borders, 188, 240
bounced flash, 124–26
bracketing exposures, 89–92, 210
bulk film, 26
Burke, Bill, *Abandoned U.S. Embassy,
 Danang, 30*
burning-in, 193–97, 220–21

cable release, 101
Cambon, Claudio, *Ghost Horse, Spring
 Blizzard, 96*
camera accessories, 99–111
 cases and bags, 110–11
 cleaning materials, 111
 close-up equipment, 109–10

filters, 101–8
 tripods, 99–101
camera basics
 checking batteries, 4
 choosing and loading film, 4–6
 developing and printing, 9
 focusing, 7–8
 removing film, 8
 settings, 6–7
camera shake
 and film speed, 73
 and shutter speed, 62, 63–66
 and telephoto lenses, 46
 and type of camera, 14–15
camera system, 11
camera types, 11–21
 digital cameras, 21
 film formats, 11, 13, 15
 front view of manual, *4*
 Holga cameras, 18–19
 instant cameras, 17
 point-and-shoot cameras, 17
 rangefinder cameras, 14–15
 single-lens-reflex cameras, 3, 11–14
 twin-lens-reflex cameras, 17–21
 view cameras, 15–16
 See also specific types
camera wrap, 110
Caplan, Lana Z., *Gloriosa Lilies, 216*
Carter, Keith, *Sleeping Swan, 106*
cases and bags, 110–11
centerweighted metering, 78–79
changing bag, 134
chemicals
 film-processing, 134–40
 printing, 173–75, 182–85
chromogenic film, 31
circular polarizer, 107
cleaning materials
 for camera, 111
 for negatives, 168, 175, 176
close-up photography
 depth of field in, 109
 equipment for, 53, 100, 109–10
coarse-grain films, 25
cold-tone images, 171
colored filters, 103–5, *106*
coloring, hand, 222

Acknowledgments

Revising this book has been a huge task, involving a total rewrite and all-new illustrations and photographs. I am enormously grateful to all those who helped out.

Many thanks to Tom Gearty, who worked with me throughout on the text, picture editing, and the overall direction of the book. Russell Hart and Ann Jastrab acted as technical editors and aided stylistically as well. All were most qualified due to their high degree of knowledge about the crafts of both photography and teaching.

Special thanks to art director Janis Owens, who contributed her usual clarity and vision on how an instructional book should look and read, with admirable assistance from Carol Keller, who also produced the many clear and accurate drawings. Their colleagues at Books By Design in Cambridge, Massachusetts provided the final touches: copyediting, proofreading, and indexing. For their efforts, hats off to Alison Fields, Rebecca Favorito, and Chrissy Kurpeski. Also, thanks to top copyeditor Nancy Burnett.

Helping me put together the book also was a group effort. Grateful thanks to master printers George Bouret and Allison Carroll. And, of course, Sarah Andiman, who pulled together many loose ends, including picture permissions.

Others who contributed in various ways include Steve Brettler, Alicia Kennedy, Michael Guerrin, Dori Miller, David Prifti, and Christiane Robinson—not to mention a long list of wonderful photographers, all of whom are credited in the text along with their images.

Kim Mosely of St. Louis Community College at Florissant Valley in Ferguson, Missouri has produced an excellent teacher's guide to this book, called *Workbook for Black and White Photography*. For more information, contact Kim at

www.kimmosley.com/workbook.

Continuing thanks to all others who helped in earlier editions of the book: Mary Allen, Leslie Arnold, Sheri Blaney, Bill Burke, Linda Burnett, Bobbi Carrey, Barbara Crane, Peter deAngeli, Lan DeGeneres, Jim Dow, Pam Edwards, Emma, Carl Fleischhauer, Sharon Fox, Stephen Frank, Peggy Freudenthal, Russell Gontar, Margaret Harris, Allen Hess, Jenny, Teri Keough, Sue Kirchmyer, Paul Krot, Dick Lebowitz, Peter Macomber, Robbie Murphy, Marjorie Nichols, Claire Nivola, Lorie Novak, Elaine O'Neil, Nancy Palmer, Carolyn Patterson, Barbara Pitnof, Neal Rantoul, Ben Rosenberg, Lewis Rosenberg, Joann Rothschild, Eric Roth, Stanley Rowin, J. Seeley, John Sexton, Frank Siteman, Jim Stone, Anne White, and Sean Wilkinson.

And, not least, very special thanks to my faithful longtime editor, Mary Tondorf-Dick, for her great patience and support. And to Richard McDonough, who originally brought me to Little, Brown. Thanks also to others at Little, Brown who have helped, most notably Marie Mundaca, Kerry Monaghan, and Jennifer Brennan.

About the Author

Henry Horenstein is a professional photographer, author, and educator. His photographs have been published and exhibited worldwide and are included in many public and private collections including the Museum of Fine Arts, Boston; the National Museum of American History, Smithsonian Institution; and the Museum of Fine Arts, Houston. He has published more than thirty books including other textbooks (*Beyond Basic Photography; Color Photography;* and, with Russell Hart, *Photography*) and books of his own photographs (*Honky Tonk, Aquatics, Creatures, Canine, Racing Days,* and *Humans*). He is professor of photography at Rhode Island School of Design and lives in Boston, Massachusetts.